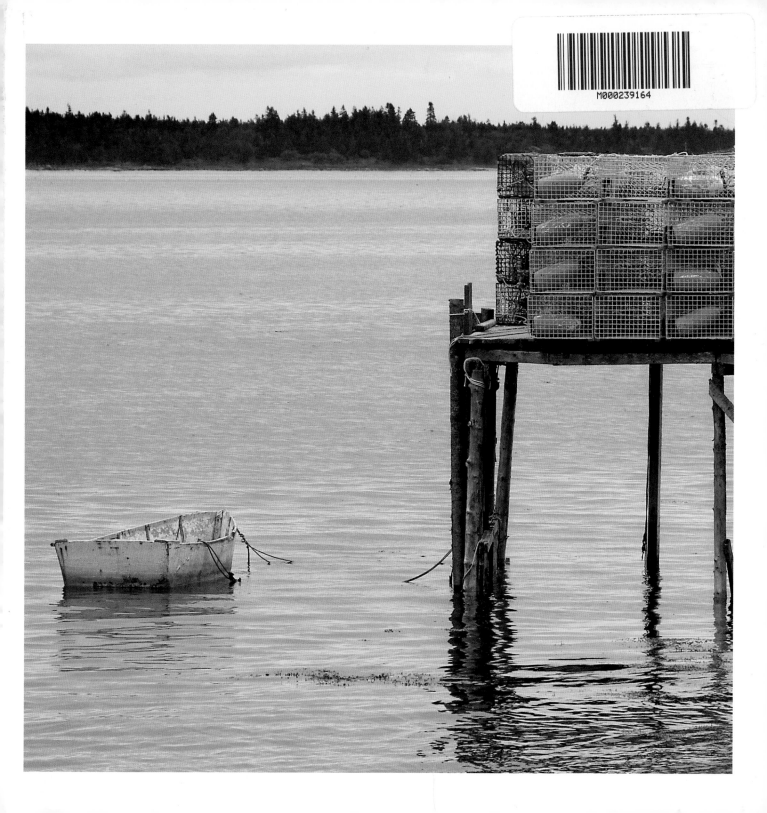

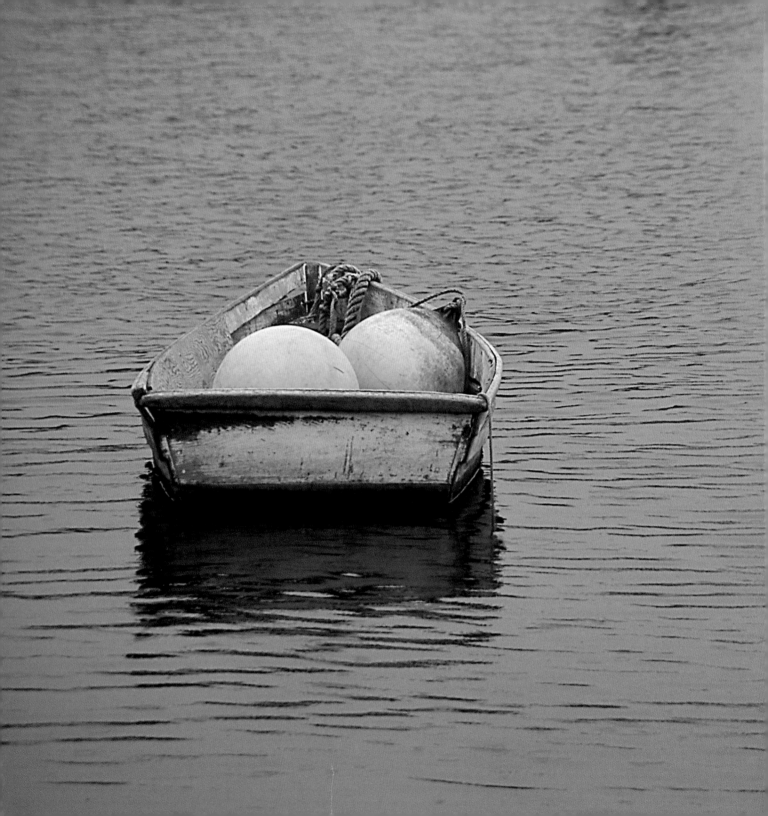

# AFLOAT ON THE TIDE

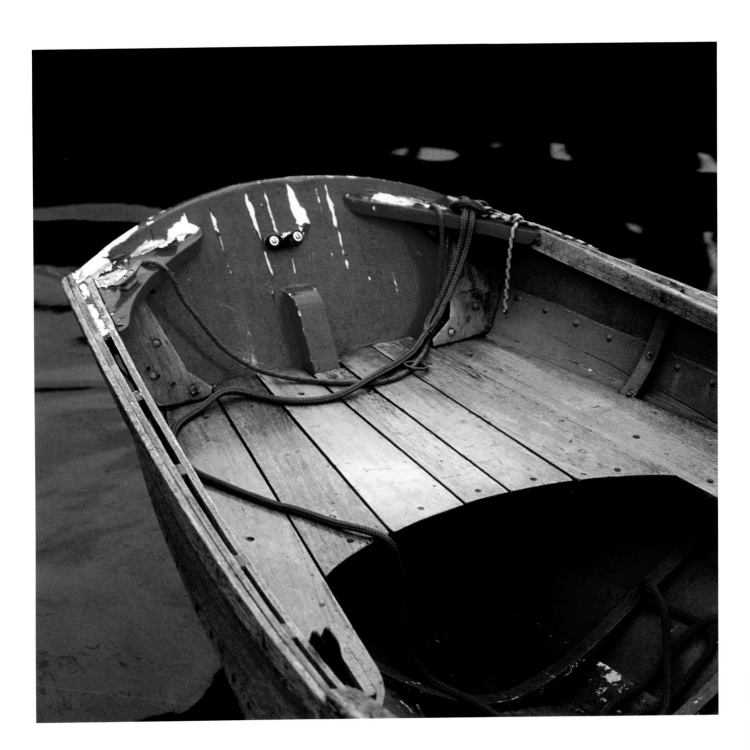

# AFLOAT ON THE TIDE

## Wooden Dinghies, Prams, Skiffs, and Other Rowboats

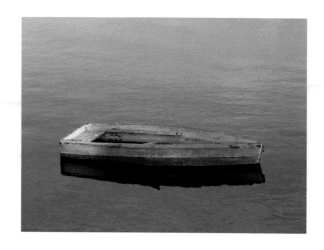

**Photographs by Nancy Rich**
**Text by Peter H. Spectre**

 Sheridan House

This edition published 2009 by
Sheridan House Inc.
145 Palisade Street
Dobbs Ferry, NY 10522
www.sheridanhouse.com

Library of Congress Cataloging-in-Publication Data

Rich, Nancy
 Afloat on the tide : dinghies, prams, skiffs, and other
wooden rowboats / photographs by Nancy Rich ; text by
Peter H. Spectre.
    p. cm.
 Includes bibliographical references and index.
 ISBN 978-1-57409-285-1 (pbk. : alk. paper)
1.  Dinghies—Atlantic Coast (North America)—Pictorial
works. 2.  Skiffs—Atlantic Coast (North America)—Pic-
torial works. 3.  Wooden boats—Atlantic Coast (North
America)—Pictorial works. 4.  Boats and boating—
Atlantic Coast (North America)—Pictorial works. 5.
Harbors—Atlantic Coast (North America)—Pictorial
works. 6.  Atlantic Coast (North America)—History,
Local—Pictorial works.  I. Spectre, Peter H. II. Title.
 VM351.R49 2009
 623.82'9—dc22

                                        2009023776

Design by Sherry Streeter

Printed in China

ISBN 978 1 57409 285 1

# Contents

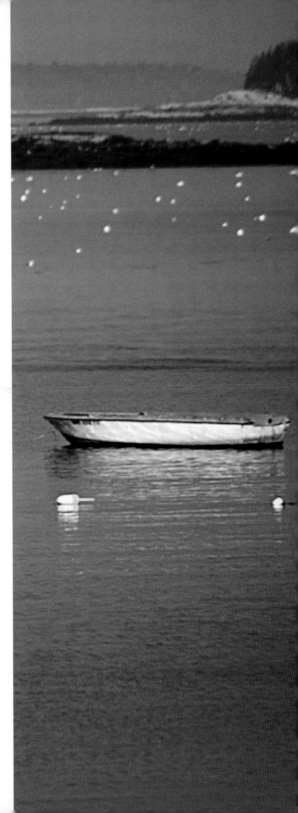

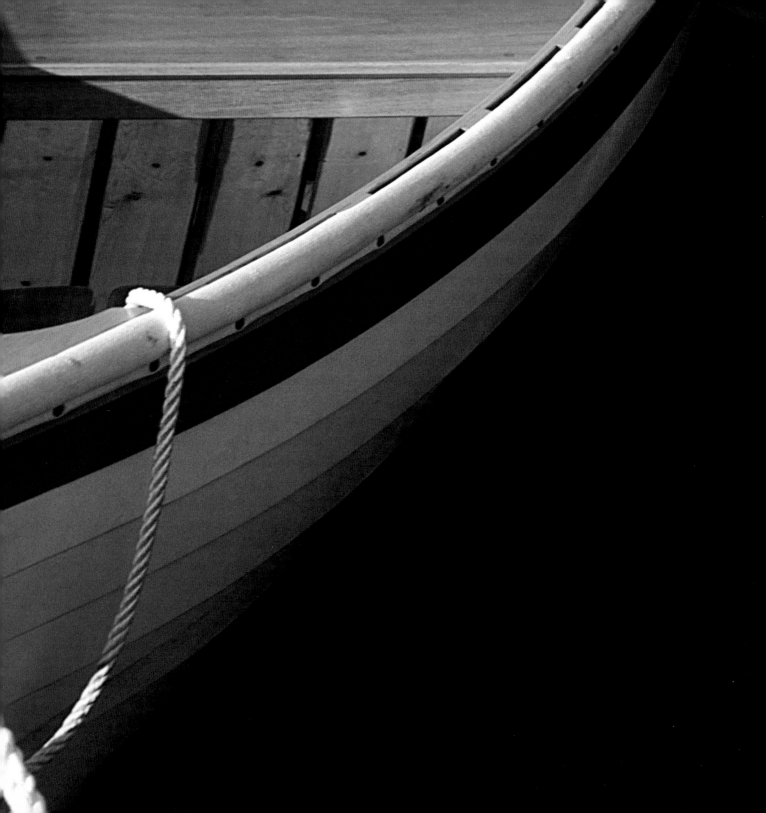

Dedicated to the men
and women who build
wooden boats and to the
owners who preserve them
for the benefit of future
generations.  And to Adam and
Laura whose strengths and talents
inspire me.　　　　　*—Nancy Rich*

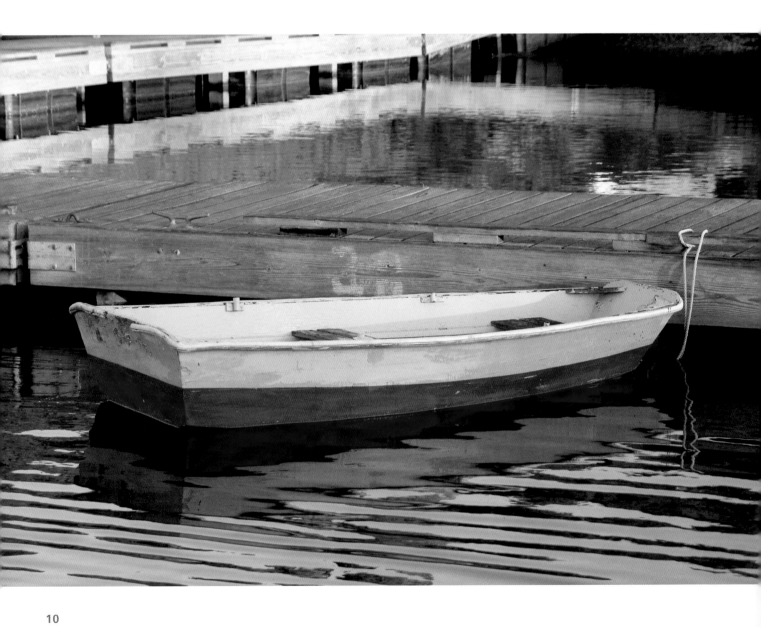

# Notes from the Photographer

ALL ALONG THE ATLANTIC COAST, from Newport to Nova Scotia, charming harbors beckon with names such as Sorrento, Friendship, Roque Bluffs, and Whale Cove. Wooden rowboats are the mainstay of these harbors. These small boats can be rudimentary in their design or works of exceptional craftsmanship. Rowboats remain at the ready in service to their owners. Most are intended to provide safe passage to and from larger vessels moored in deep waters—others simply offer leisure time afloat on the tide.

Greatly outnumbered, wooden rowboats share the dock with other boats made of fiberglass, aluminum, and rubber—materials that do not readily succumb to the wearing effects of weather, water, time, and use. While functional and utilitarian, these boats lack the history, artistry, and charm of their wooden counterparts.

Each rowboat has a distinct character that is revealed through its worn wood and peeling paint, its scars, and its faded or vibrant colors. That character, the simple lines, and a subtle beauty attract me to these special boats and define what I strive to capture in my photographs. Regardless of their condition or role, wooden rowboats are a beautiful reflection of our lives—colorful, with purpose and integrity, profoundly small in an immense world, worthy of attention, and symbolic of a rich life story through their weathered and handsome form.

I treasure my time searching for small boats. Admittedly, these pursuits can lead to both awkward and comical situations. When the northeastern Atlantic shifts to low tide, taking photographs often involves negotiating a long, vertical ladder or steep, slippery ramp to gain access to a floating dock. I lose my footing on occasion, or a camera strap or clothing catches the ladder causing me to stray a little too far from my comfort zone. The exposed seaweed-covered rocks tease me with their treacherous path to a "must have" boat floating just off shore. And I have lost more than one shoe to the clawing muck. On a blustery day,

standing on a dock requires the stealth and equilibrium of a cat, and like a cat, the threat of making contact with the water is a most unwelcome thought. I am often compelled to call upon the generosity of yachtsmen and fishermen to indulge my need to get closer to a boat just out of range. I have mixed success in my efforts to be simultaneously at ease, grateful, and invisible. Despite the challenges, the moment of discovering the right boat, in the right light, in the right setting, is exhilarating.

The evolution of *Afloat on the Tide* paralleled a revolution in the art of photography. During the decade spent preparing this photographic record of wooden rowboats, the century-long prominence of the film camera was usurped by advances in digital technology; as such, this collection includes photographs captured on both slide film and in a digital file. The vast majority of photographs in *Afloat on the Tide* were taken along the shores of Rhode Island, Massachusetts, Maine, and the Canadian Maritimes. Wooden rowboats epitomize the people and landscape of these coastal regions: hardworking, pragmatic, picturesque, and rugged. I hope that you enjoy my portraits of these special boats.

My gratitude goes to Alan for the countless hours he spent by my side seeking just the right boats for this collection; to Hope and Ted Sage of North Haven, Maine, who were generous hosts on many dinghy-hunting trips; to June Hopkins, owner of the North Haven Gift Shop and Gallery, for her advice and support all along the way; to photography teachers Carrie Peterson, Arlene Collins, and Harvey Stein, who did what great teachers do—nurtured my skills and enthusiasm; to maritime bookseller and publisher Louie Howland of Howland and Company, Jamaica Plain, Massachusetts, for his wise counsel; and to Gary Jobson, America's Cup champion, ESPN sailing commentator, and prolific writer of sailing books; publisher Lothar Simon and editor Janine Simon at Sheridan House; designer Sherry Streeter; Liz Gray, Library Director at Dana Hall School, Wellesley, Massachusetts; photographer Peter Engledrum; and editor Heather Mather for their invaluable help preparing this book for publication.

—*Nancy Rich*

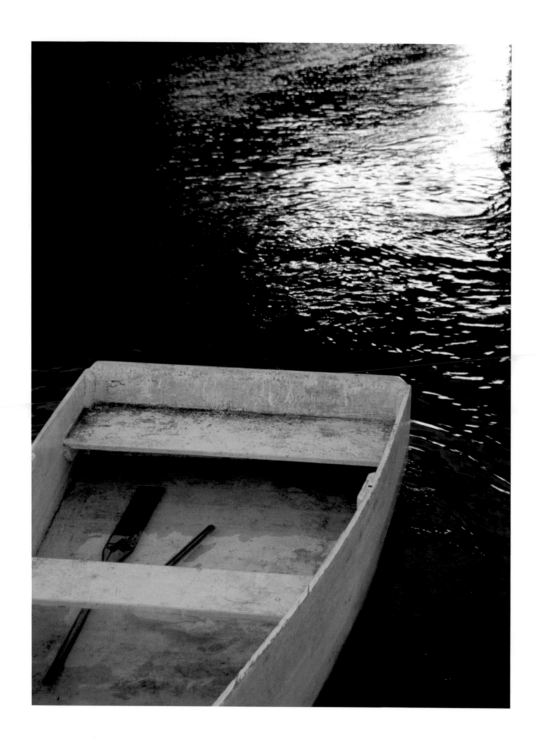

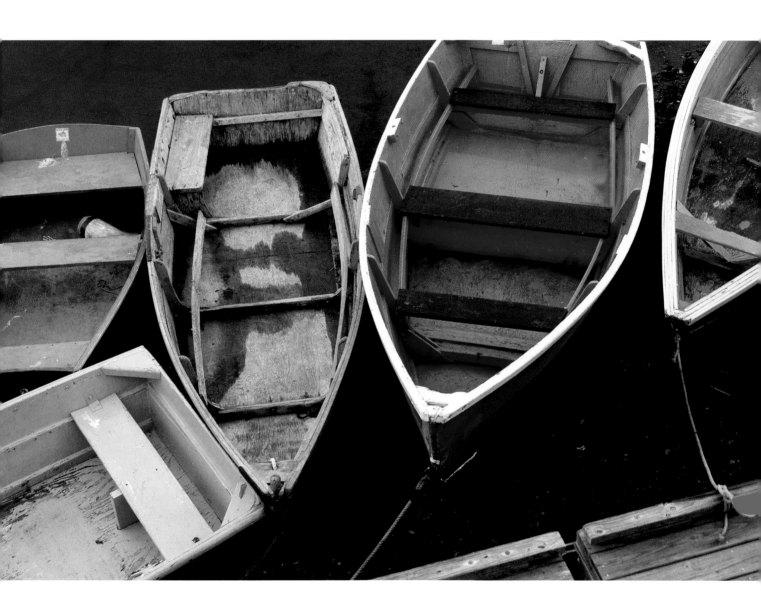

# A Few Words About the Boats

IN A GENERAL SENSE, all the boats pictured in this book are rowboats; that is, small craft propelled by oars. Some have been modified to carry a small outboard motor; others have a notch in the transom for sculling with a single oar; still others are capable of carrying a small sail. Many are stand-alone craft; others are used as tenders to larger boats. Most are working craft used by lobstermen, commercial fishermen, boatyard workers, and the like. As such, the greatest concern of their owners is that they float, not that they win first prize at a concours d'elegance.

Rowboats are of different types, and how they are defined depends on where on the coast they are found. Roughly, the types are these:

*Skiff*—a flat-bottomed boat with a blunt stern and a pointed bow. Also called a flattie, a sharpie, and a flat-iron skiff (the latter because its shape resembles a clothes iron).

*Dory*—a high-sided skiff-like boat with a pointed bow and a "tombstone" transom; that is, a stern transom that is wide at the top and very narrow at the bottom.

*Punt*—a flat-bottomed boat with transoms in the bow and stern that are more or less equal in size. Sometimes called a scow, especially if it is wide in relation to its length.

*Pram*—generally a flat- or V-bottomed boat with flat bow and stern transoms, the bow transom being smaller than that in the stern. Prams of Scandinavian origin have a round bottom.

*Dinghy*—a small round-bottomed boat.

*Tender*—any small boat that serves a larger one as a water taxi or lifeboat.

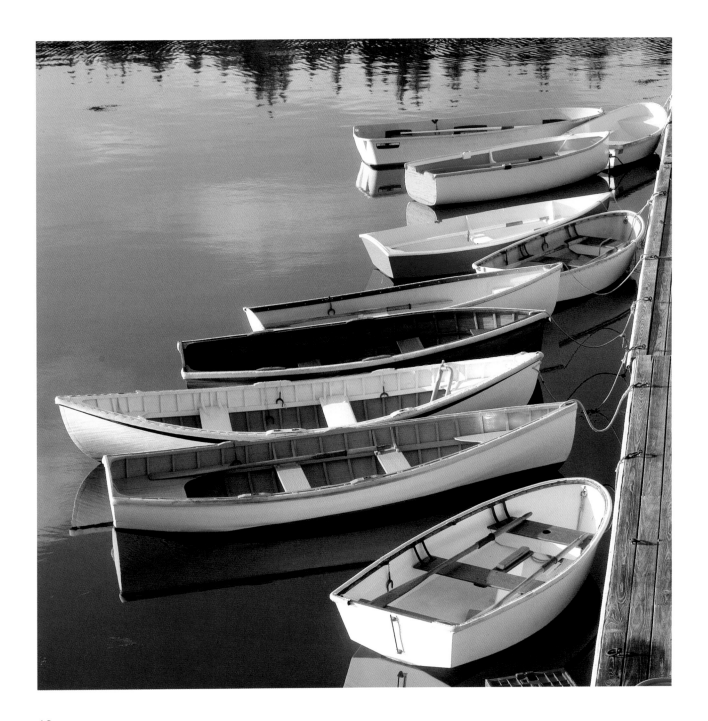

# Rowboat

## by Peter H. Spectre

WHEN I WAS A BOY, growing up on Cape Cod, I lived for a couple of years in Truro, way down the Cape next to Provincetown. It was a tiny town then, no more than a couple hundred people year round, perhaps 500 or so in the summer, and a general store and a post office and a boatyard near the mouth of the Pamet River where it emptied into Cape Cod Bay.

There wasn't much for a boy to do. To break the boredom I used to hitchhike into Provincetown and hang around the fish pier, or hunt for Indian arrowheads on Corn Hill, or help a friend who lived on a farm shoot rats in the chicken barn, or, when really desperate, lay pennies on the railroad tracks and wait for the single freight of the week to pass by and flatten them out. But my favorite pastime was to go down to the Pamet and poke around the boatyard.

I can't remember much about the place now, but it was a typical old-style boatyard of the time (mid-1950s): a common variety that you'd find down a narrow Cape Cod road that wound through the beach plum and bayberry bushes. The standard yard of that type would be half on land, half sort of falling into a tidal river, and the owner would live in a shack off to the side. There would be a couple of big sheds filled with boats in storage, boats on cradles sitting in the open out in a field, and a bunch of dinghies by the dock, upside down in the muck with tarps to keep off the winter scudge. Some of these craft would be maintained with a certain measure of pride, depending on the state of their owners' pocketbooks, but a significant number would be in varying degrees of decrepitude, either abandoned or carrying signs that said "For Sale—Make an Offer," which more or less amounted to the same thing.

Over in a corner would be a shop filled with all sorts of fascinating objects. A new wooden boat under construction, an old rowboat being reframed, a bandsaw, a thickness planer, and a table saw running on leather belts off the same motor, benches piled with tools, nails, and rust-

> Waking or sleeping,
> I dream of boats.
> —*E.B. White*

ing engine parts, mounds of sawdust, and a black dog scratching fleas by the side door. Several rather graphically illustrated calendars would hang on the walls; none would be there because the owner and his yard crew were interested in the date, if you know what I mean. The dominant smells would be of native cedar, linseed oil, and wood smoke; sour oak on those days when they were sawing out frames.

Down at the dock there would be an old Flying Horse gas pump with an "Out-of-Order" sign taped above another that said "No Credit Except Regular Customers." You got to be a regular customer by storing a boat in the yard or buying gas for about a month and actually paying for it. Besides credit, the regulars were given skiff privileges at the float and the right to hang around in the spring, getting their boats ready for launching. More boating enthusiasts than you would imagine considered spring fitting-out to be the high point of the season; launching the craft was, in more than one sense, going downhill; actually sailing was anticlimactic; the end of summer was a relief.

Spring fitting-out in the boatyard was a ritual. Lots of scraping, lots of burning off built-up paint, lots of jacking garboards back into position after the fastenings let go when water froze in the bilges over the winter. Caulking, puttying, painting, varnishing, grunting, sweating, swearing, drinking beer, listening to Florida exhibition baseball on a portable radio with an antenna jury-rigged from a bent coat hanger.

One day when I was skylarking through the Pamet River yard and coincidentally suffering from a near-terminal case of I-gotta-have-a-boat, I saw a rowing punt by the door of a shed, carrying a For Sale sign. It was an unremarkable boat: a couple of side planks, a cross-planked bottom, flat transoms at both ends, and lots of peeling paint, but it reminded me of the punt that Walt Kelly's cartoon character Pogo used to row around the Okefenokee Swamp with his friends. Pogo's punt would start out in the first frame of a comic strip with a simple name like *Frenchie* with no hailing port, and in the next frame it would become something like *Shikuma*, and then *Henry Shikuma* from Hilo, and then *Henry and Ellen* from Oahu, and then *Missie B* from Dubuque, and later the SS *Helen Barrow* from Spokane, and so on. Only primordial boat junkies paid any attention to this running gag. Straight folk were too busy trying to figure out whether

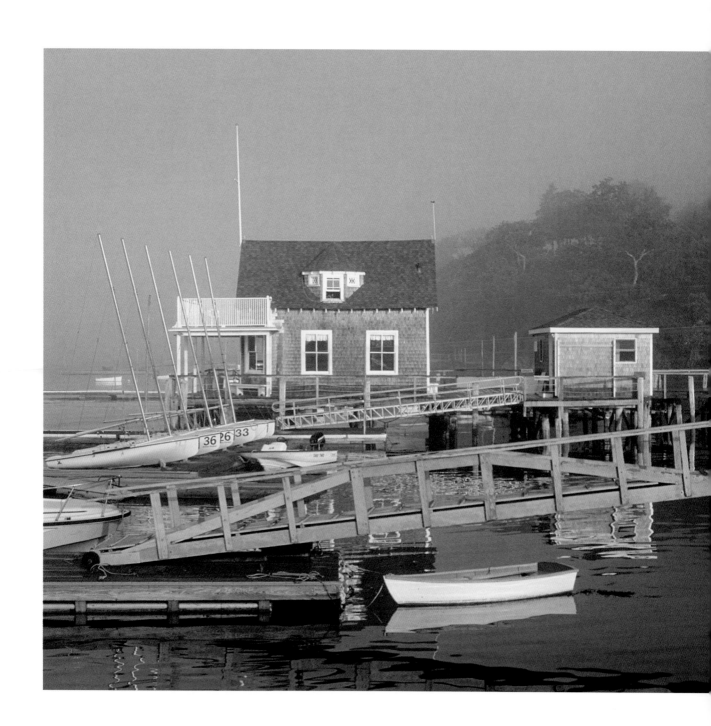

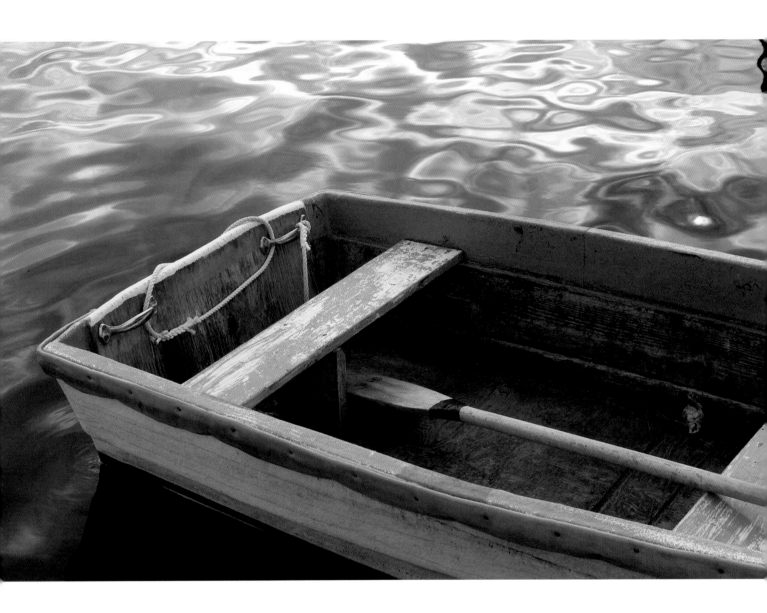

Pogo was a Republican or a Democrat or a socialist verging on a pinko Commie fellow traveler.

One of the carpenters at the Pamet River boatyard told me that the asking price for the punt was $35, which doesn't sound like much now and probably wasn't much then, but it might as well have been a thousand dollars as far as I was concerned. My family wasn't living on easy street in those days; I wasn't old enough to have a paying job.

Broke or not, I was at once a rowboat nut and a Pogo fan, and I had to have that boat. So I decided to build a copy of it, even though I had never built a boat before, or anything else more complicated than a tree house lashed together from planks and an old door or two. I ran back home and got a ruler and ran back to the boatyard and took off a few rough dimensions, and then when nobody was looking liberated some boards from a deconstructed barn down the road.

I built that punt in a day, caulking the seams with strips of cloth cut from an old flannel shirt, painted it the next day, and launched it the third. It wasn't fancy and it was the butt of a lot of jokes, but it was good enough for mucking around in the salt marshes and for fishing in a nearby freshwater pond, and it was stable and it didn't leak and it didn't cost $35 and it was mine.

I was then, and am to this day, a certifiable rowboat junkie, and that little punt, my first rowing craft, couldn't have come at a better time. At least my old man probably thought so. I had been collared at one point during the previous summer for stealing someone else's rowboat. I protested that I had merely borrowed it, that I was simply testing it out to see how she rowed, but the town constable who ran me in for Grand Theft, Watercraft, failed to appreciate the distinction.

I had been mucking around the waterfront, checking out the important things, when I came across a skiff pulled up on the shore with a pair of oars and locks in place. How thoughtful, I thought, for someone to leave this beautiful little craft for me to try out. The intention was to whip around the harbor before the owner came back, but one thing led to another and then another and another. About five hours later I was pinched by the law way up where the main road crossed a tidal river I had been exploring for blue crabs. (The owner of the rowboat had thoughtfully

She was my own boat, and I knew her very well, and I loved her with all my heart.

—*Hilaire Belloc*

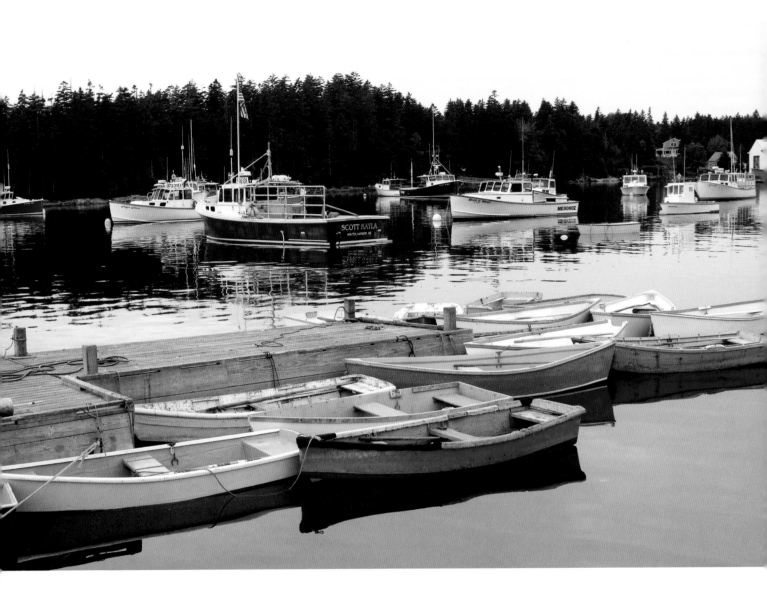

included, with the oars and the locks, a long-handled net and a pail.)

The constable ran me up to his office in the town hall, sat me on a stool, and discussed crime and its punishment for awhile. I remember he talked a lot about reform school and jail and losing all hope of ever getting a good job and other dire consequences ("Do you know what happens to 12-year-old boys in jail?"). Then he said maybe he should take me home to talk to my old man. I told him thanks but no thanks; I'd rather go to jail.

That, as it turned out, was a big mistake. The constable smiled the way the Grinch did when he told the little Who child that he was just cleaning up around the place, that he definitely wasn't stealing Christmas, and said, "Get in the car."

It was mid-afternoon, and my old man was taking a nap. The constable stayed in the car, the one with the blue bubble light on top and the billy club under the front seat, and sent me in after him.

"What is it?" the old man said when I tapped on the bedroom door.

"There's someone outside who wants to talk to you," I said.

"Who is he?" he said.

"I don't know," I said.

"What does he want?" he said.

"I don't know," I said.

Right, and Grant's Tomb is an ice cream parlor.

It was damned uncomfortable standing out there in the yard while the town constable told my old man that his son was a common boat thief. So, too, was listening to the harangue that followed. What happened? Let's just say that I didn't go to jail and didn't spend much time during the rest of that summer beyond the imaginary line that ran between the stakes defining the corners of my old man's investment in the American dream. I got to go to the dentist's office to have my teeth reamed out and that was about it. Definitely not anywhere near the waterfront.

It was the second time that year I had been caught with a rowboat that didn't belong to me. I have lost track of the number of times I "borrowed" a rowboat and didn't get caught. Let's say it was more than 50, less than 100. In my irrational moments, I've often wondered why my old man didn't recognize this overpowering need to get in a rowboat and buy me one. In my rational moments I recognize that (a) he was not nautically

In little vessels, there is joy. In large vessels there is travail and perplexity.
—*Ernest K. Gann*

inclined, and therefore didn't know a rowboat from a pitchfork, and (b) he was at the time so close to financial ruin that he had more pressing things to attend to than indulging a son who had criminal tendencies—such as keeping his creditors from repossessing the family car.

Some time later we moved to an island—a winter rental in a summer cottage, something the old man could afford while he reestablished his wherewithals—a little dot of a thing at the top of Buzzards Bay, right on the edge of the approaches to the Cape Cod Canal.

There was less to do on our island than there had been in Truro. I read a lot of books, skipped a lot of flat stones from the beach, dug a lot of clams and quahogs on restricted flats when no one was looking, and otherwise made a nuisance of myself, or so people who knew me from that era remember. I principally recall sitting for hours by the window of our tiny living room and reading boat books and magazines, a pair of binoculars by my side, looking out from time to time for ships making their way up the bay for Boston and points north and east, and down the bay for New York and points south and west. I was watching for the regulars, the ships I knew, and when I spied them I would run down to the point and climb onto a high rock and wave to the crew. There could very well be retired merchant mariners alive today, men in their 80s and 90s, old geezers who remember the kid with romance-of-the-sea on his brain who waved and jumped up and down and shouted greetings across the water. At least I like to think there might be.

When I wasn't looking for ships, I was after whatever flotsam and jetsam lay out on the bay. A strong flood tide ran twice a day into the Canal, and with it came all sorts of interesting stuff, from battered life rafts to packing crates, broken oars, buckets lost overboard, and even a couple of sealed bottles with messages in them. (One of the latter came from a boy down the road; he tossed it into the outgoing tide; I discovered it, to his great disappointment, on the very next incoming.) Our yard was piled with treasures I had dragged from the sea.

My greatest find came in the spring, following a strong storm and abnormally high tides. I got up one morning, went to the window, picked up the glasses, and studied the horizon. Nothing. I studied the far shore. Nothing. I swept the bay. Noth... Wait! What's this? Something low, long...

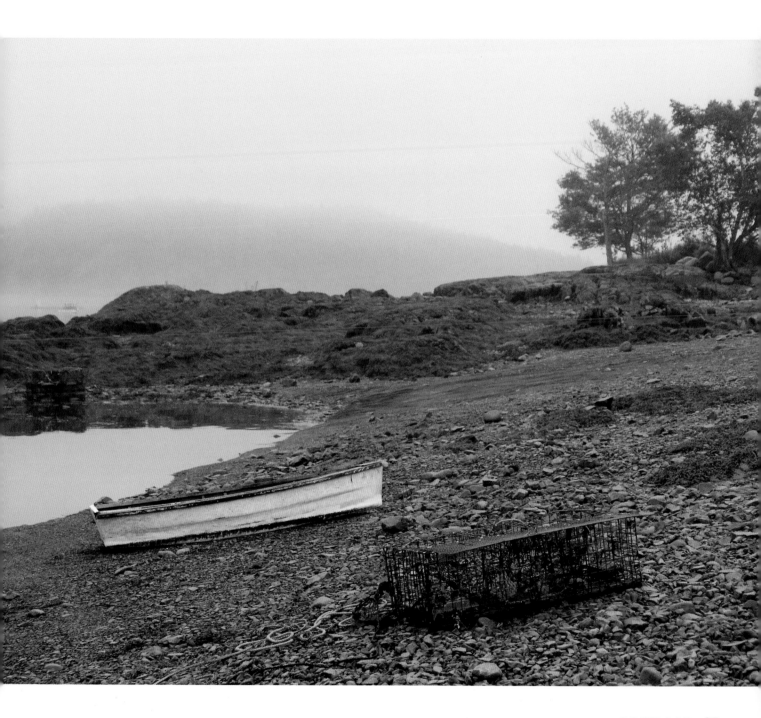

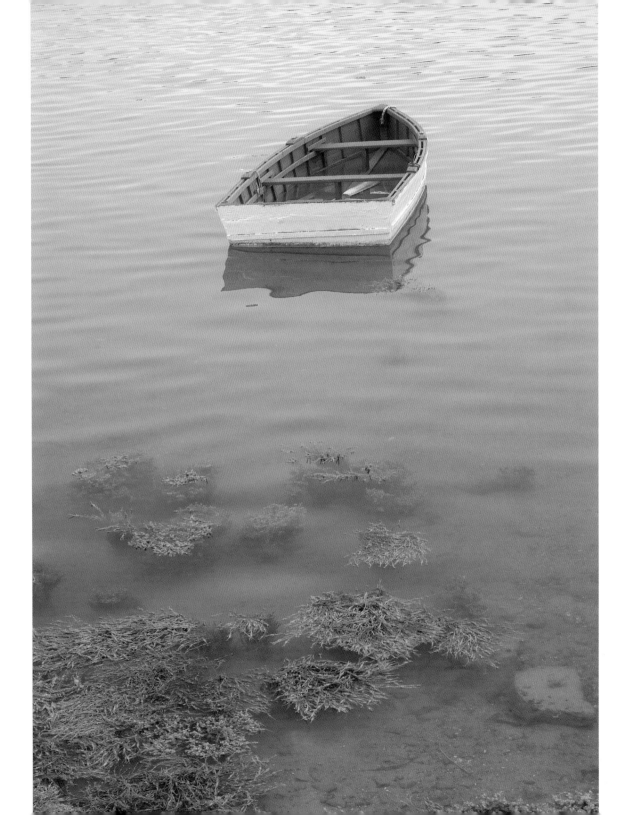

a sweeping curve along the top edge... could it be?... might it be?... Great Jumping Jangling Jones!... It is! A boat! It's a rowboat... half full of water... there's nobody aboard....

Or, as William Shakespeare wrote, "Fortune brings in some boats that are not steered."

I ran down to the point and waited for the tide to bring it in. When the boat was abreast I emptied my pockets, took off my shoes, waded out about chest high, and grabbed it. Hot damn! Finder's keepers. It was mine!

Frankly, it was a mess. The stern seat was gone, the transom was partially rotten, and the finish, such as it was, was scratched and chafed and peeling. It was about 14 feet long, and even when it may have been in perfect condition it obviously had never served a greater purpose than as a fisherman's punt or a workboat in a boatyard.

I knew the type well. It was a skiff—also called variously, depending on where you were from, a flat-bottomed skiff, a flat-iron skiff, a flattie, a sharpie skiff, or simply a sharpie. To my eye it was a piece of work, and since no one came along to claim it, I called it mine. Over the next week or two I replaced the stern seat and roughly patched the rot in the transom and filled the seams with white-lead putty. I painted it light blue on the outside and white on the inside and named it *Lollipop*. Then I spent one of the happiest years of my life rowing around the waterfront in a genuine, just-folks, down-and-dirty American boy's boat. A genuine flat-iron skiff.

I was a guest at a reception for writers and editors and other litterateurs at the Portland Museum of Art in Portland, Maine, a few years ago. The editor of a major general-interest magazine asked me what sort of boat I owned. (People like him never know how to make conversation with people like me. They think we know nothing about politics or sex or drugs or balancing the federal budget or anything else having to do with serious contemporary issues, so they ask us what kind of boats we own.)

I told him I had a rowboat down at the town landing.

The expression on his face was lovely to see. Surely a man of my stature must have a boat with more presence than that, he suggested. A Concordia

The little boat you are in, and know in every plank, and love too, becomes more than ever a cherished friend.
—*John MacGregor*

yawl, perhaps, or a Friendship sloop, or, at the very least, a Beetle cat. My rowboat, in short, must be transportation out to my real boat.

No, I said, I just have a rowboat tied up to the public landing.

When you're a guest at the Portland Museum of Art, it's important to get your artistic sensibilities right out on the table. Thoreauvianism, that's what it was. Wasn't it Henry David Thoreau himself who informed the Concord tax assessor at one point that the only piece of real property he owned was a rowboat? Minimalism: all stripped back to the basics, the essences, the unadorned roots.

It was a pleasant little conceit—a pseudo-intellectual puffball to go along with the hors d'oeuvres and the white wine—but it was also a bald-faced lie. Yes, I owned a rowboat, but not because I had any sociopolitical statement to make. The truth was that I was merely living out my boyhood dream. I had always wanted a rowboat tied up down there at the public landing, right where I could keep track of it, and I did, and that was all there was to it.

Generally after work in the afternoon or after supper in the evening, spring, summer, and fall—even in the winter, weather permitting—I'd go for a row. Sometimes I'd pull out into the bay and juke around in the southwesterly swell, but more often than not I'd circumnavigate the little island at the mouth of our harbor, or sprint out to a point about a half mile away and back. If there was weed on the boat's bottom and no one was at home in the house on the point, I'd haul her onto a beach there, turn her over, and scrub her down.

During that period I had two rowboats—a winter boat and a summer boat. Neither was much in the speed and elegance departments. Rather, they were extremely utilitarian craft that were noteworthy for being un-redeemingly common in an era of shining gel coats and dynamic graphic schemes on the fiberglass boats and wineglass transoms, hand-rubbed varnish, and custom bronze fittings on the renaissance wooden craft.

The summer boat, 12 feet long, was a derivative of the old-style flat-bottomed skiff made a bit more seaworthy by a Maine boatbuilder who understood such things. The bow and sides were shaped just right to take the modest seas of summer, and the flat bottom allowed the boat to be easily beached. Two rowing stations allowed me to take a passenger or two for

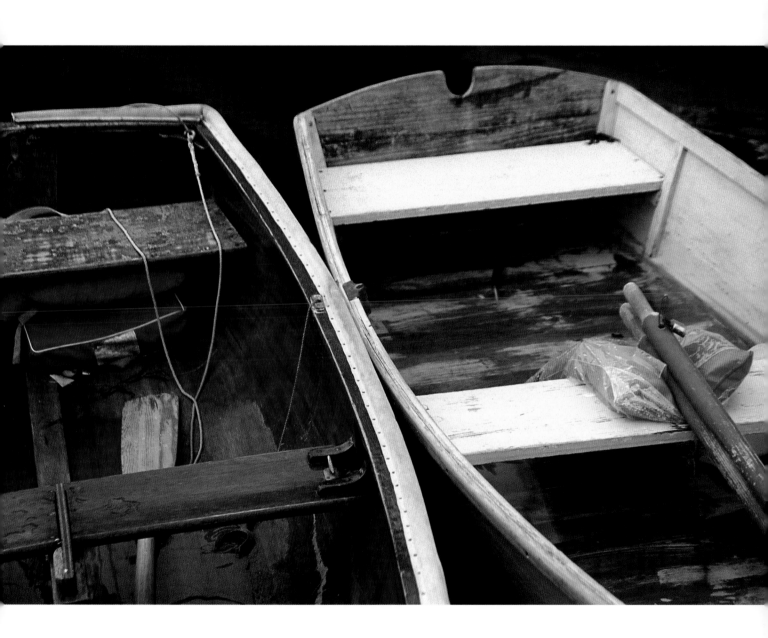

The pleasure you get
from a boat is often
reckoned to be in
inverse proportion
to its size.

—*anon.*

a little cruise without throwing the trim out of whack. Maintained by me for the long haul, it looked the way a summer boat should; it wasn't out of place even when the New York Yacht Club made its biennial visit to my harbor.

The winter boat was my favorite. A funky old 13-foot round-bottomed rowboat said to have been built on Deer Isle, Maine, somewhere between 30 and 50 years previously, it spent a good part of its career in Newport, Rhode Island, though when I took possession it was lying in a barn in Brooklin, Maine. Crudely built yet of moderately fine model, it lasted all those years for reasons that were not entirely clear. The frames were pulling away from the planking, the transom had a huge check—thankfully above the waterline—that opened and closed depending on the strength of the relationship between the humidity and the sun, and the keel had a long hook in it that required a certain touch by the oarsman to keep the boat going in a straight line, when a straight line was what was to be achieved. (On the positive side, she turned fast to port.)

I bought the boat for $50, and, because the seams were so wide "you could throw a cat through 'em," the previous owner included in the deal enough tubes of caulking goop to keep her afloat. I spruced her up with a few new frames and some extra fastenings here and there, and painted her off-white on the outside and light gray on the inside. She was fast, seaworthy, and comfortable and gave me great service for several years, fair weather and foul.

What with the ice and the snow and the howling gales, nobody in his right mind keeps a rowboat in the water during the winter in Maine, but I did. A few other oddballs did, too. I never discussed the matter with them, but I can tell you what motivated me. I needed a rowboat in the water for peace of mind. I needed to know that in the January Thaw or any other day between November and March when the temperature went above freezing I could row out to the island or the ledges and take a look around. And, yes, I needed an excuse to get out of the house in the darkness of winter. "I'm going down to the harbor to bail the rowboat, my dear," was a sentence heard often around my home, and no one begrudged me the privilege.

Early one winter when I was out of town, the boat filled with rainwater during a storm, and then the Montreal Express came through dragging

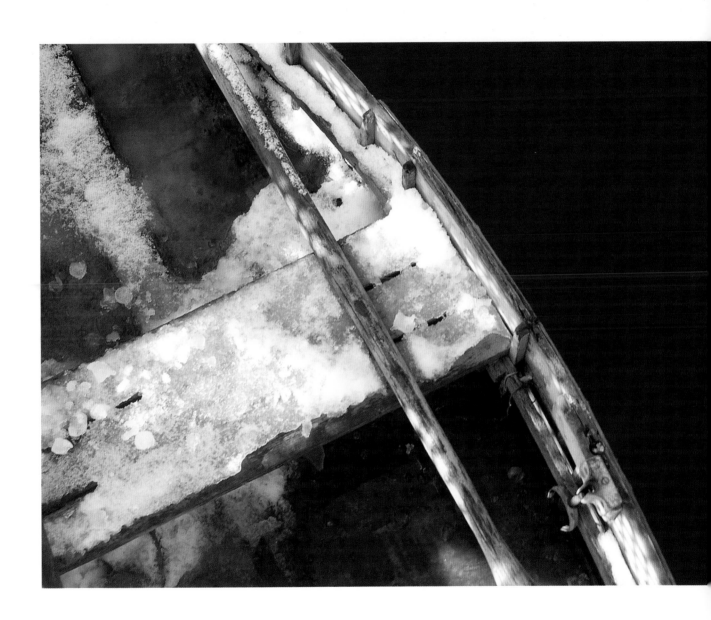

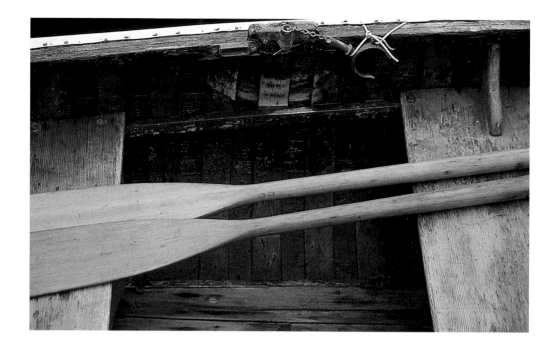

below-zero cold and by the time I got back, her bilge was a solid block of ice that lasted until the January Thaw, and that was that. She went loose as a goose. I hauled her out, blocked her up in the backyard, and shifted over to another boat.

One day I was visiting with Dynamite Payson, a professional boat-builder in South Thomaston, Maine. He was telling me about a boy down the road who had decided that he would be a lobsterman. The boy had the wherewithal for some used gear but not for a boat, so he was setting and hauling his traps directly from shore by wading out at low tide.

I don't know about you, but I've done a fair amount of wading around the edges of Penobscot Bay, and I'm here to say that it's a cold, nasty business. Any boy who wants to be a lobsterman so badly that he'll do that on a regular basis deserves anyone's help, so I said, okay, he can have my old winter boat.

I trucked the boat down to South Thomaston, and Dynamite went to work. He cleaned her out and tightened her up, and then he and his wife

gave her a nice lobsterboat finish and presented her to the boy. Hauling traps from a rowboat may be hard work, but it sure beats wading around at low tide.

That was several years ago. I recently asked Dynamite for the rest of the story. He said that the boy worked the rowboat until he had saved enough for an outboard skiff; eventually he graduated to an inboard lobsterboat and became a full-fledged lobsterman. My old winter rowboat—my favorite—had done its job.

I sit as I write this on a small island at the mouth of a harbor on Penobscot Bay. The season is high autumn. The mountains by the edge of the western shore are green, with patches of red, orange, and yellow where the hardwoods grow. I can see the barest hint of Matinicus Island on the horizon, out there on the edge of the Atlantic Ocean, and the white foam making up around the ledges out in the bay. The central image is of my summer rowboat, swinging to a buoy connected to the island by a simple haul-off rig.

She is cocked into the wind, her bow slightly higher than her stern and the two connected by a sheer line that could make you weep, it is that perfect. Her bottom is a dark red and her topsides are a deep, rich green, and she carries a manila rope guard that was once part of the main halyard on a big schooner and a line of fenders to protect her from docks and other boats coming alongside.

She's the latest of a long line of rowboats I've owned over the years. Perhaps not the best, perhaps not the one that embodies everything I ever wanted in such a craft, she nevertheless is symbolic of something I have only recently come to recognize: I came to my career—I do what I do—because when I was a boy I wanted a rowboat just like her.

I remember the first time I was in a rowboat as if it were yesterday. I was six years old. Every detail is clear in my mind: The Oyster River in Chatham, at the elbow of Cape Cod, the fast-ebbing tidal current, the barrenness of early spring by the edge of the sea, the boat a little wooden flat-bottomed skiff, the smell of oiled wood and tarred rope and salt air blowing across the sea grass.

It is very notable how commonly the poets, creating for themselves an ideal of motion, fasten upon the charm of a boat.

—*John Ruskin*

My friend was rowing. He knew what he was doing; I knew nothing. I almost jumped out of my skin with fear when we pushed away from the dock and the current grabbed at the boat and pulled us at a ferocious rate down the river and around a bend.

By the time we pulled into Stage Harbor among the gathered fishing boats—the little draggers, the quahog skiffs, the power catboats—I was no longer scared. I had discovered that all I had to do was know how to work the oars, and in the space of an hour, with my friend yelling instructions and howling hysterically with laughter over my awkwardness, I knew. You didn't have to know anything about engines or sails or rigging. You could walk down the road to the harbor or the shore and step into a little boat without any preparation whatsoever, sit down on the thwart, slide the oar-locks into the sockets, cast off the painter, put the oars into the oarlocks, take a long pull, and be underway. I was hooked by the freedom of the rowboat.

For years I've carried around a piece of paper with several lines from the novel *Flying Colours* by C.S. Forester. The passage has to do with the escape of Captain Horatio Hornblower, Royal Navy, from the interior of France in the early nineteenth century. Hornblower and his two companions didn't elude their pursuers by taking off on horseback or by trekking across the countryside like a band of lubbers. They stole a rowboat and pulled down the Loire River to the sea:

> The coach was poised perilously on the brink of the river; Hornblower could see the black water sliding along almost under his nose. Two yards away a small rowing boat, moored to a post, swayed about under the influence of wind and stream.... On a night like this it was easy to lose one's way altogether—except in a boat on the river; in a boat one had only to keep shoving off from shore to allow the current to carry one away faster than any horse could travel in these conditions....
> "We're going to escape down the river in that boat, Brown," he said.

We're going to escape in a rowboat.... It was simple, it was elegant, and it could be done by anyone—a captain in His Majesty's Royal Navy who wanted to escape his enemies or a boy who was curious about what lay

For genuine excitement and
thrill, give me the small boat.
—*Jack London*

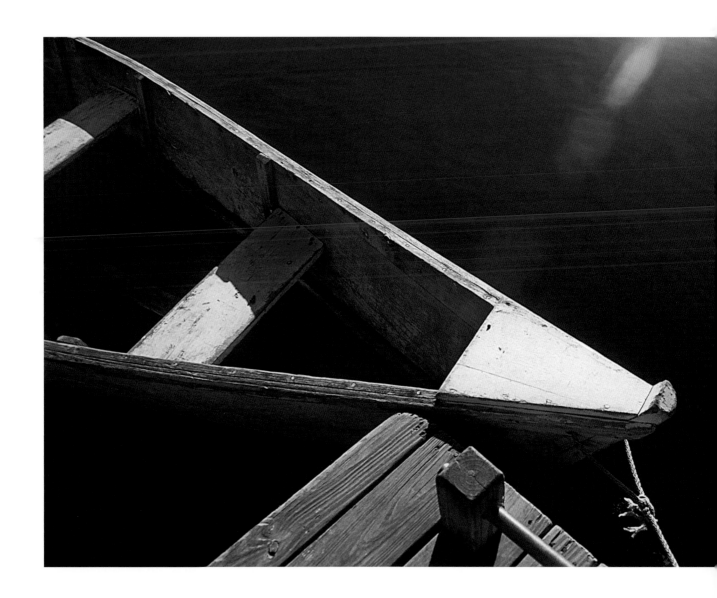

beyond the next headland or a man who needed a little time now and again to himself.

Yes, it was all about escape. And about romance, too.

I'm at the oars; you're sitting in the stern. I can look into your smiling eyes. You can hear my witty banter. I can show off my rippling muscles. You can see them. Is there a better way to impress a date? Is there a better way for a date to be impressed?

I don't know how many romances originated in a rowboat, or how many, commenced elsewhere, were brought to a higher level there, but I do know that there's something exhilarating about the combination of water, boat, fresh air, and thou.

When I was attending the U.S. Coast Guard's Officer Candidate School in Yorktown, Virginia, this kind of thing was known as skylarking and was strictly forbidden. Any aimless pursuit of happiness, especially with a member of the opposite sex, could get you into big, big trouble. Especially if it were in a rowboat.

Rowboats were for work, not for fun, and the harder the work, and in our case as trainees, the more instructive, the better. Grunt, sweat, suffer, and learn. That's what rowboats were for, and don't you forget it for a minute, Buster.

One day after navigation class (or was it fire fighting? I can't remember), our platoon was marching down a path that ran alongside a creek. We were engaged in an exercise called Project X. The gent in charge was one of those red-faced warrant officers who had earned a high-school equivalency certificate by correspondence course and who didn't mind telling all and sundry that he had a bachelor's degree from the School of Hard Knocks and who had risen through the ranks and who yelled all the time because he couldn't believe he had to waste his precious time with a bunch of effete boneheads who may have had a college education but still couldn't tell the difference between a 3-inch naval gun and a 10-foot boat hook.

Project X was an intermittent marathon intended to bring out latent leadership potential in the officer candidates. Call it Outward Bound with

a mean streak. It consisted of a series of seemingly impossible tasks, induced randomly, that in theory would separate the men from the boys, the leaders from the followers.

The day was oppressively hot, with a relative humidity index that by comparison would make New York City at high noon on a mid-August day seem like a Swiss alpine meadow. My scalp itched. My neck ran with sweat. My woolen coastguardsman's shirt stuck to my back.

We came to a wharf that ran about 50 feet into the creek. At the end was a pair of davits. Slung in the davits was a double-ended Monomoy surfboat, an ancient lifesaving icon, as potent a symbol to the Coast Guard as USS *Constitution* is to the Navy.

The warrant officer called the platoon to a halt, strolled to the end of the wharf, threw a life ring as far as he could into the creek, turned around, put his hands on his hips, and addressed us thus:

"Okay, you overeducated jugheads," he shouted. "That life ring is a drowning man. You're coastguardsmen, and your task is to rescue him. You must do it with the surfboat and only the surfboat. The victim will be dead in three minutes. You must rescue him in under that time, and you must return the boat to the davits. Total time: 5 minutes. Mr. Spectre, you're in charge."

Mr. Spectre? Me?

There were a lot of landlubbers among us. We had heard of Monomoy surfboats, and we had also heard of davits. The best you could say was that we were indeed college educated; the worst you could say was that we were theorists. But at least we could read. From our personal copies of the Coastguardsman's Manual, we knew what surfboats and davits were supposed to do. We just hadn't done that with them before.

I'm not going to describe the panic, the agitation, the confusion that ensued. It's sufficient to say that for the first minute, minute and a half, there was a lot of arguing about how to get that boat in the water, who should use what oar, and how the oar should be used (most of my chums didn't know how to row), and a lot of theorizing about the uses of blocks and tackles. Hell's bells! We wasted at least 20 seconds, maybe more, in a heated dispute over which end was the bow and which was the stern!

Being in charge, I told everyone to shut up. I sorted out the bow from

the stern, the lifeboat falls from the painter, made quick, arbitrary assignments, got the boat in the water, the crew in the boat, and shipped the steering oar. I was a Manly Man in Training, was I not?

We had the drowning life ring in hand in under three minutes, and we had the surfboat alongside the wharf in four. The real problem came in getting the boat falls two-blocked in the davits. Actually, we had little difficulty with the two-blocking part (if this is too technical, look it up). Getting the bitter ends of the falls tied off on the cleats without dropping the several-hundred-pound boat overboard and developing a severe case of rope burn in the process was—how should I say?—more problematical than I had thought. That part of the operation took an extra four minutes.

"Eight minutes for a simple five-minute task!" the warrant officer shouted after we were finally lined up at attention next to our Monomoy surfboat. He smirked with satisfaction.

"Mr. Spectre! Front and center!"

"Aye, aye, Sir."

"Ten demerits, Mr. Spectre," he said. "Five for taking too much time and five more for skylarking."

"Skylarking?"

"That's right, college boy," the warrant officer said with a sneer. "You looked like you were having too much fun."

One would think that after an experience like that I would be incapable of having fun in a rowboat again. At least not without many, many hours of psychological counseling to raise my self-esteem. But you can't keep a good man down. Skylarking in a rowboat had been habitual since I was a little boy. No warrant officer could ever whipsaw me into low self-esteem in a rowboat. Not a chance.

Not long after I was awarded my commission and had strapped my Ensign boards on my shoulders and blew that training center in a cloud of dust, I was easing along with my lady love in a skiff, skylarking to beat the band.

I was showing off my rippling muscles. She could see them.

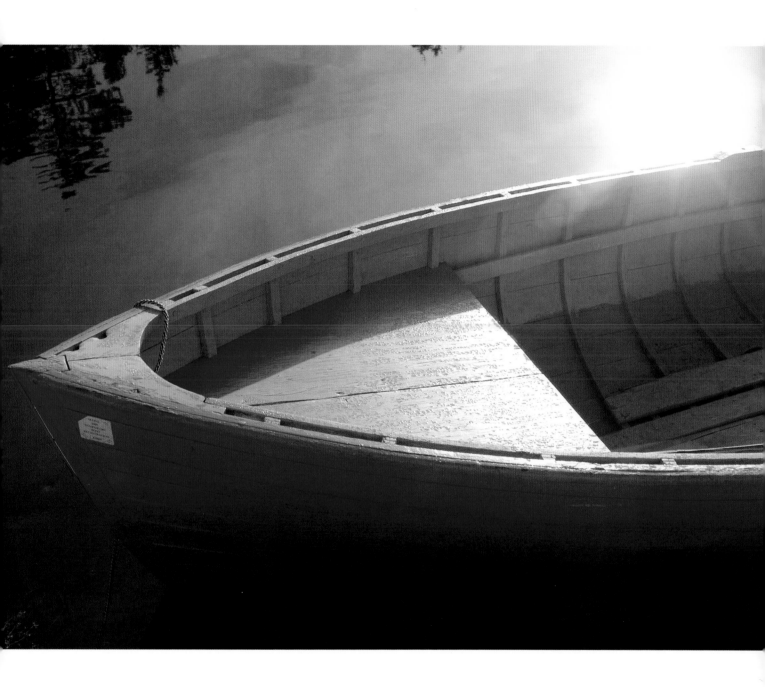

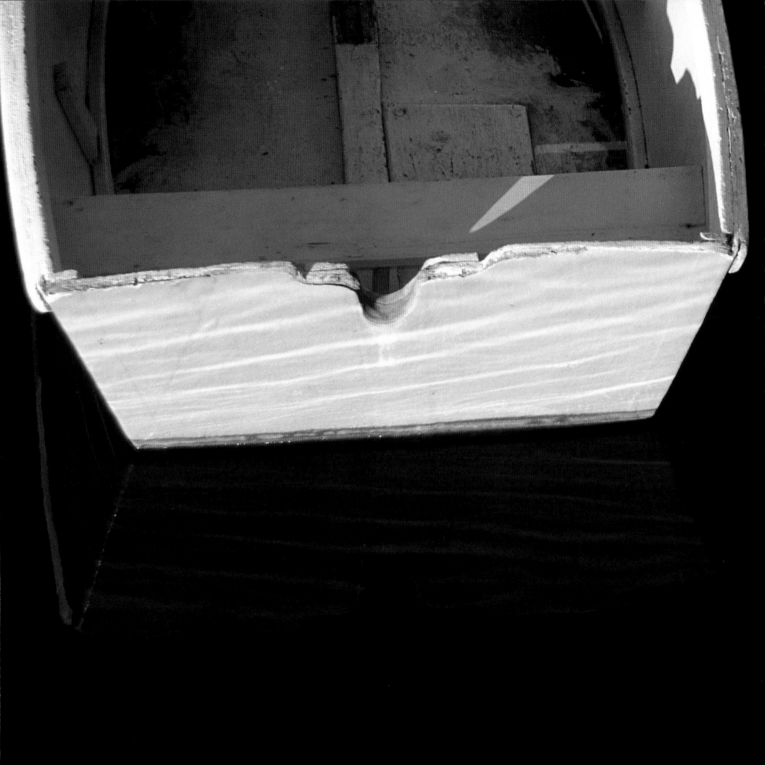

# A SIMPLE STYLE

Less is more.
—*Ludwig Mies van der Rohe*

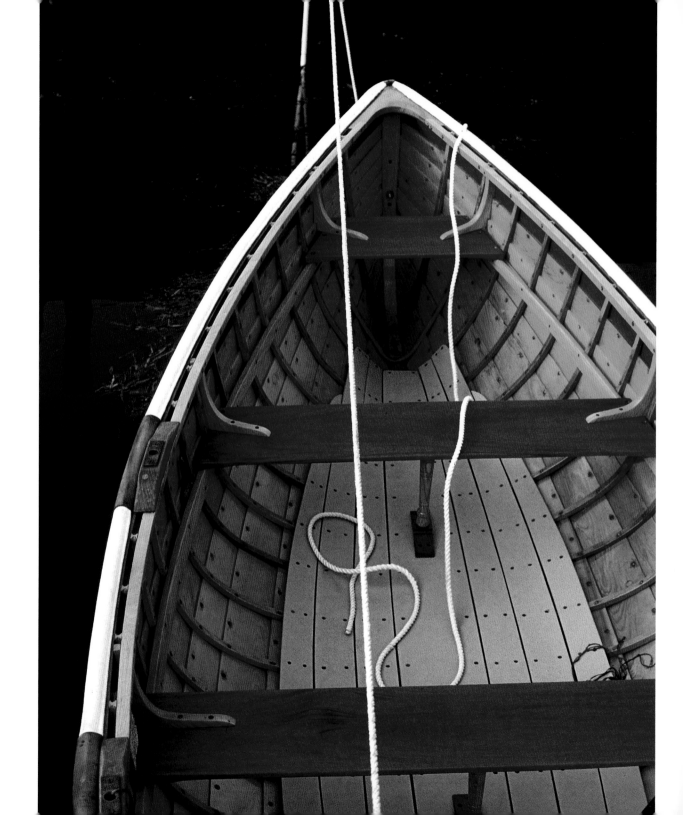

# The Bow

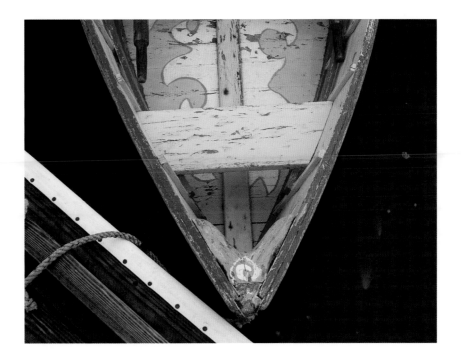

To touch that bow is to rest one's
hand on the cosmic nose of things.
—*Jack London*

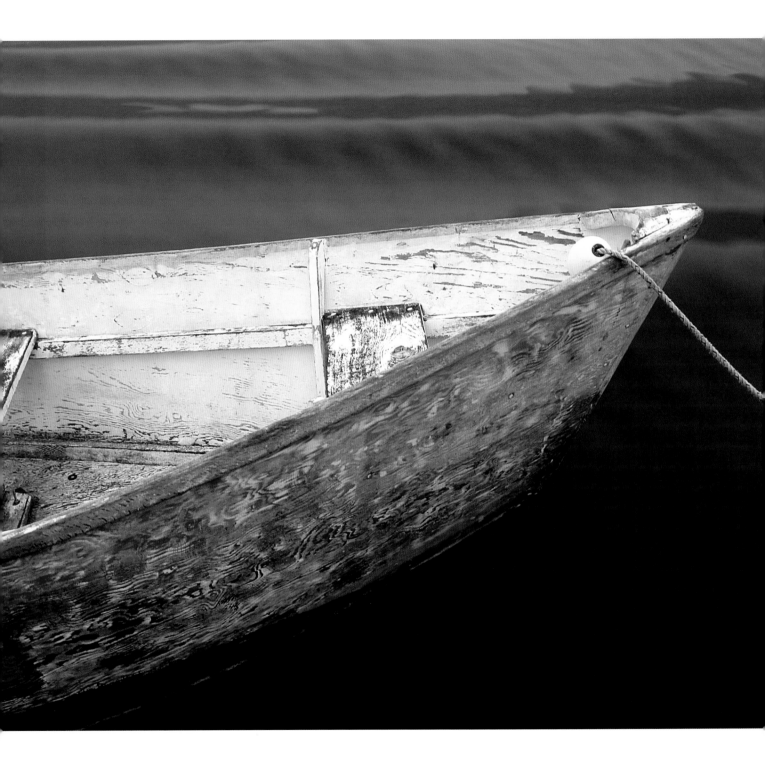

The wisdom of life consists in the
elimination of nonessentials.
—*Lin Yutang*

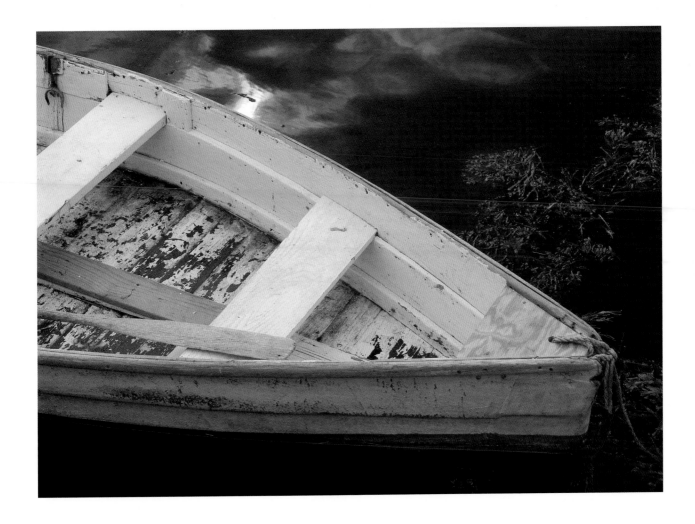

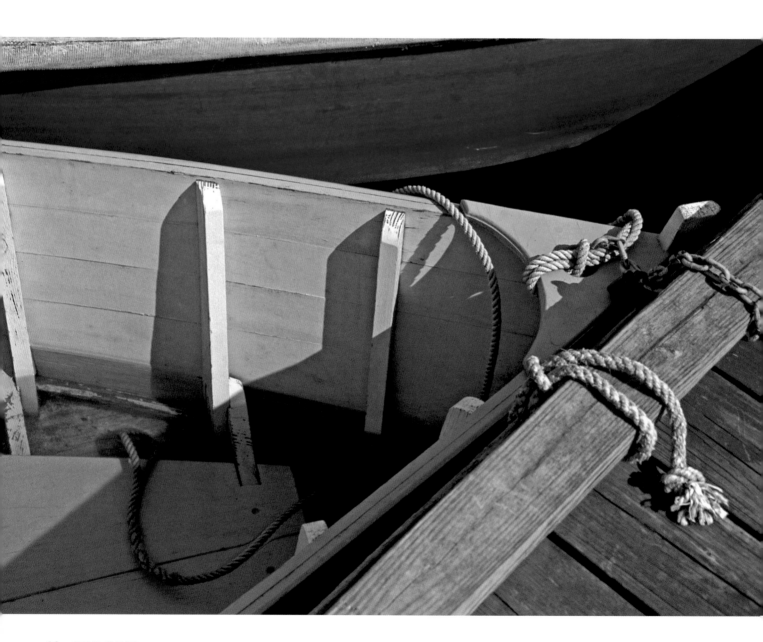

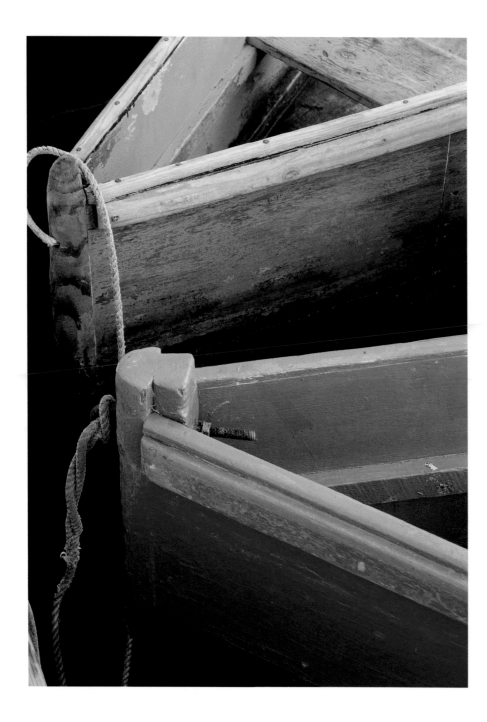

The firm, the enduring, the simple, and the modest are near to virtue.

*–Confucius*

There is no greatness where
there is not simplicity.
—*Leo Tolstoy*

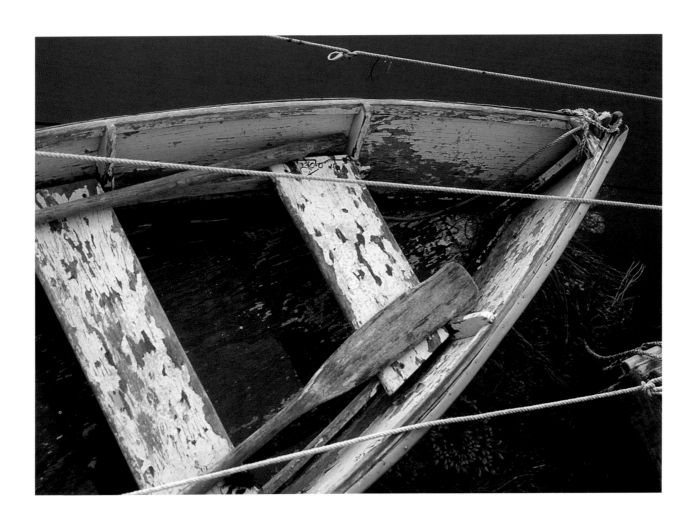

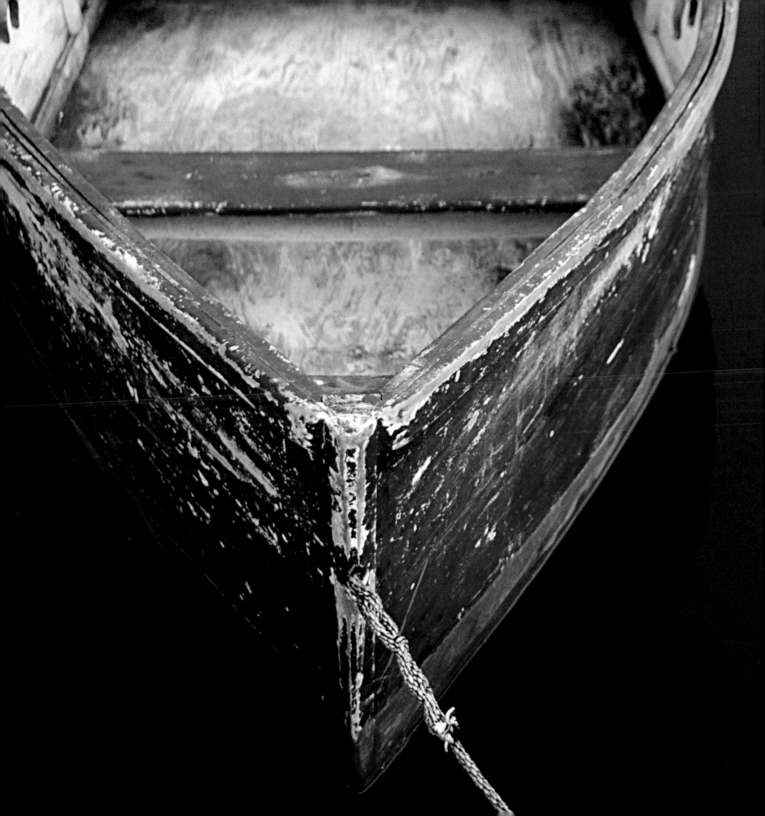

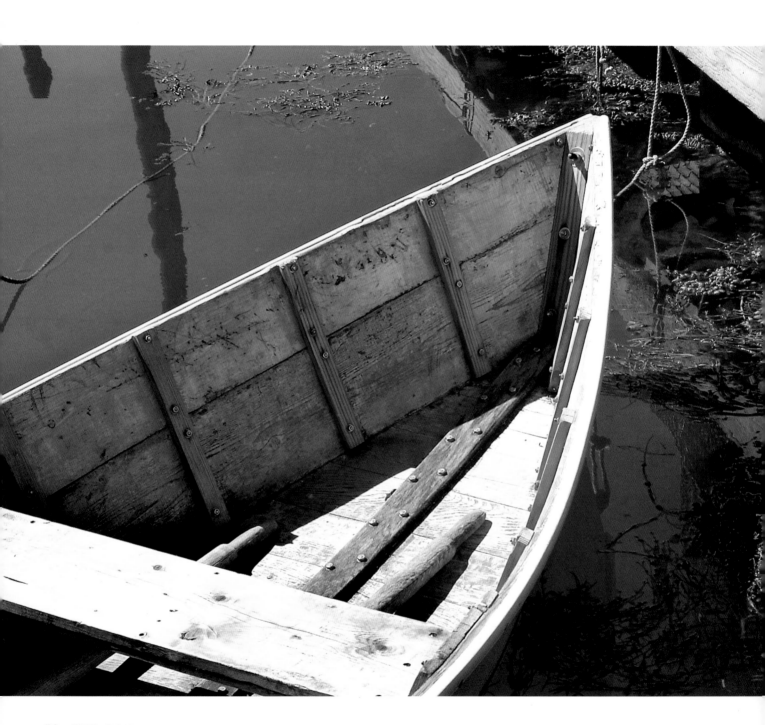

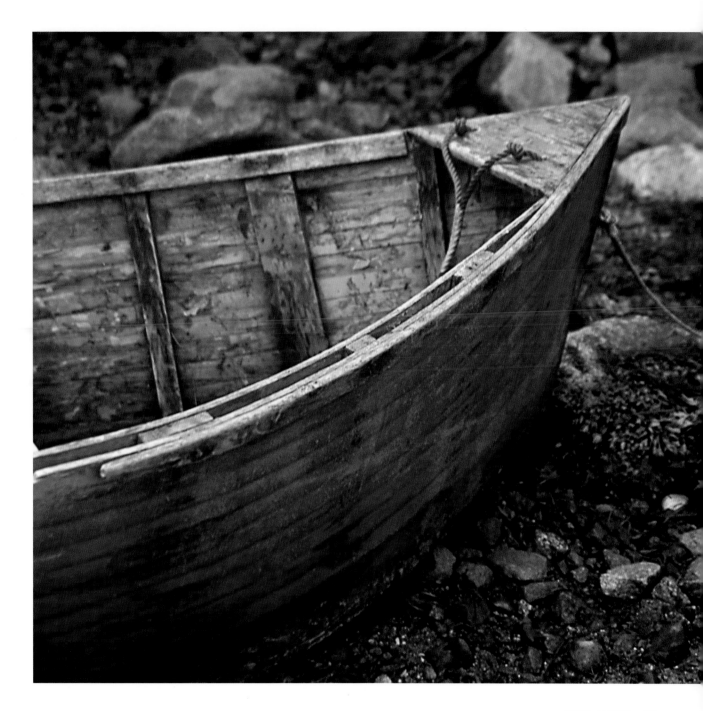

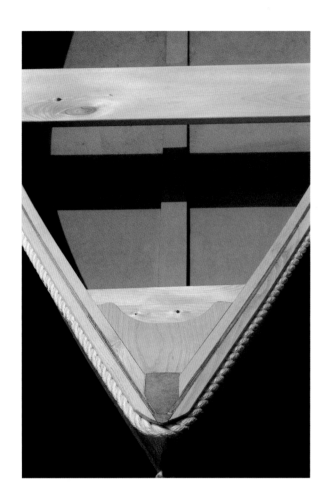 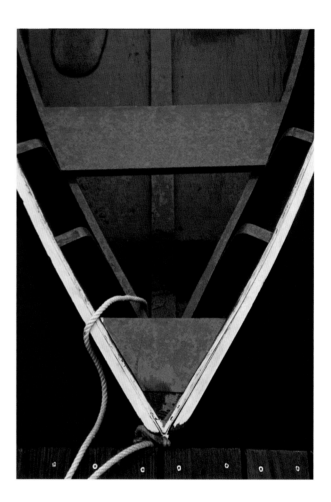

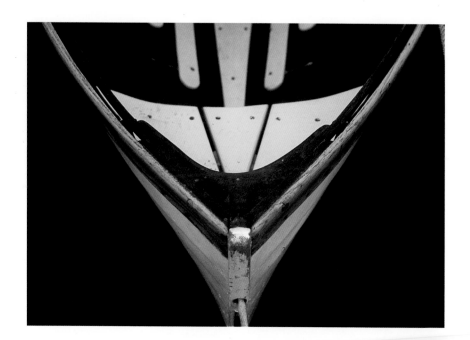

Perfection is achieved, not when there is nothing more to add, but when there is nothing left to take away.
—*Antoine de Saint-Exupéry*

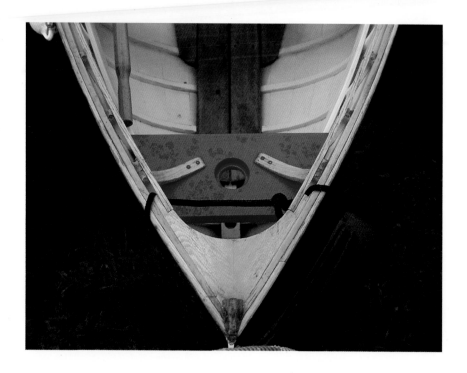

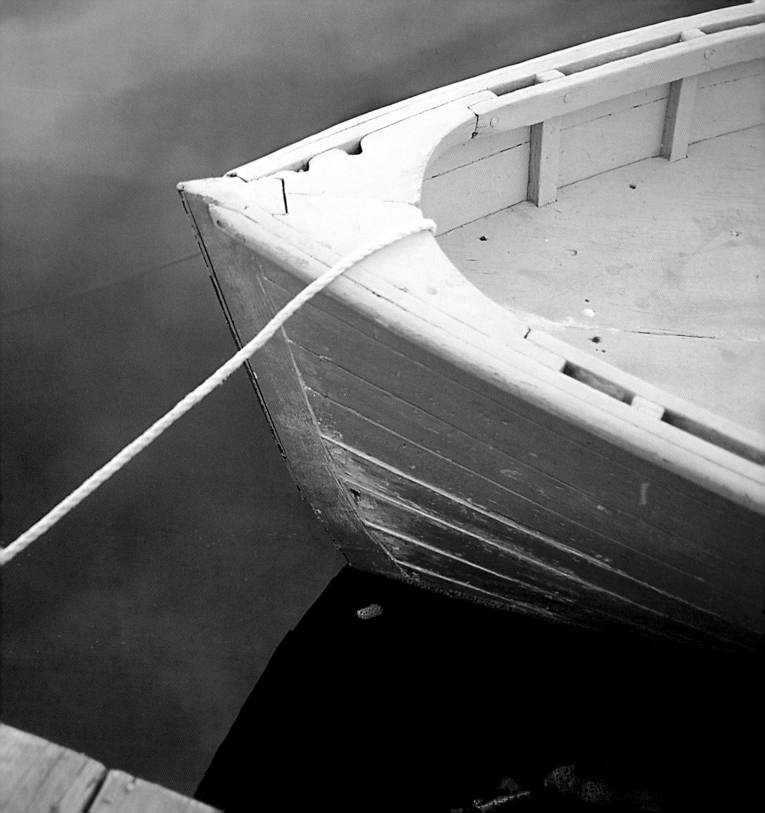

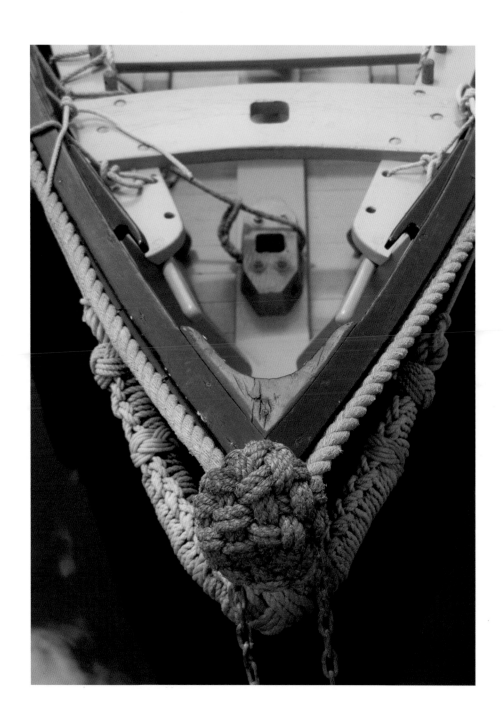

The boat is like a plow
drawn by a winged bull.
—*Henry David Thoreau*

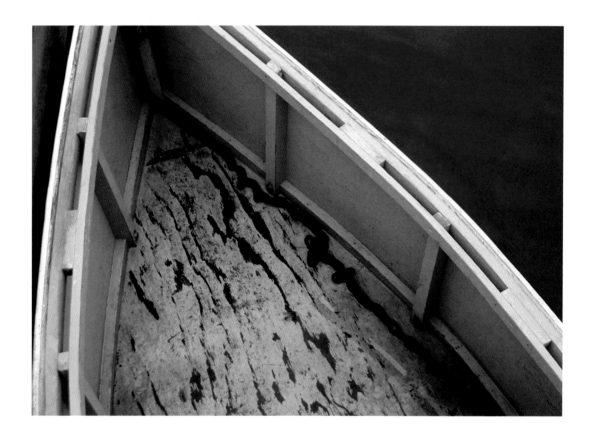

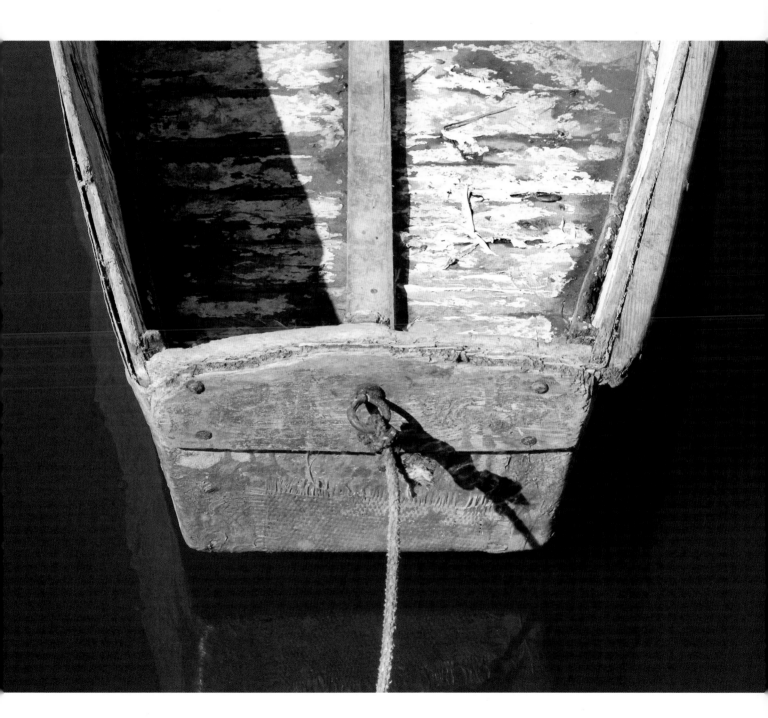

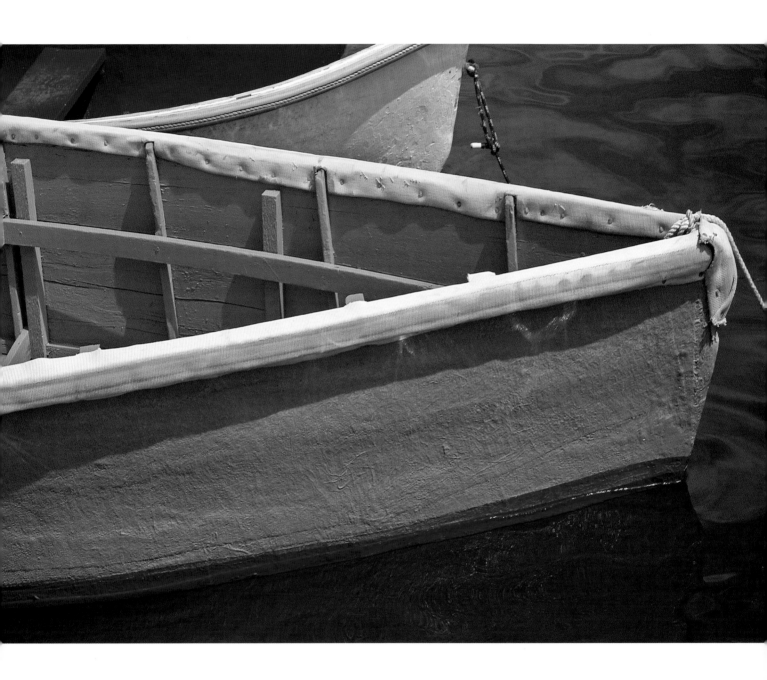

The boat's bow is naively perfect:
complete without an effort.
—John Ruskin

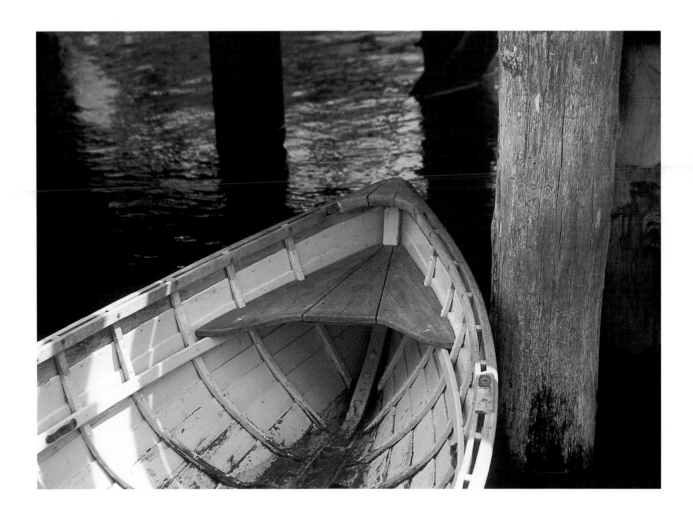

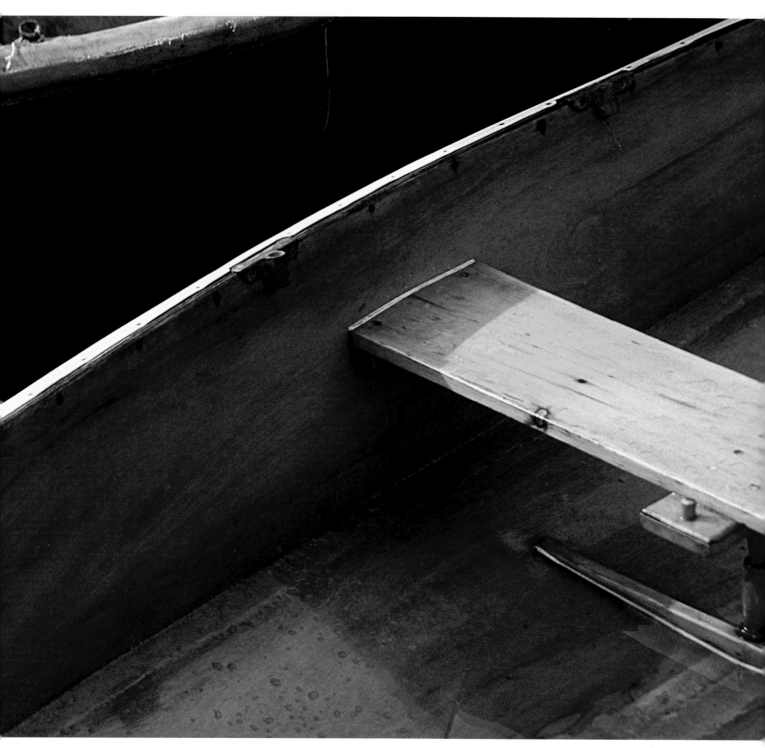

# The Mid-Section

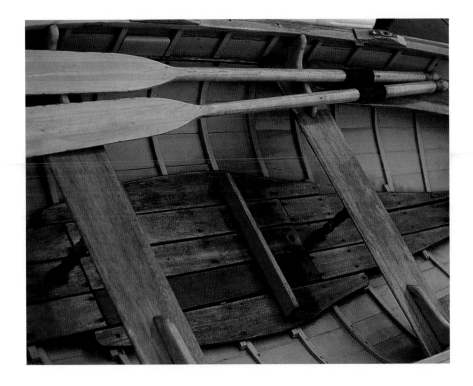

The whole character of a boat is permeated
by her midship section. It is like fate.

—*Douglas Phillips-Birt*

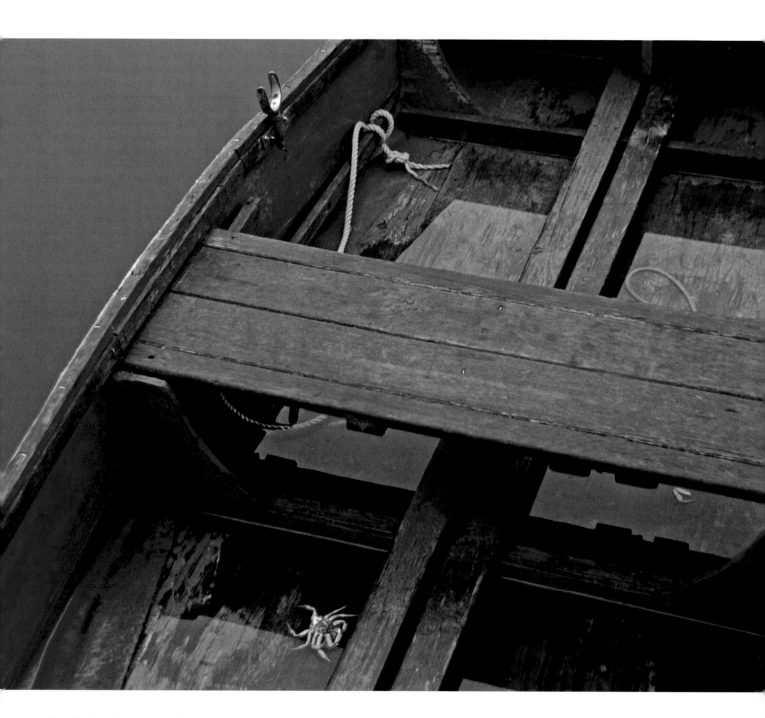

Simplicity is the
ultimate sophistication.
—*Leonardo da Vinci*

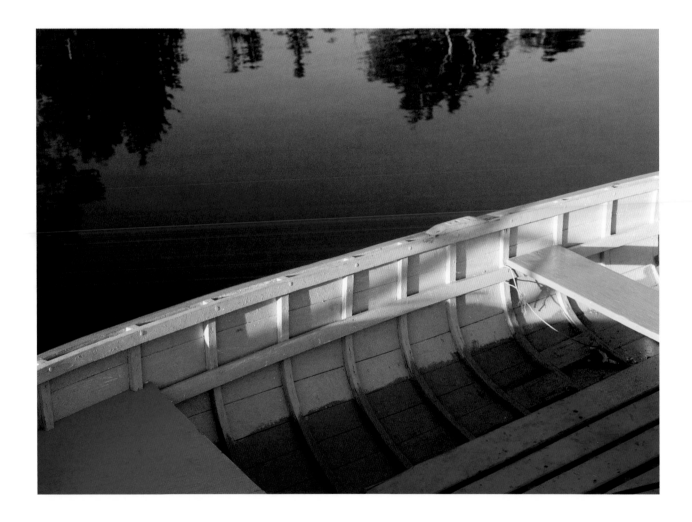

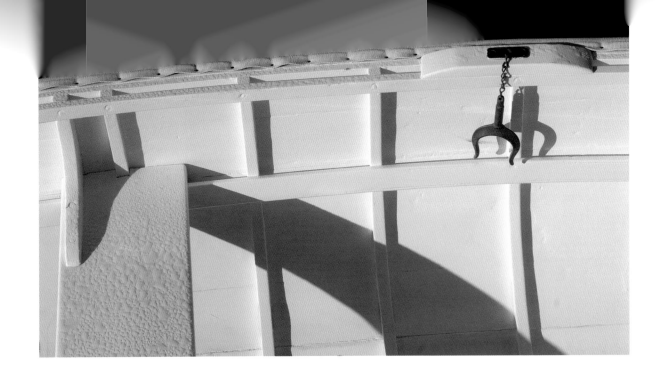

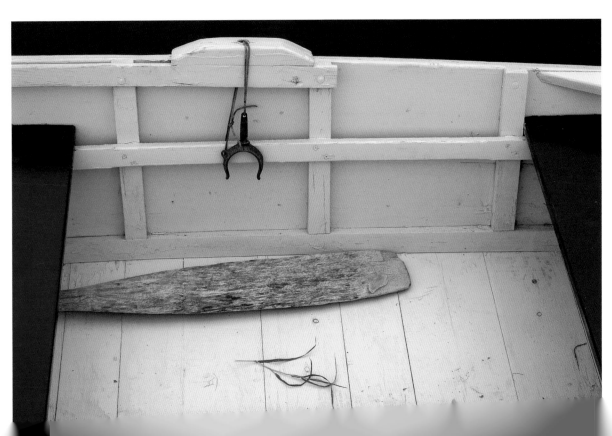

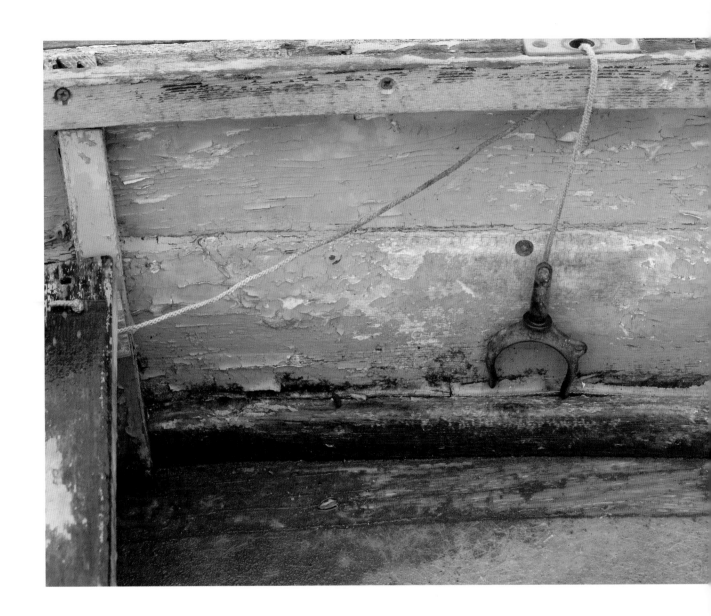

You could sense her lines, their round practicality, and get pleasure from the sensation in knowing, somehow, despite lack of experience, that they were "just right."
—*Charles Landery*

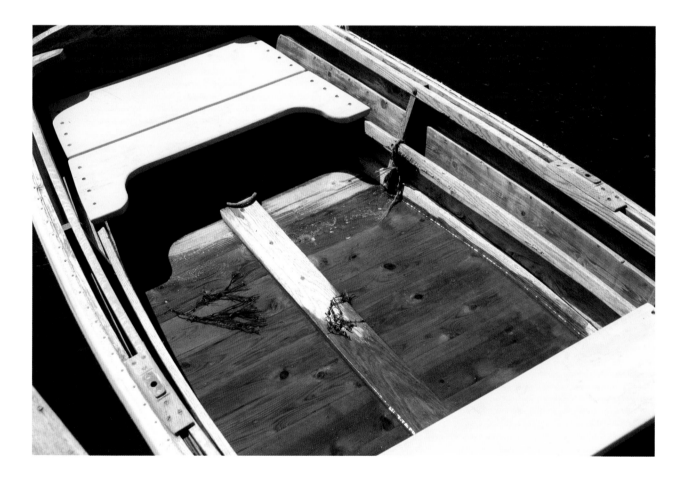

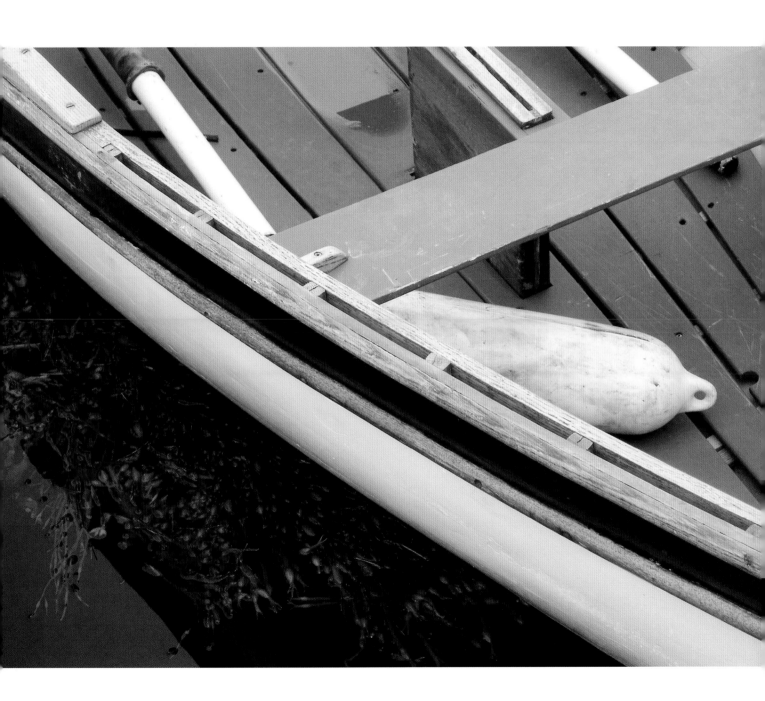

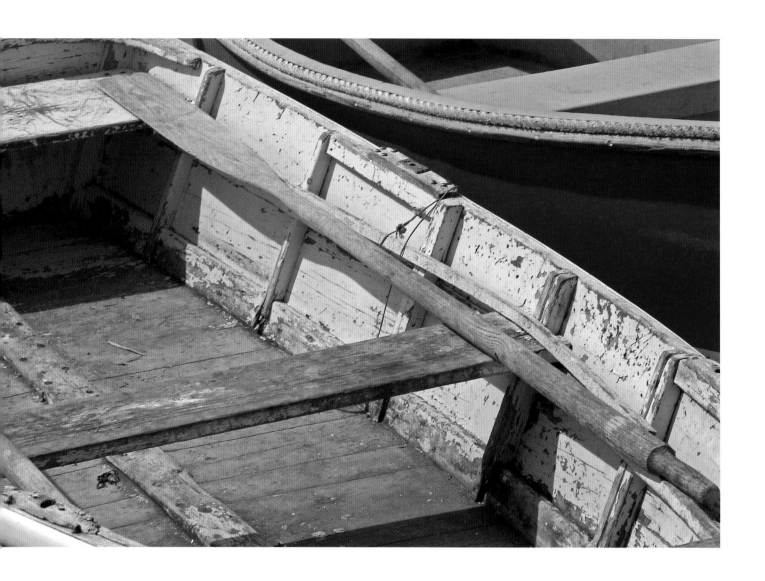

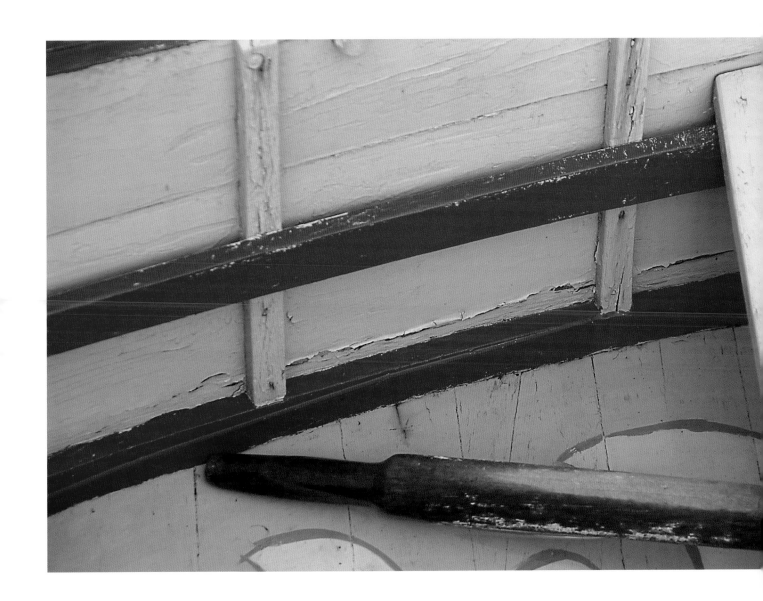

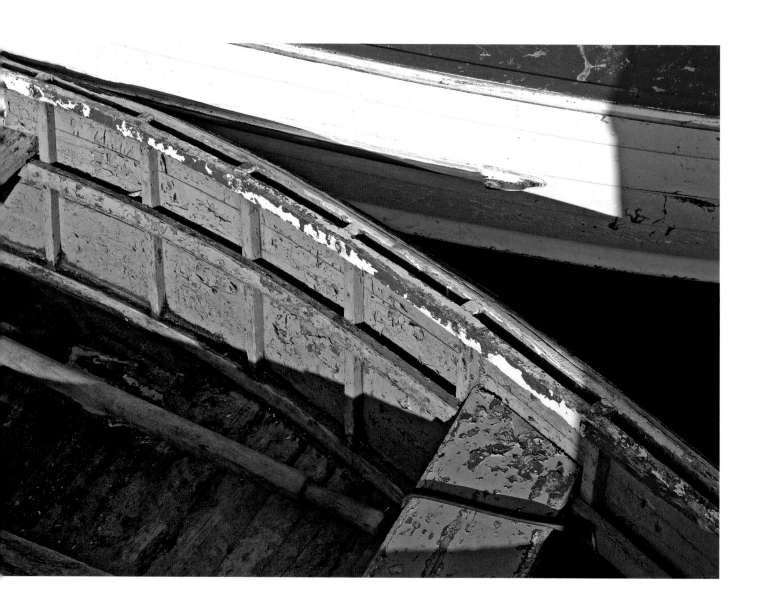

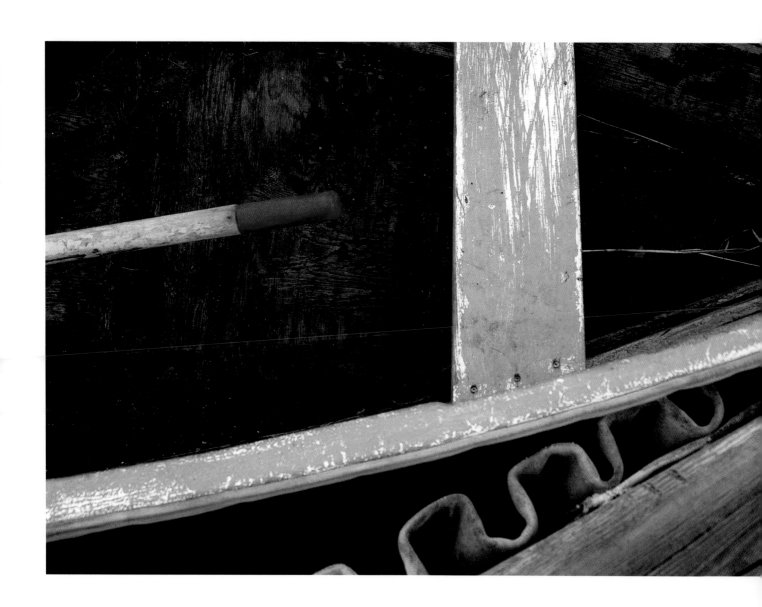

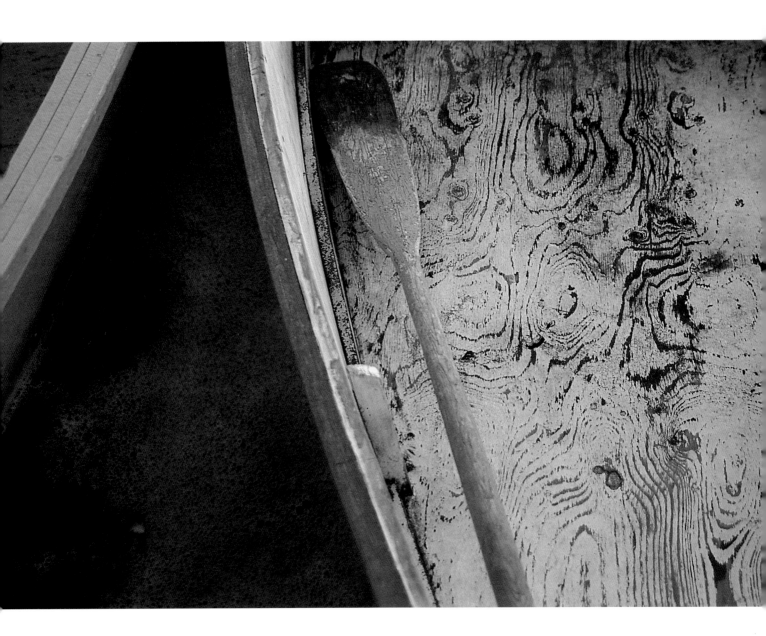

One foot cannot stand on two boats.

—*Chinese proverb*

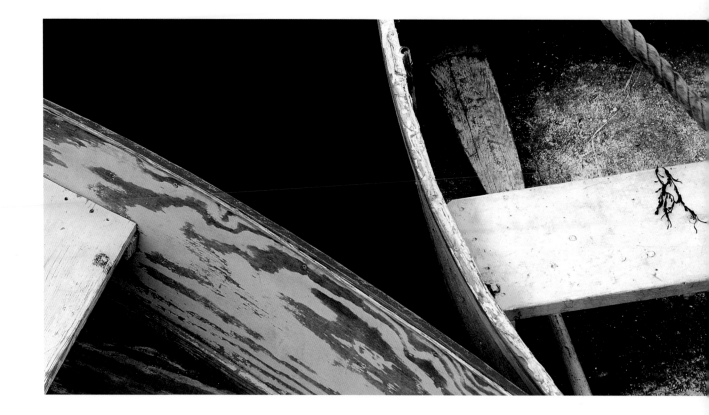

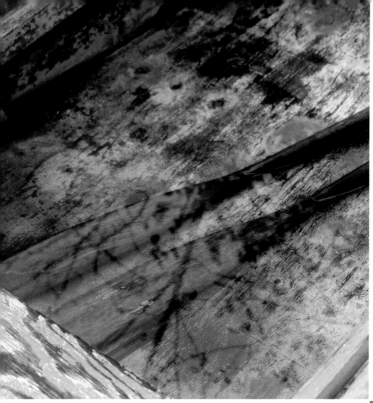

I doubt if there has been much improvement in the design and building of rowing craft since ancient times.

—*R.D. "Pete" Culler*

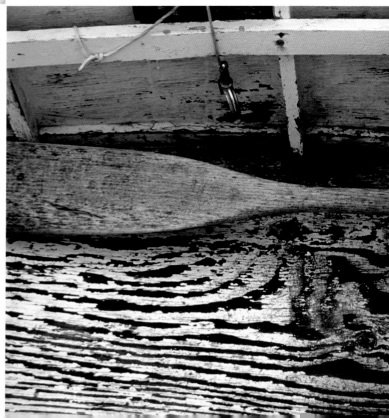

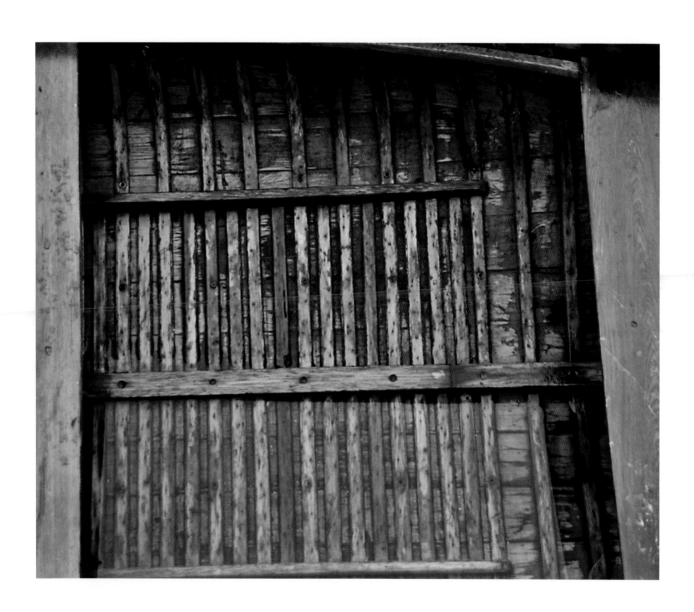

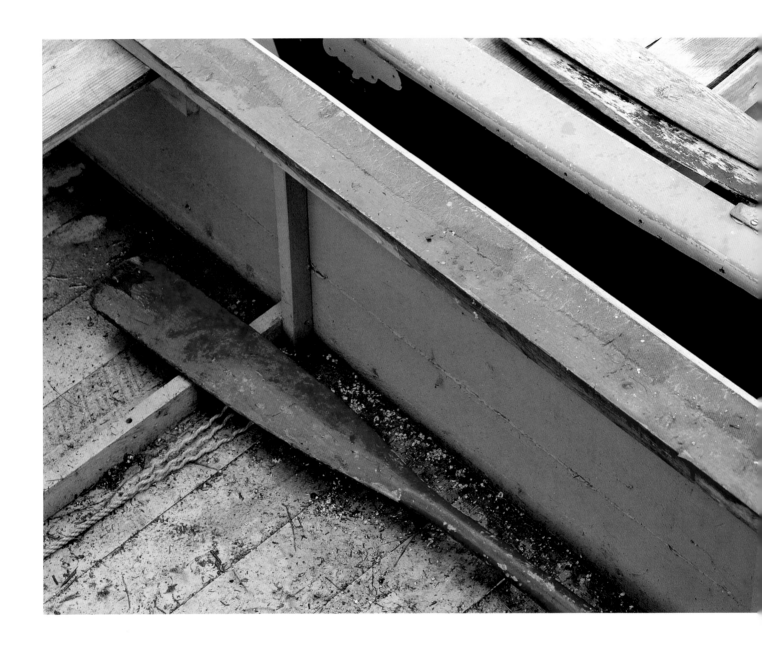

Beauty of style and harmony and grace
and good rhythm depends on simplicity.
—*Plato*

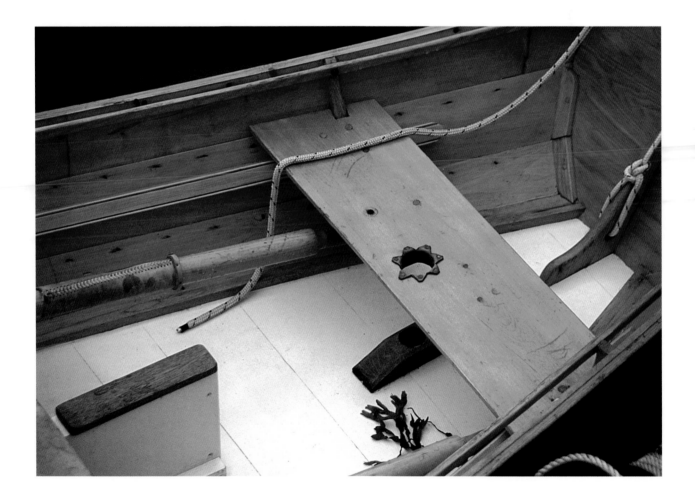

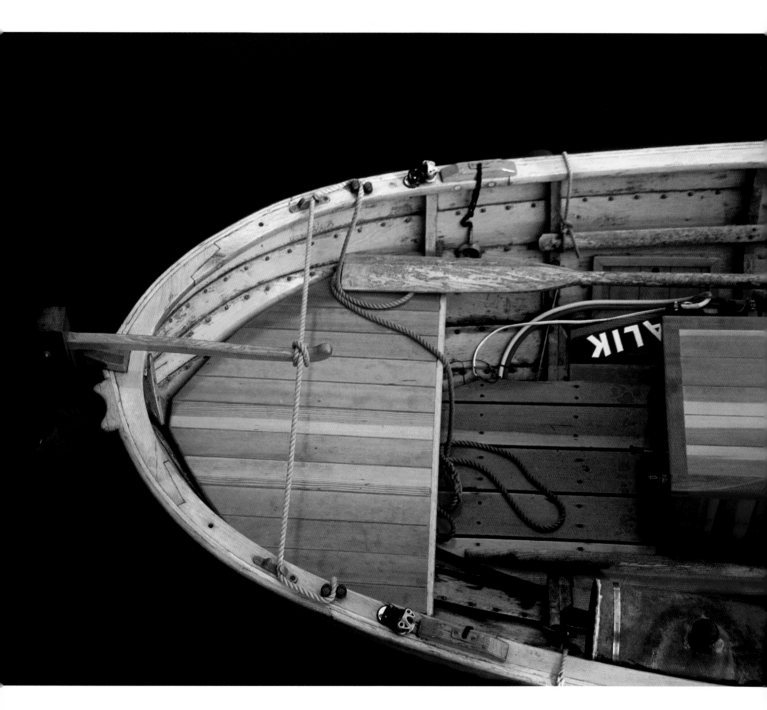

# The Stern

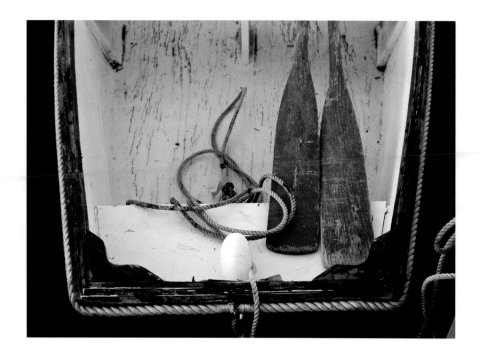

Simplicity and naturalness are
the truest marks of distinction.
—*W. Somerset Maugham*

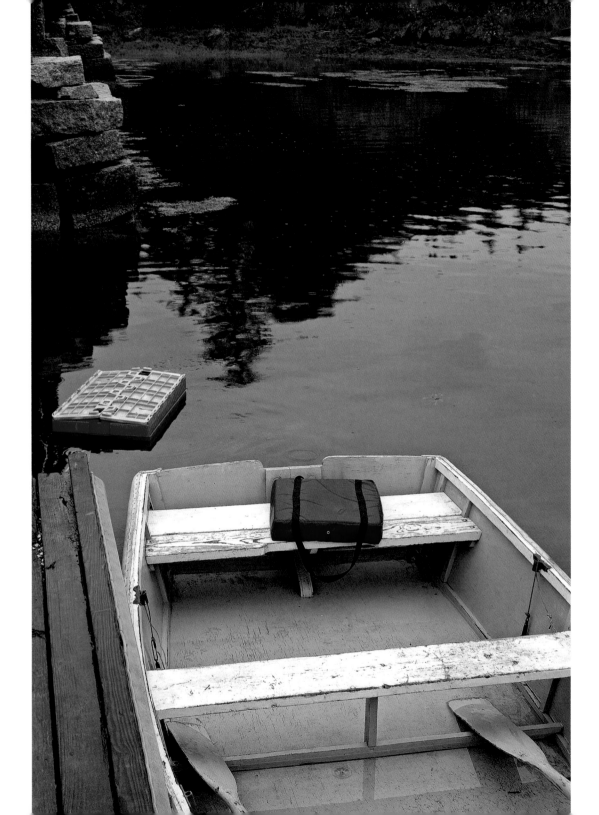

Will anyone dare to tell me what
business is more entertaining than
fooling among boats?
—*Robert Louis Stevenson*

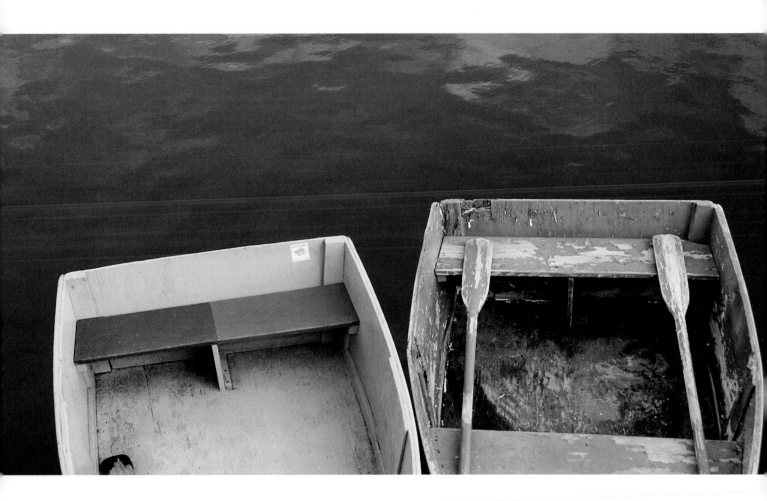

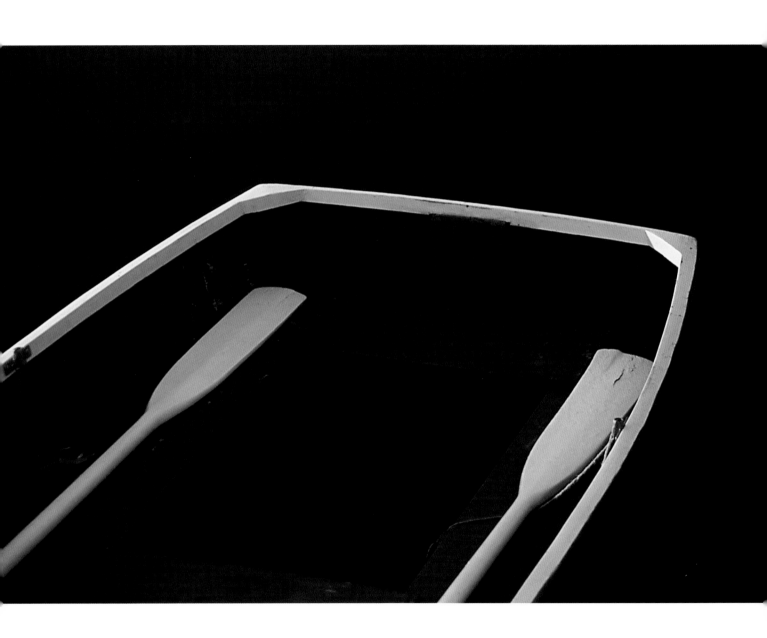

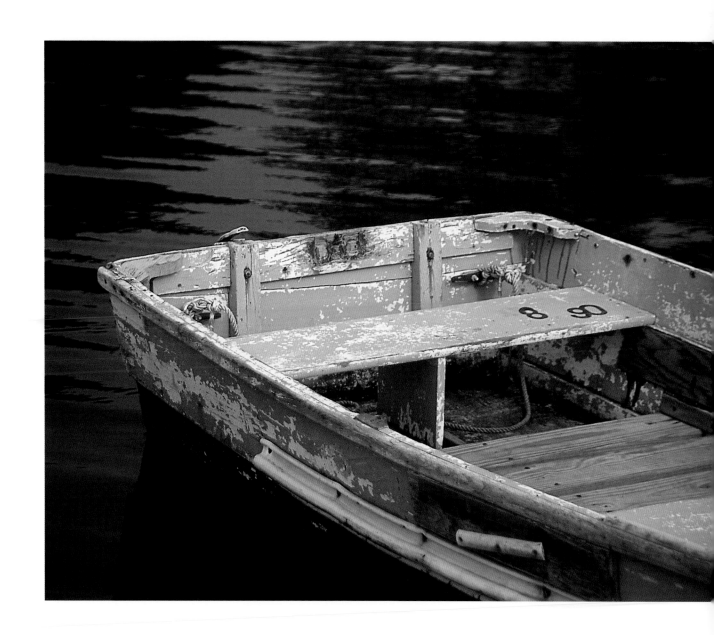

The glory of a boat is, first
its steadiness of poise.
—*John Ruskin*

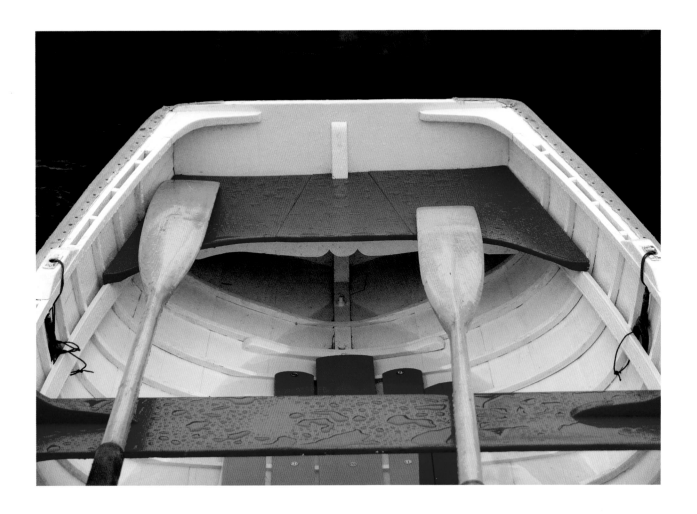

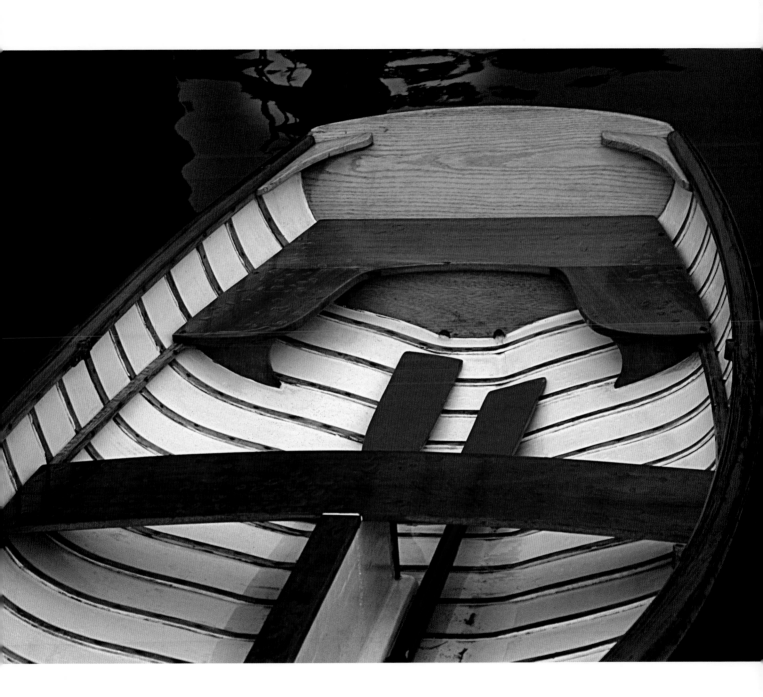

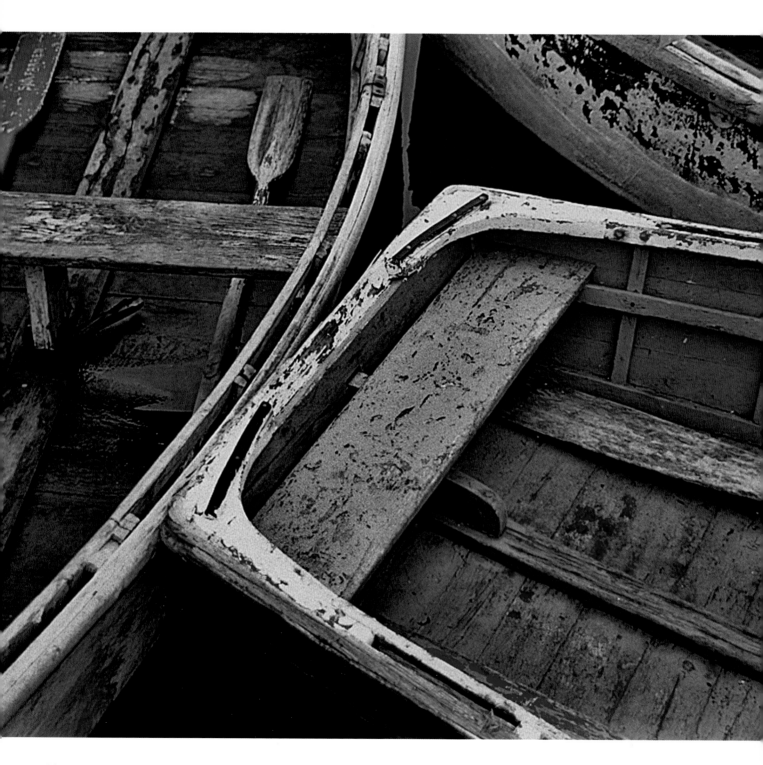

A memory of the old, old creek,
With its old, old boats and its old, old men....
                    —*Joseph Chase Allen*

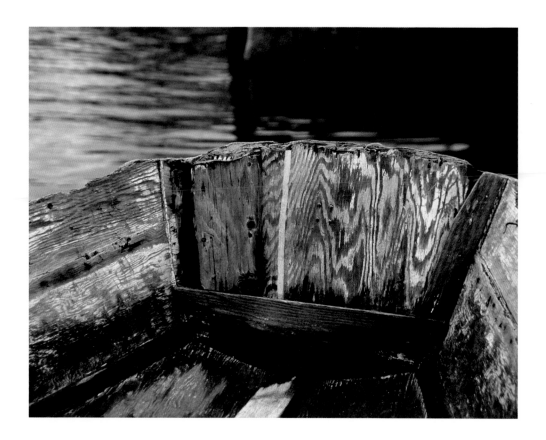

When I think how great a part of my life has been spent
dreaming the hours away and how much this total dream
life has concerned small craft, I wonder about the state
of my health, for I am told that it is not a good sign to be
voyaging into unreality, driven by imaginary breezes.

—*E.B. White*

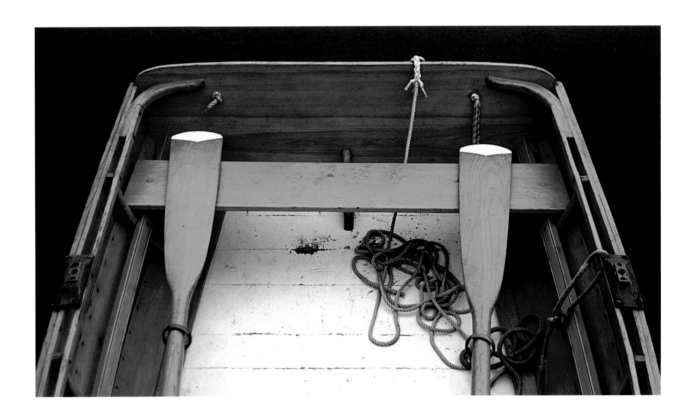

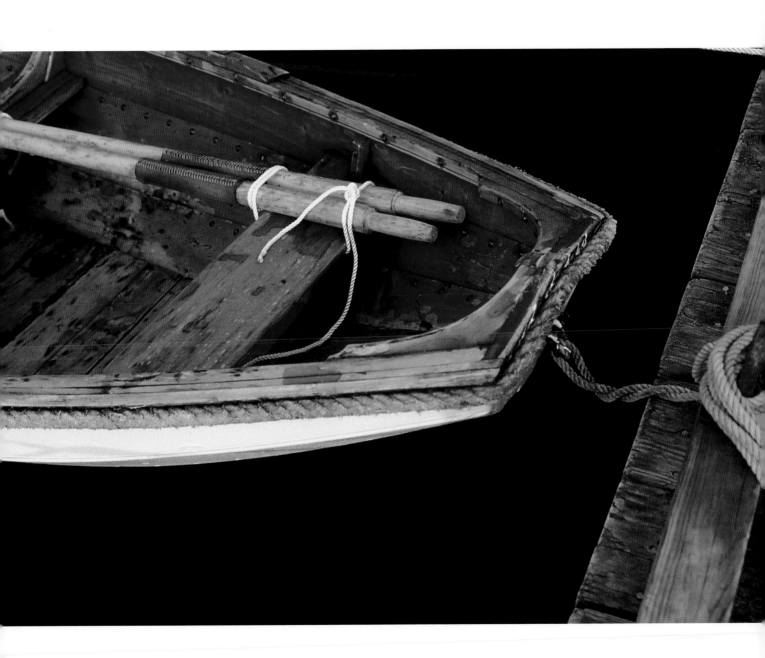

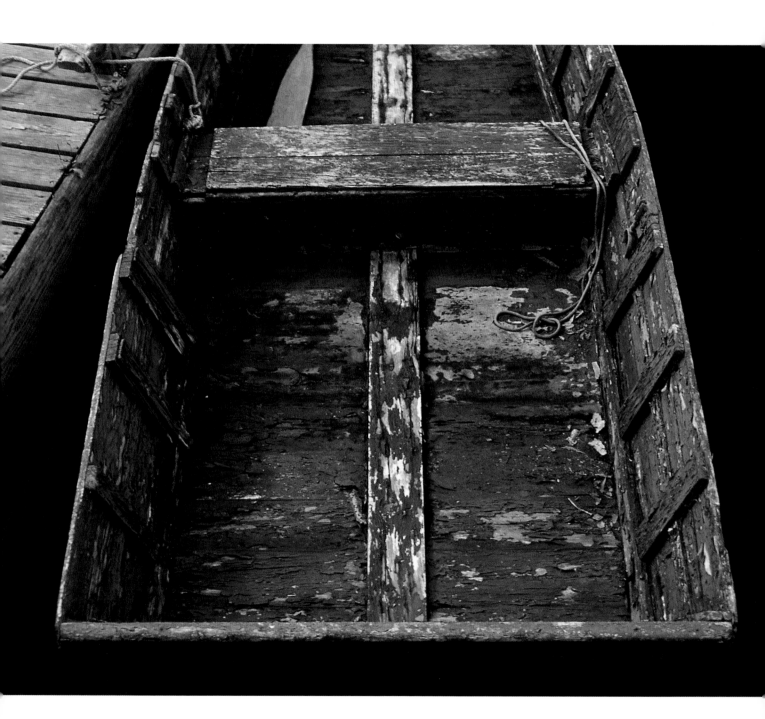

Like Leonardo, the early artists who created
the dory had a superb understanding of how
to combine form and function.

—*John Cole*

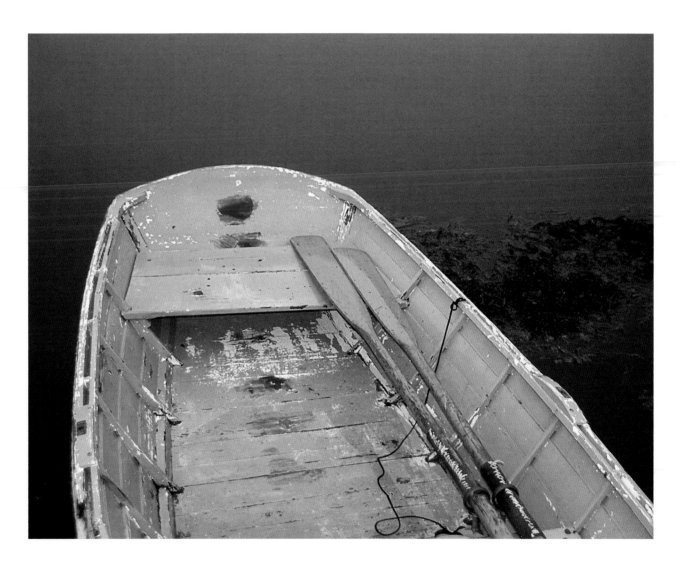

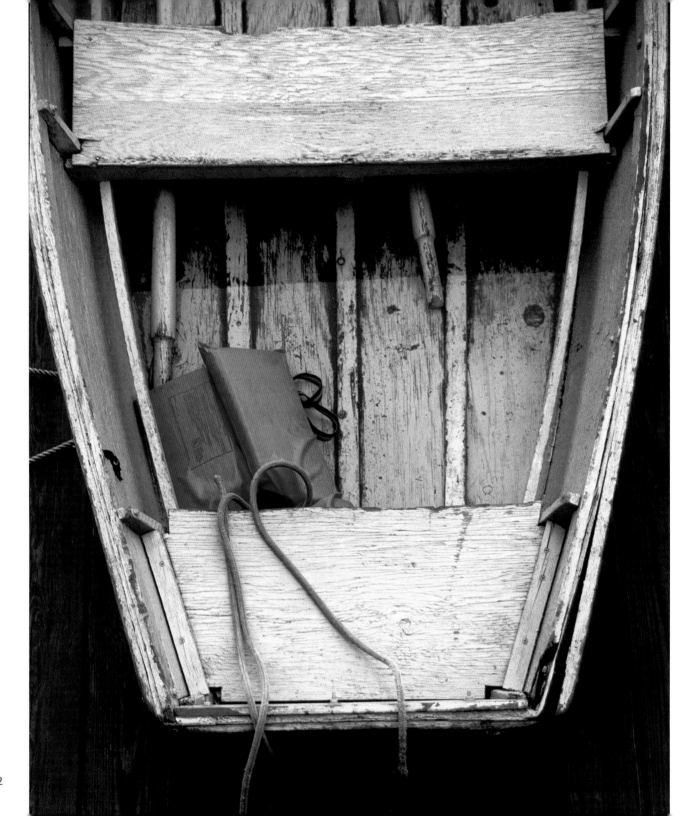

**To be simple is to be great.**
    —*Ralph Waldo Emerson*

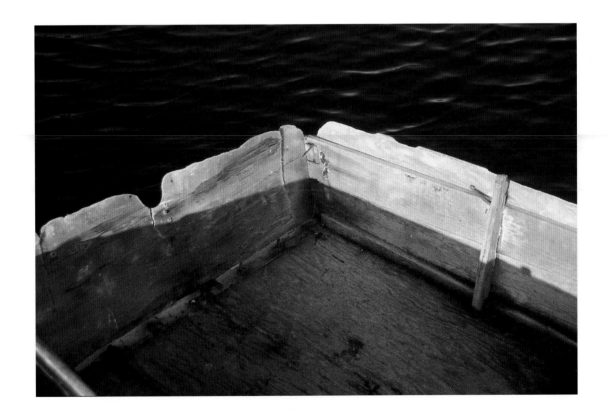

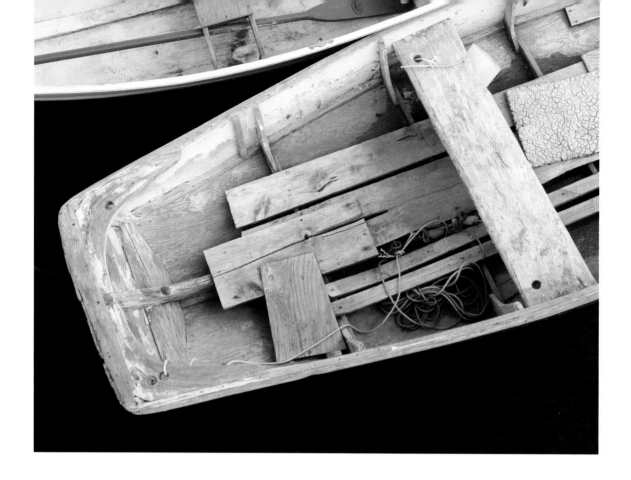

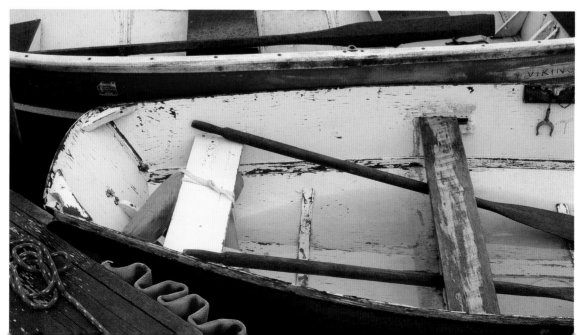

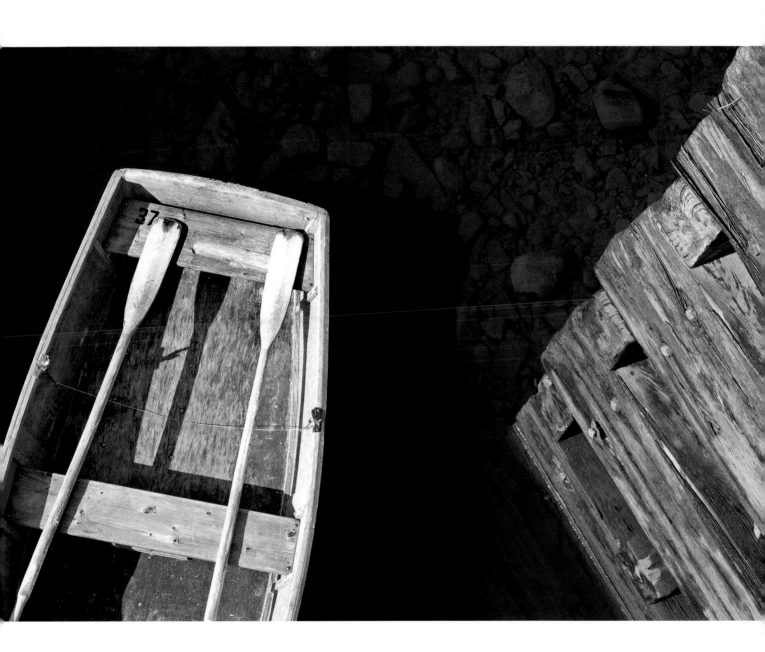

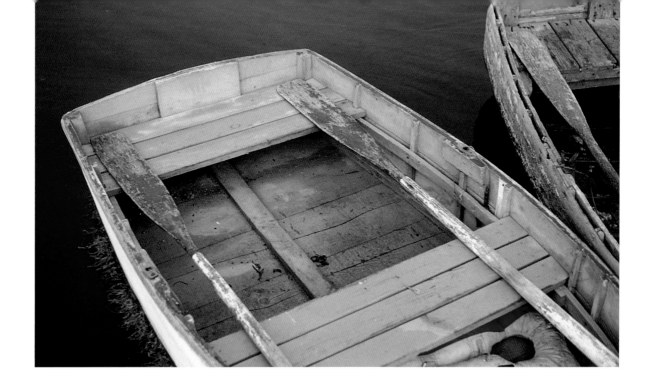

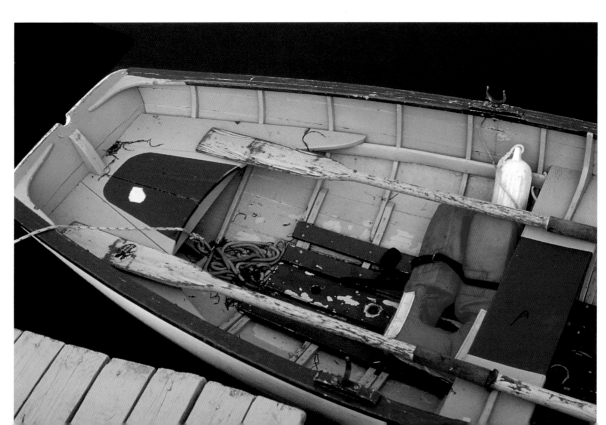

You cannot sink someone else's end of
the boat and still keep your own afloat.
—*Charles Bower*

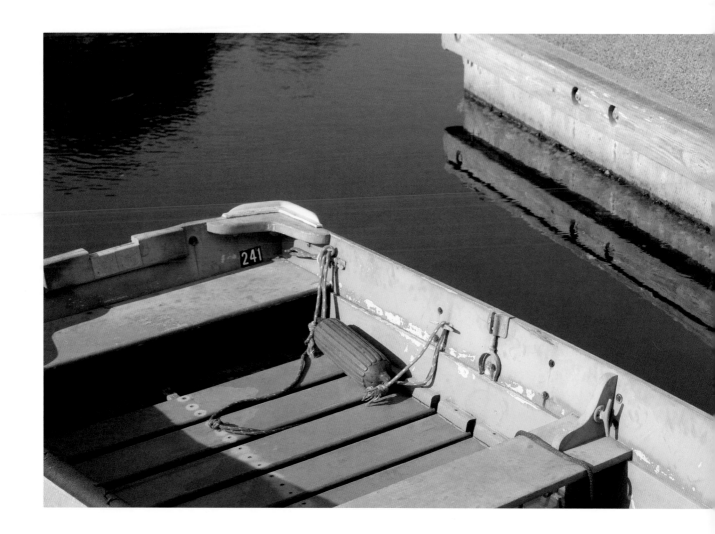

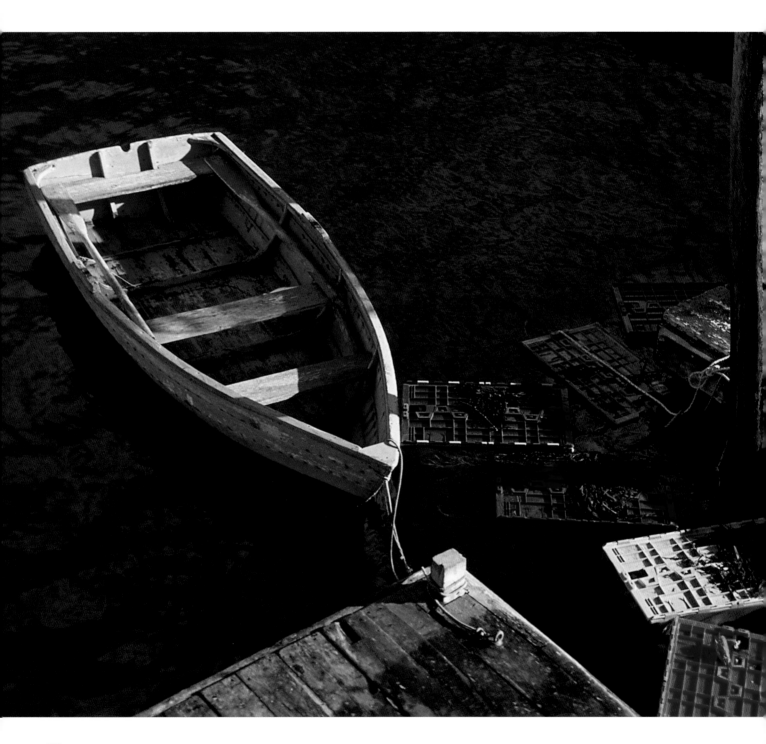

# The Noble Dinghy

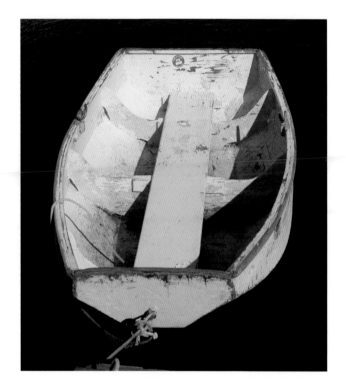

A noble craft, but somehow a most melancholy!
All noble things are touched with that.

—*Herman Melville*

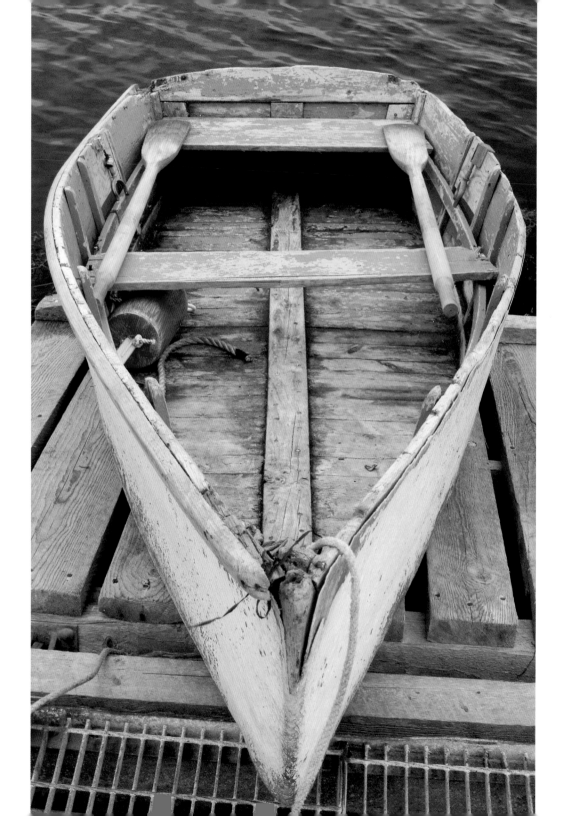

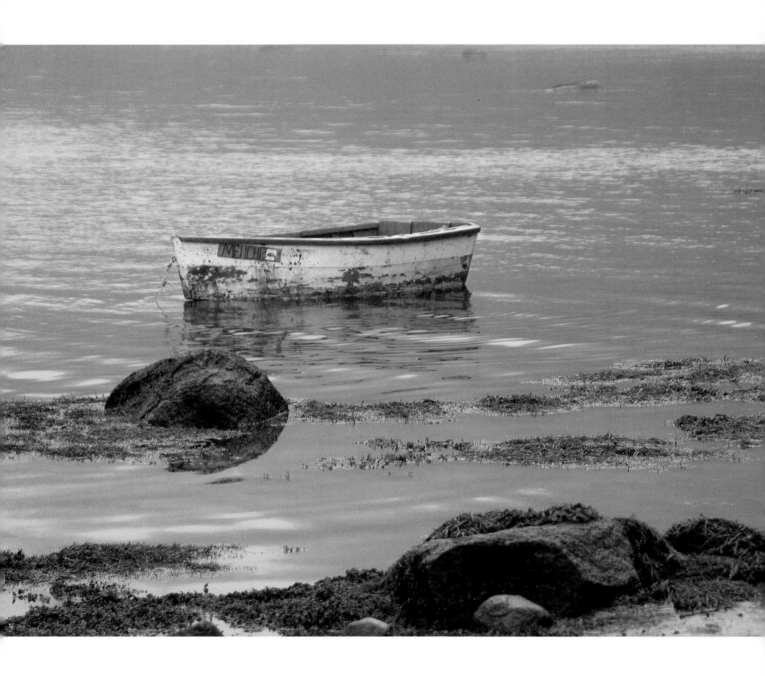

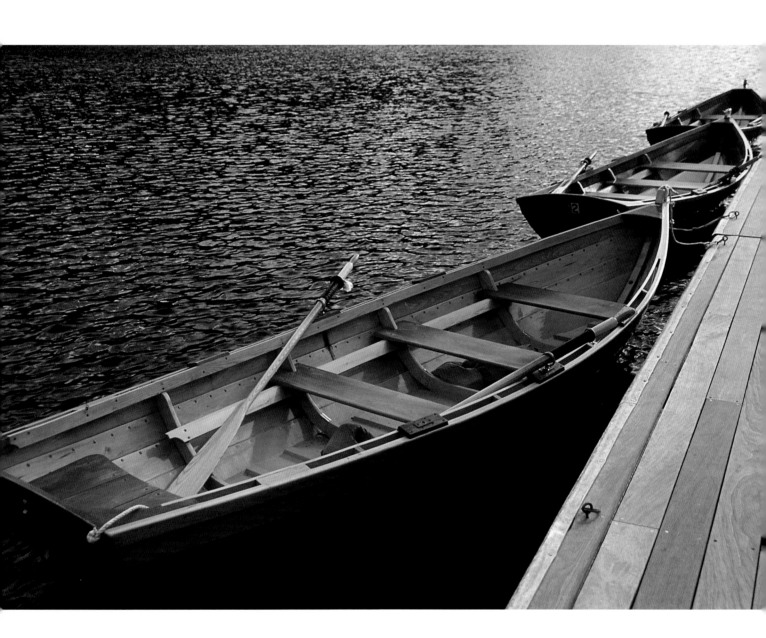

The point of a ... tender is that
it can be, and should be, a really
good boat and a work of art.
                    —*Philip C. Bolger*

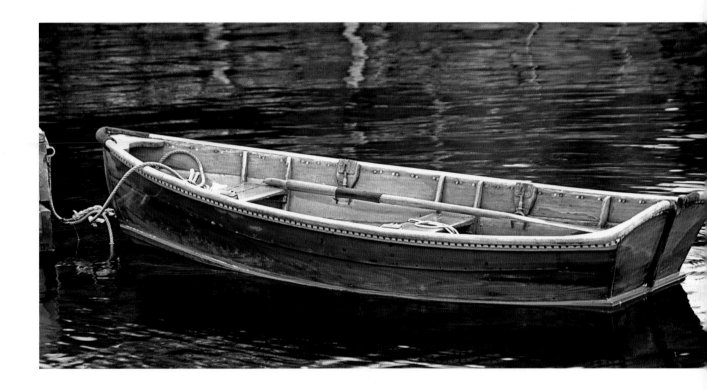

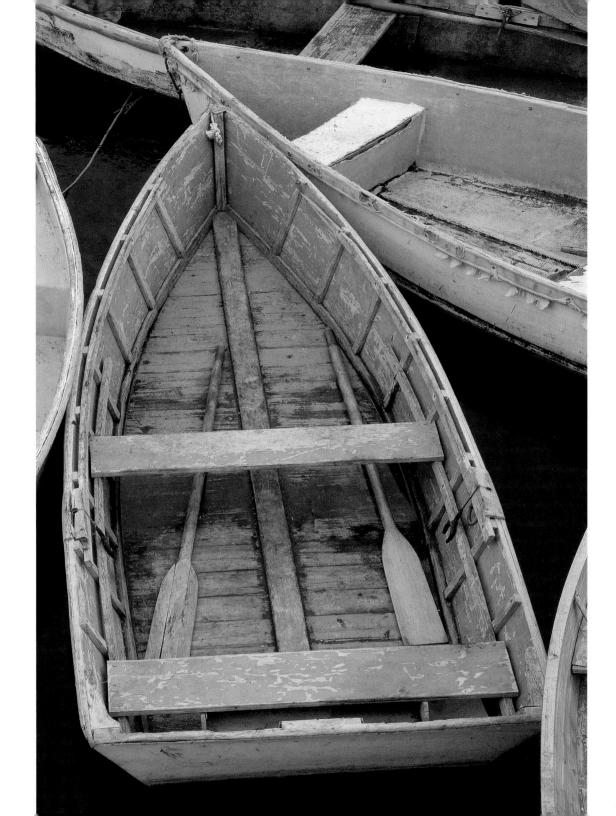

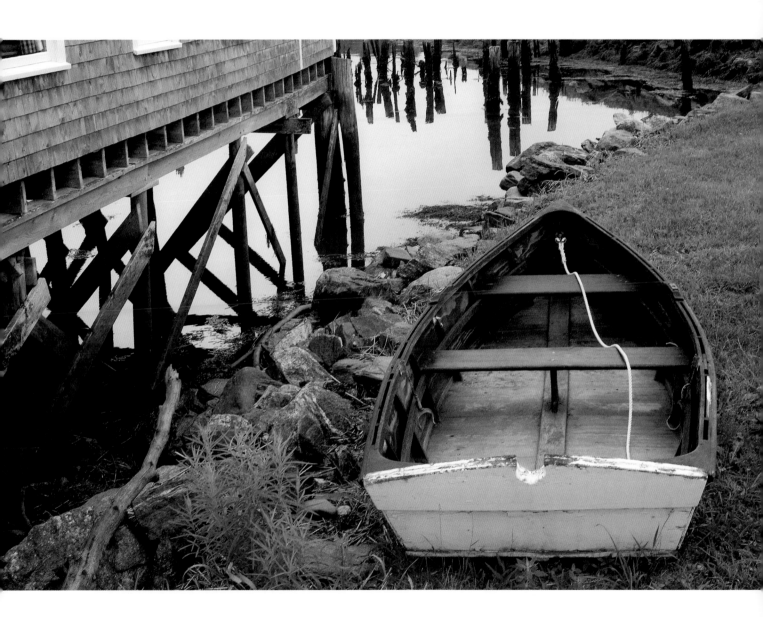

The shift from a large boat to a small one simply means trading more expense for less expense; but I'm inclined to believe that you also get an extra dividend of less worry and just as much fun.

—*Eugene V. Connett III*

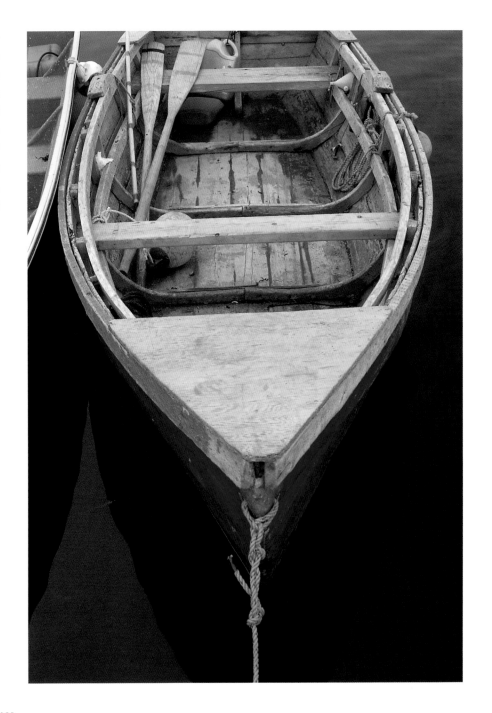

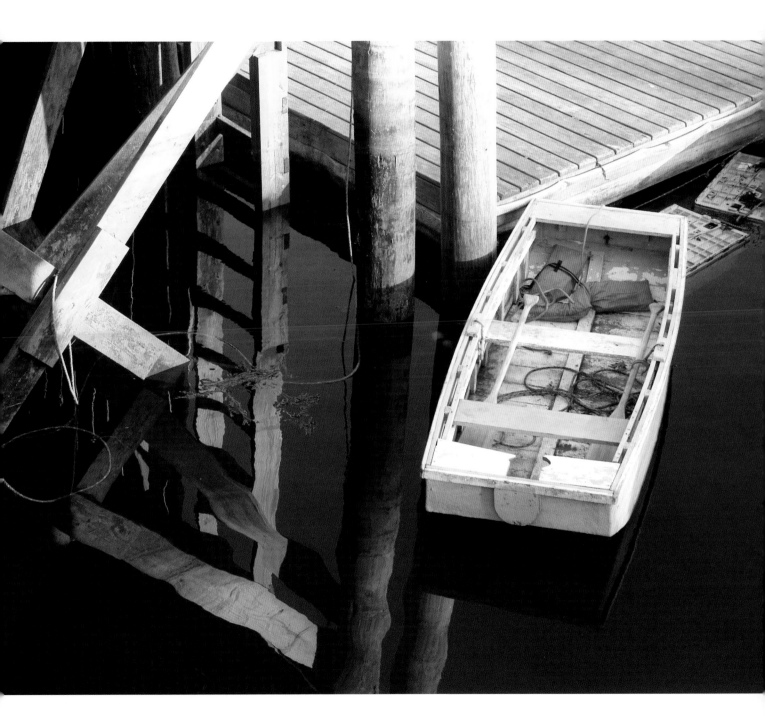

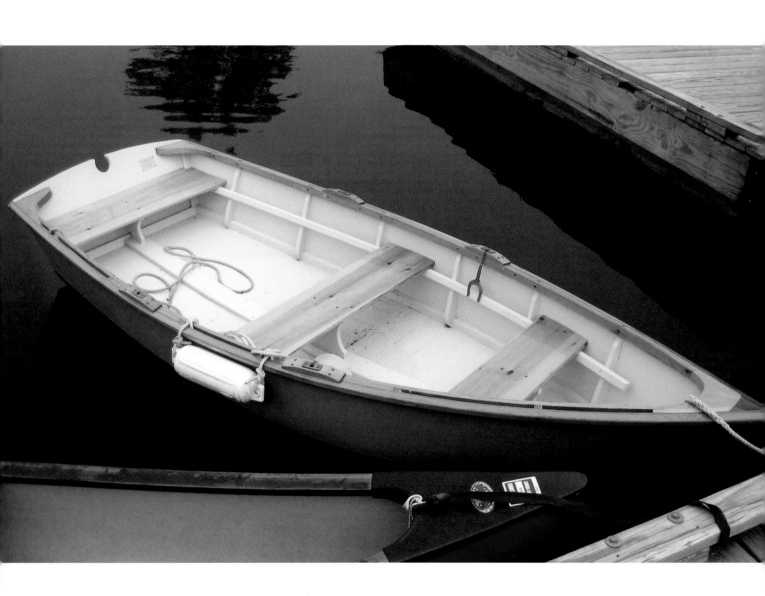

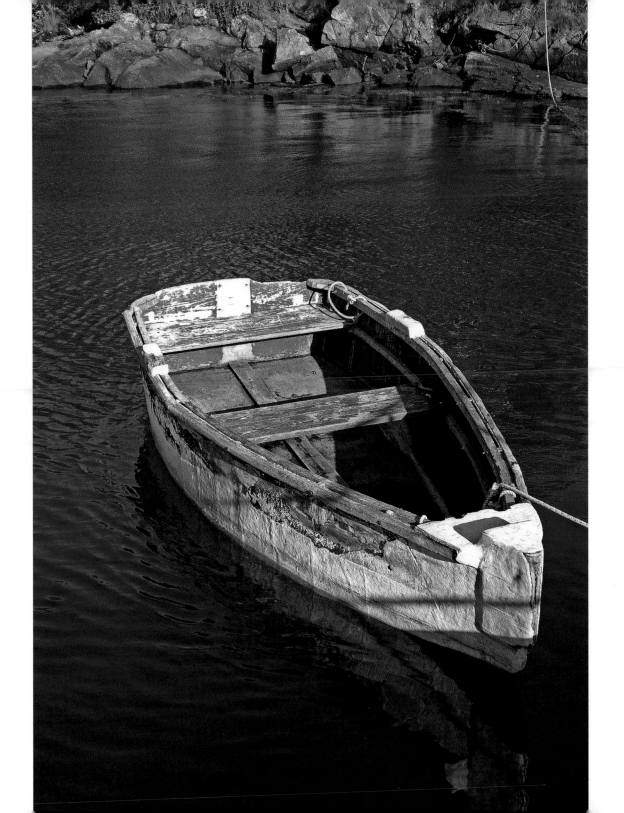

We should have more simple, prim little boats —
a joy to sail, to own, to build, to pay for. You
can't ask for much more from any boat.
—*Weston Farmer*

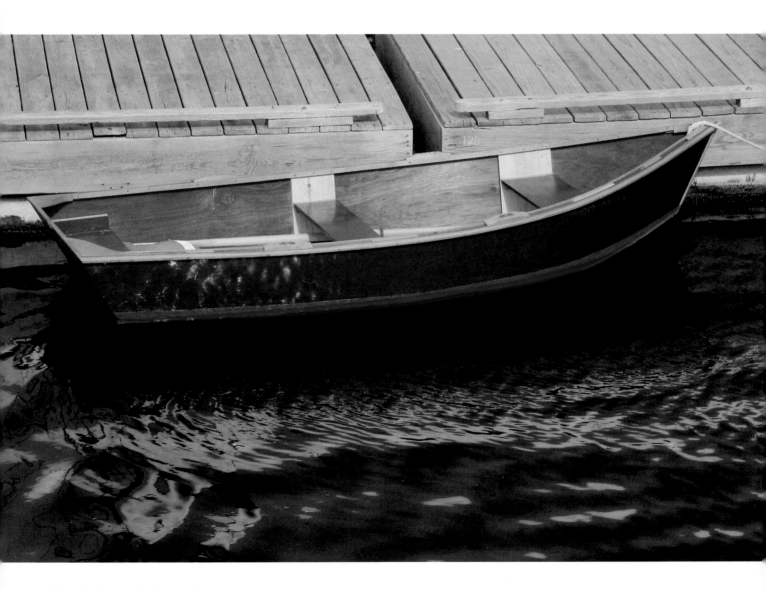

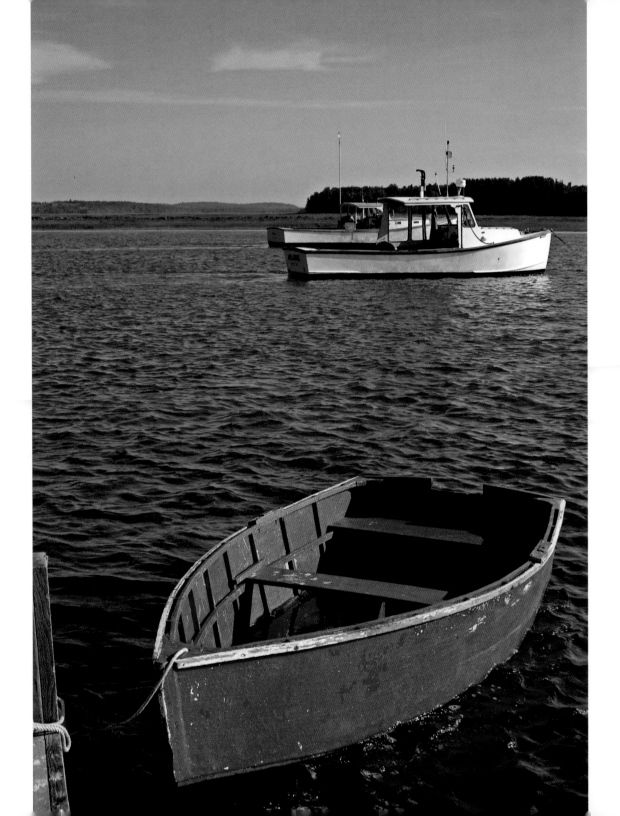

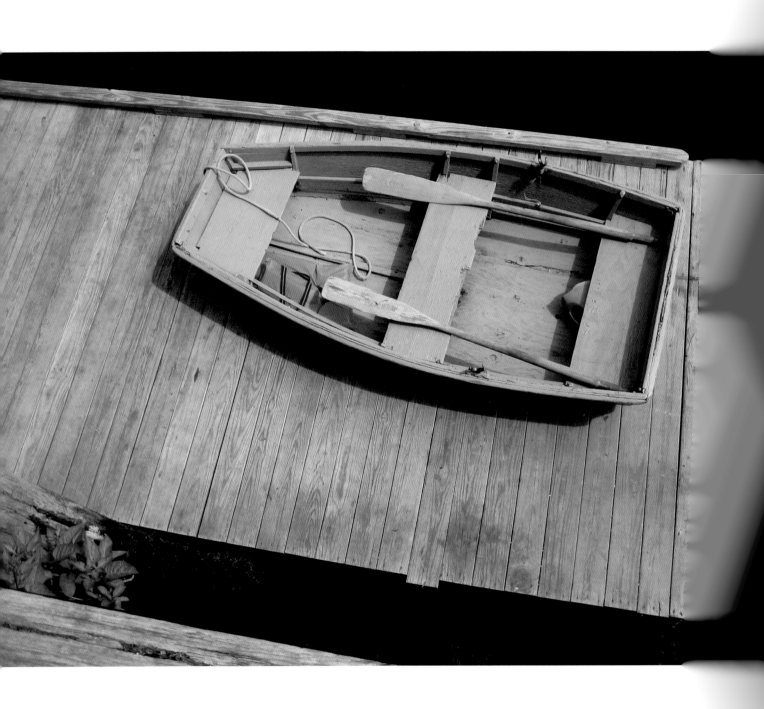

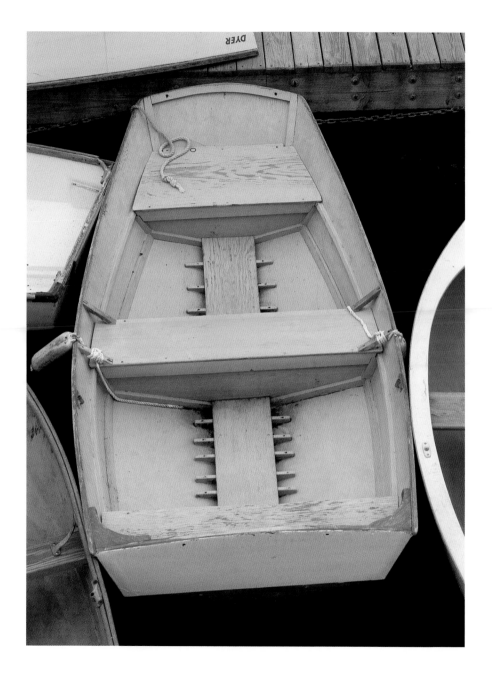

Size is the least important element in the seaworthiness of a vessel.

—*William Washburn Nutting*

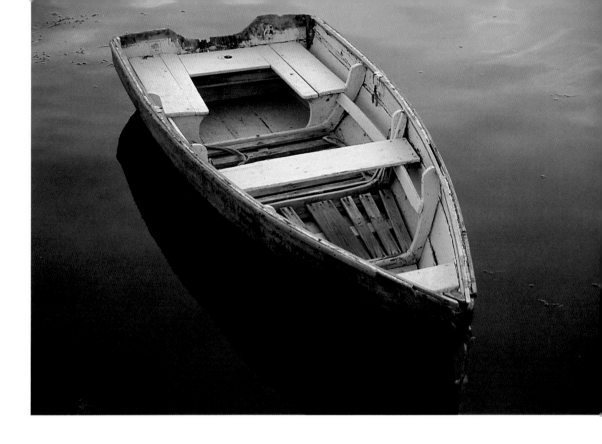

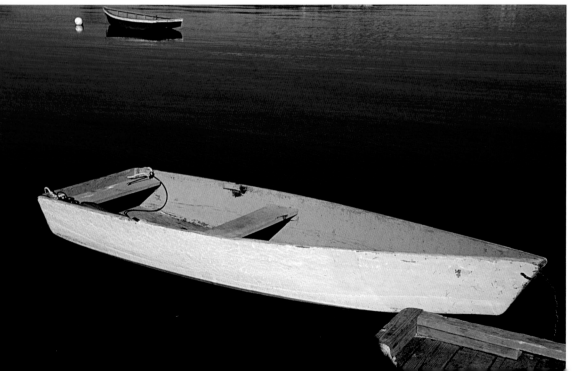

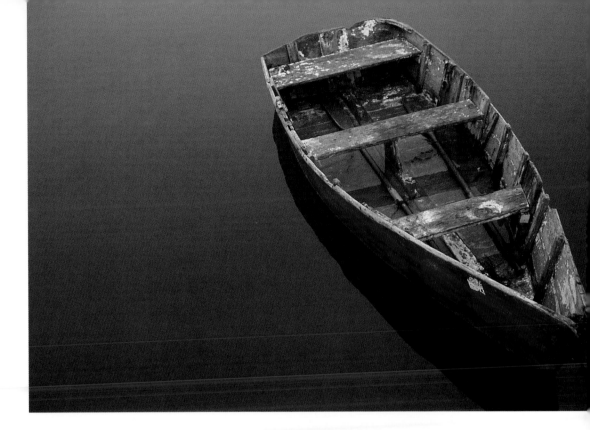

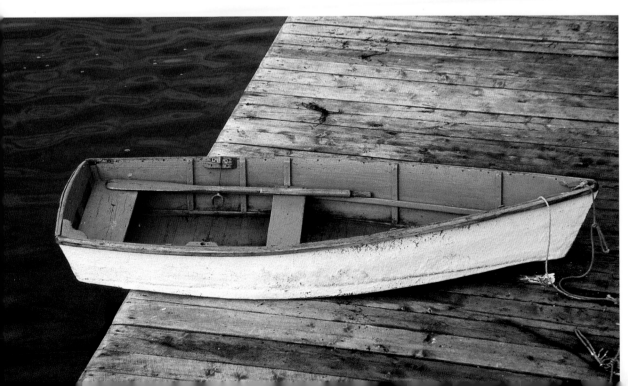

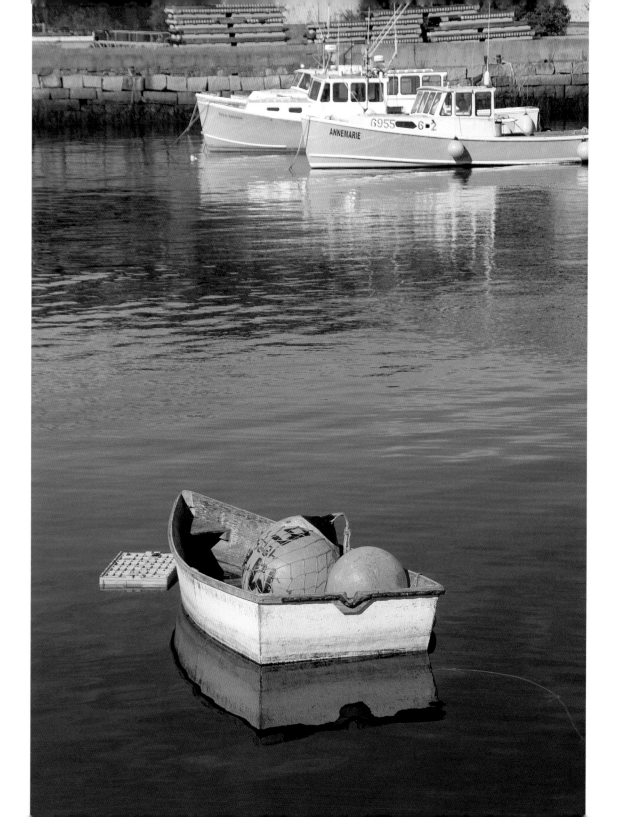

Honor lies in honest toil.
>
> —*Grover Cleveland*

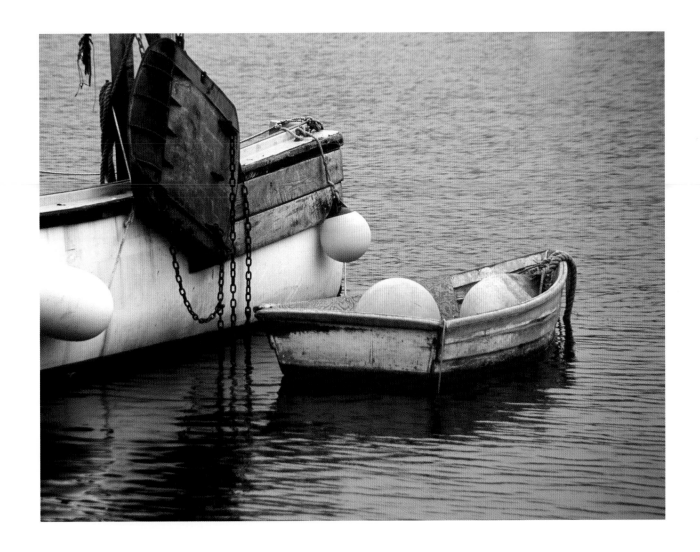

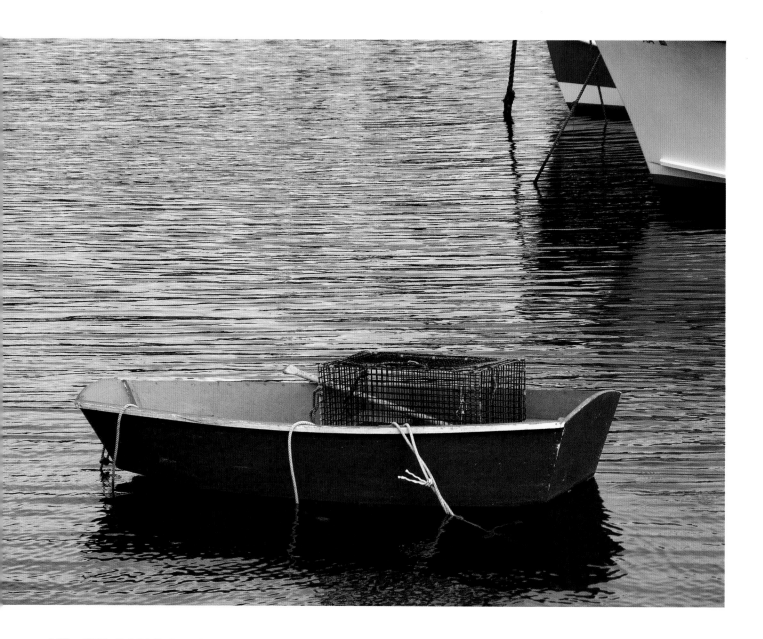

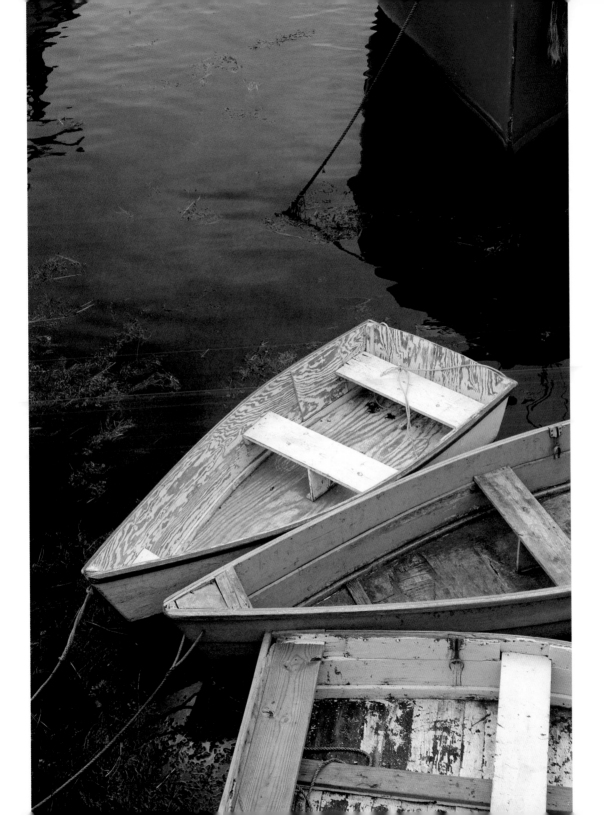

Possibly because boats are supposed to be so very good, we have, over many years, come to the idea they must be made in as difficult and expensive a way as possible. Certainly this was not the original approach, especially in working craft. Good enough to do the job and do it well was what was required.

—R.D. "Pete" Culler

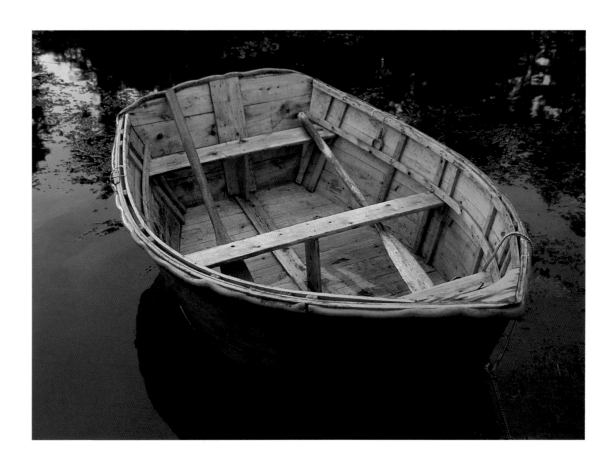

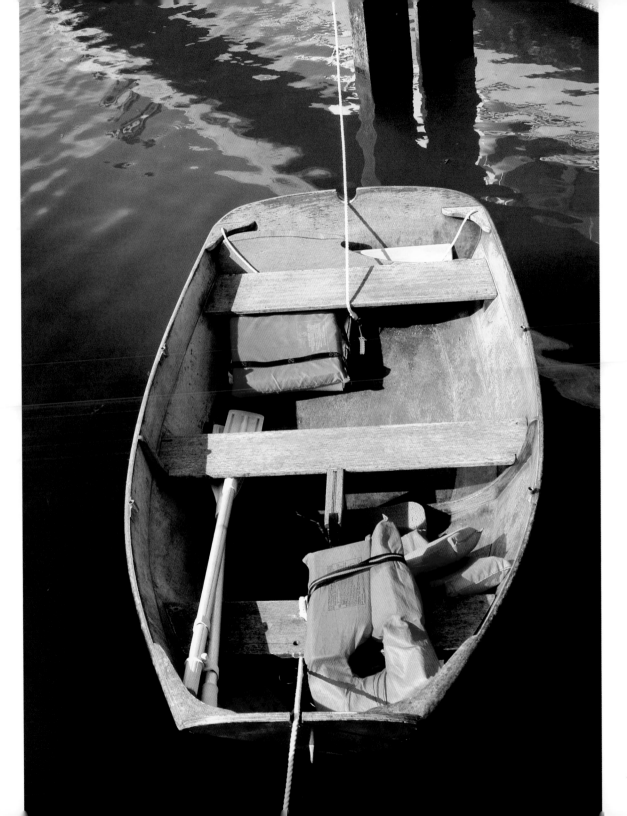

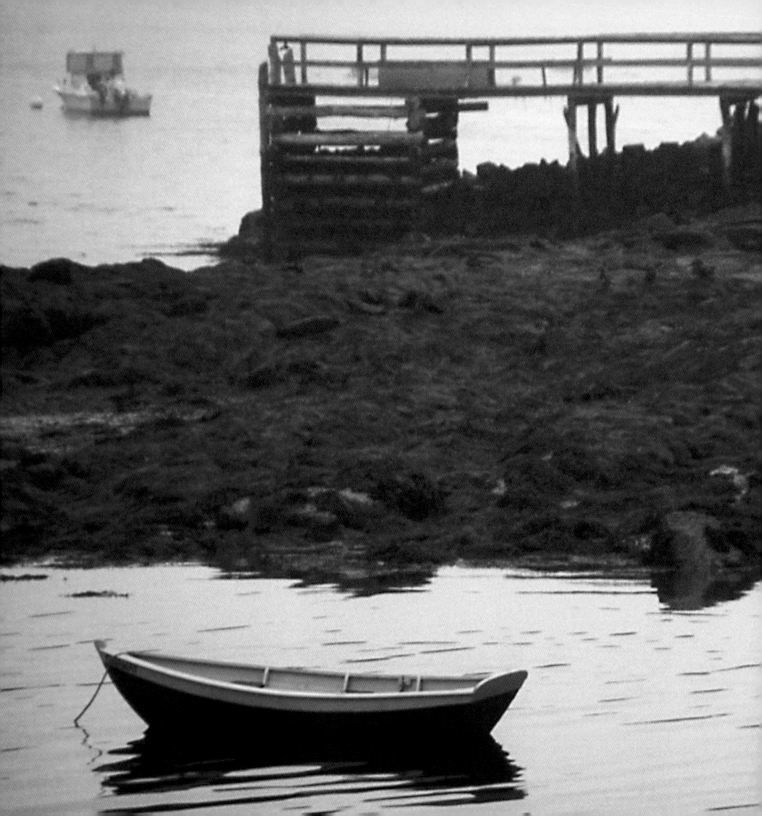

# PERSEVERANCE TO PEACE

Building and using a small wooden boat helps wonderfully to reestablish and strengthen connections with the natural world that so many of us have lost or are in increasing danger of losing. Wind and water have not changed, and the age-old workings and needs of the human body and psyche remain the same and cry for expression and fulfillment in a cold world of artificial abstractions and flickering images.     —*John Gardner*

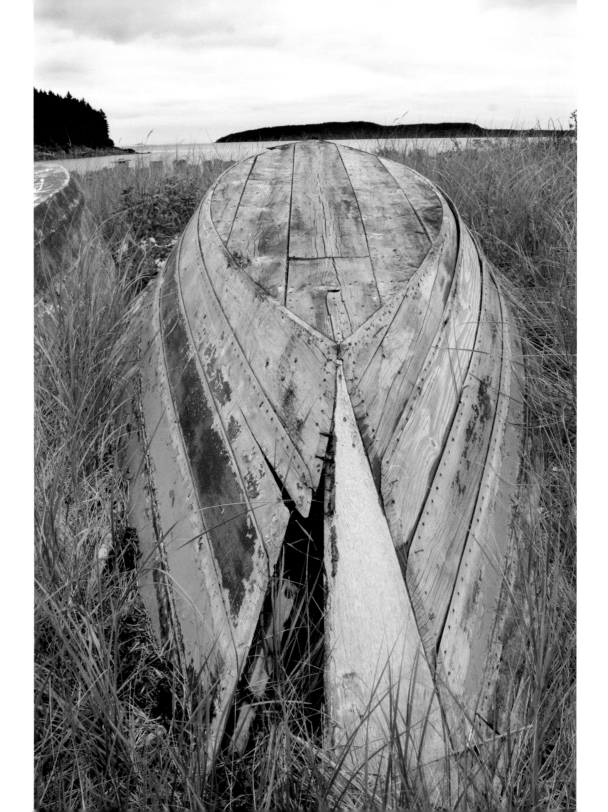

# In the Face of Adversity

The small will of the boat must
resist the great force of the sea.
—*James Wharram*

The water is the same on
both sides of the boat.
—*Finnish proverb*

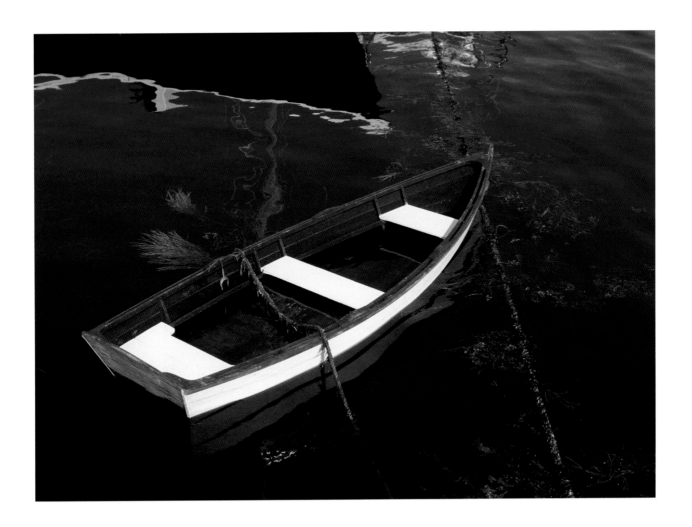

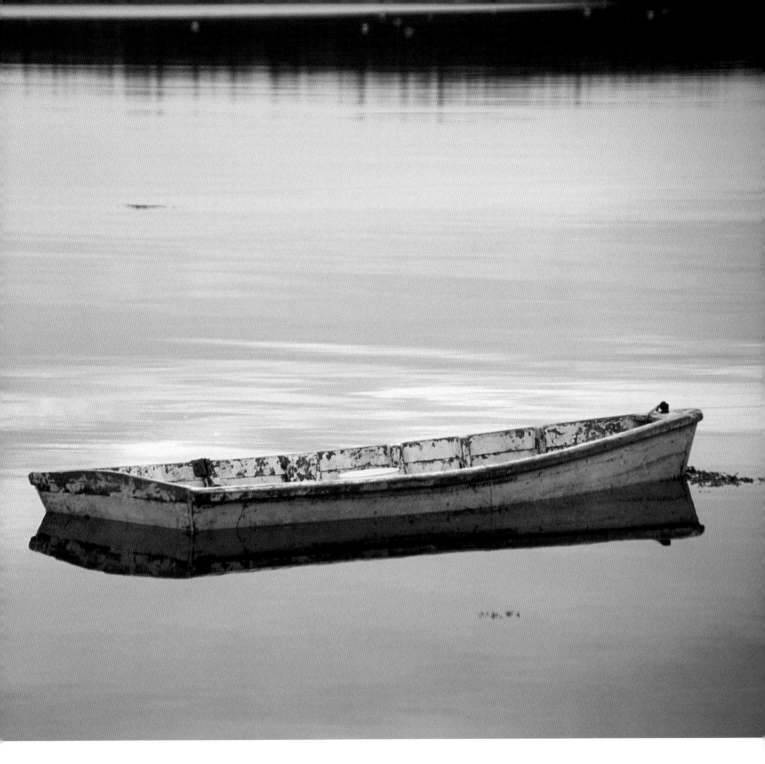

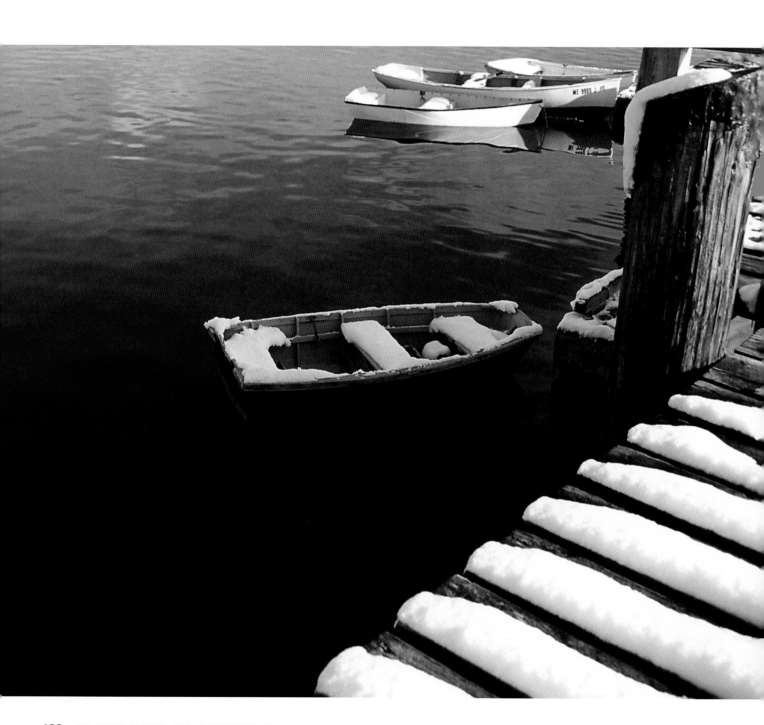

Boats cannot help who buys them. They
develop, particularly as they grow older, a
tolerance for our pretensions of ownership.
                              —*Morley Cooper*

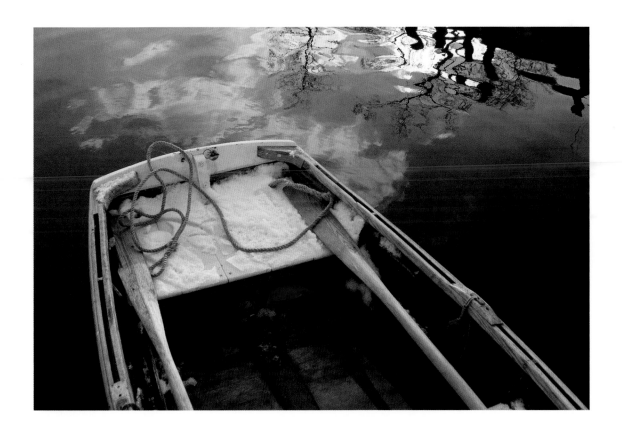

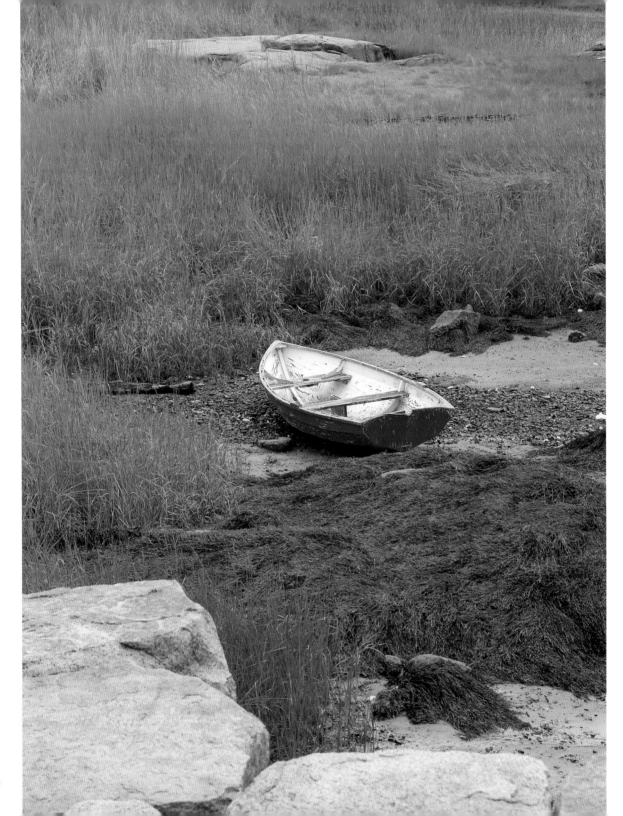

When you get in a tight place and everything goes against you till it seems as though you could not hold on a minute longer, never give up then, for that is just the time and the place the tide will turn.

—*Harriet Beecher Stowe*

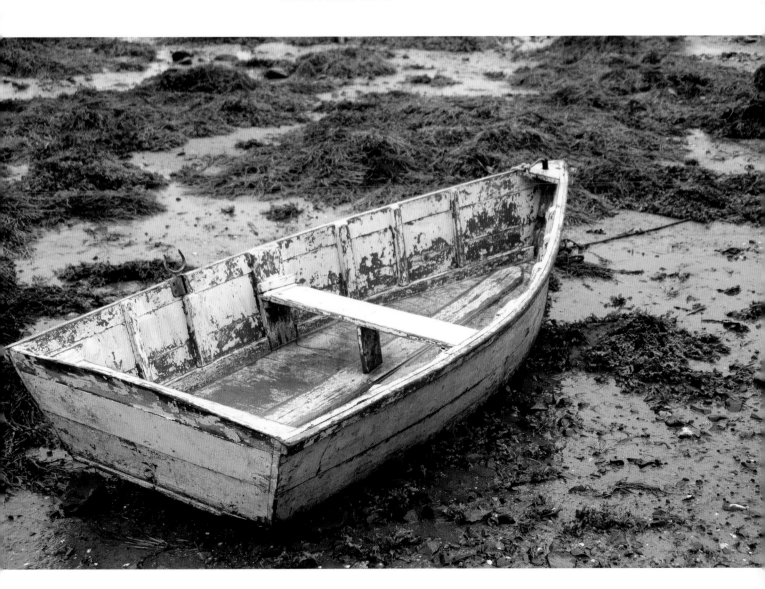

In the selection of your boats, be particular to combine lightness with strength, buoyancy with stability, and speed with seaworthiness.

—*Vanderdecken*

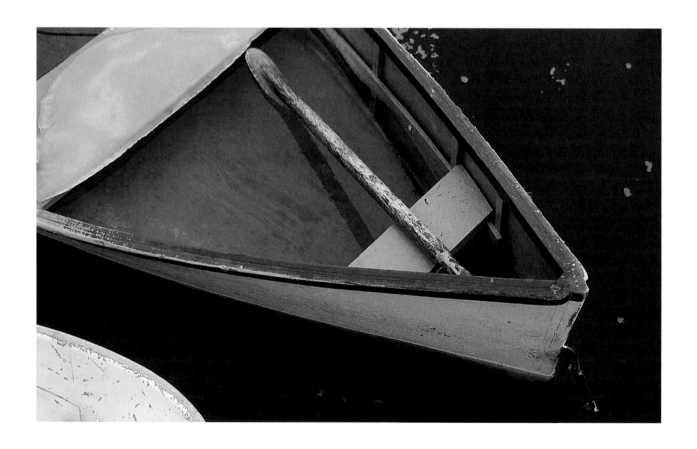

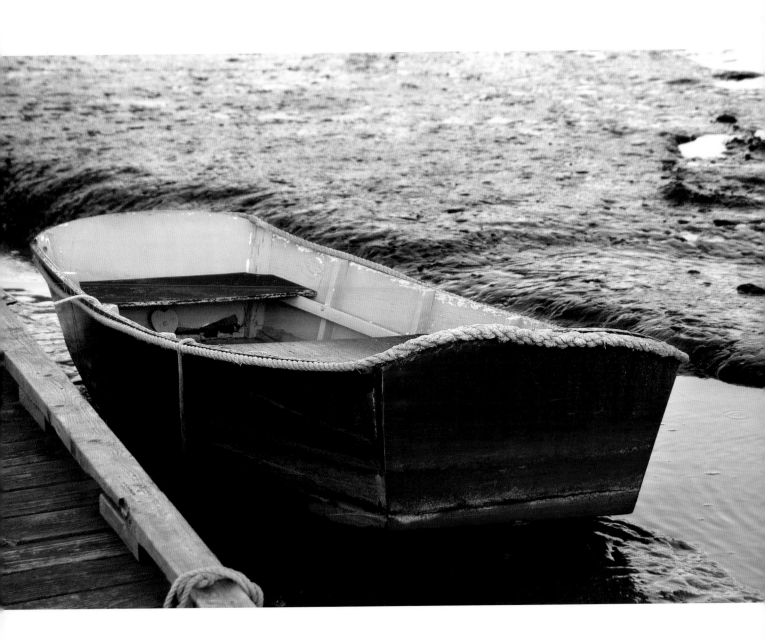

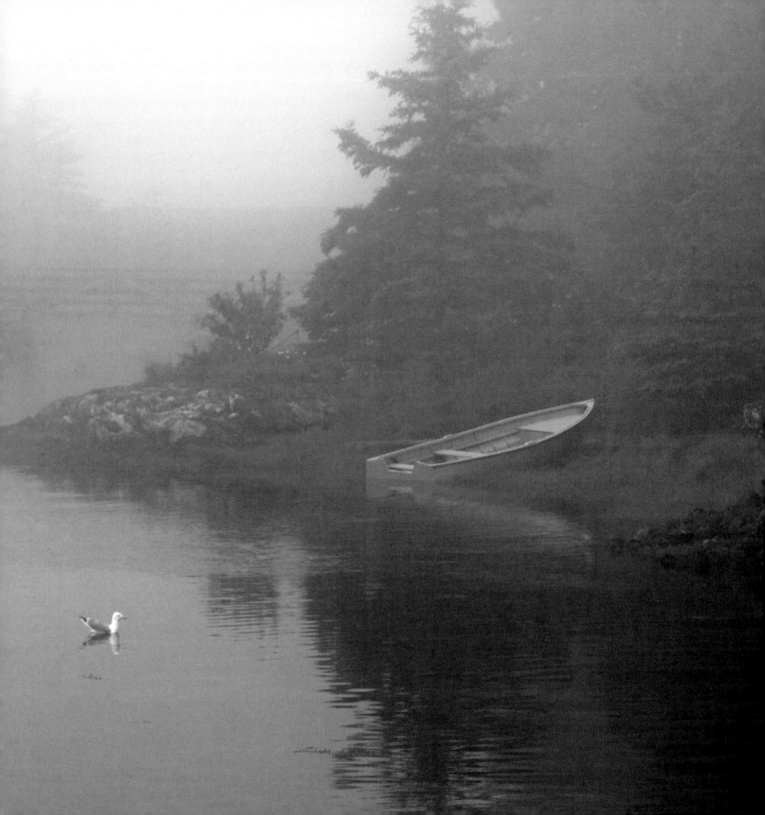

# In the Fog

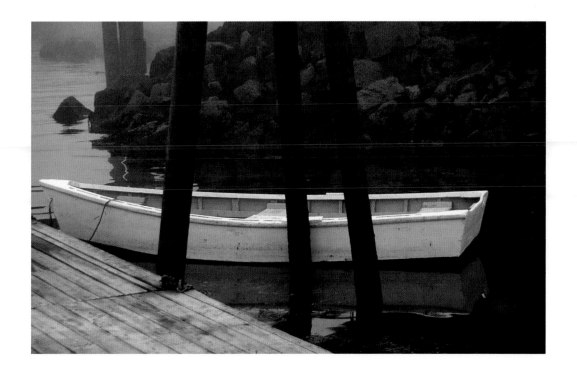

If there is no wind, row.

—*Latin proverb*

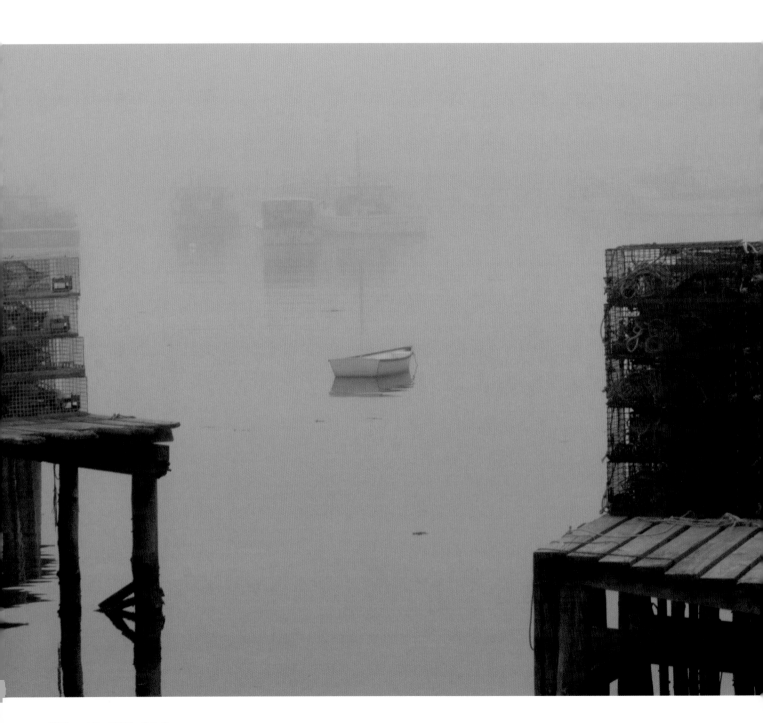

In a rowing craft you find that you are closer to the water than you ever were before, no matter how much boating you have done in other craft. You are much more aware of sea and weather conditions, and see more of your surroundings than you ever did before. You get into places, holes, and creeks you never really knew existed.
—*R.D. "Pete" Culler*

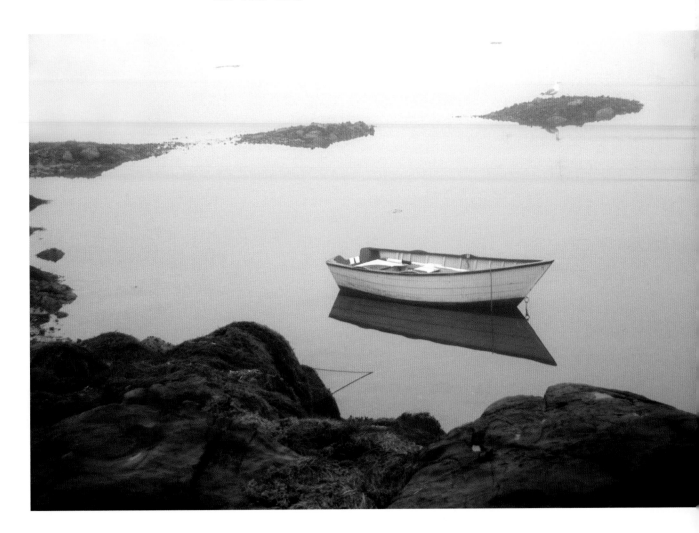

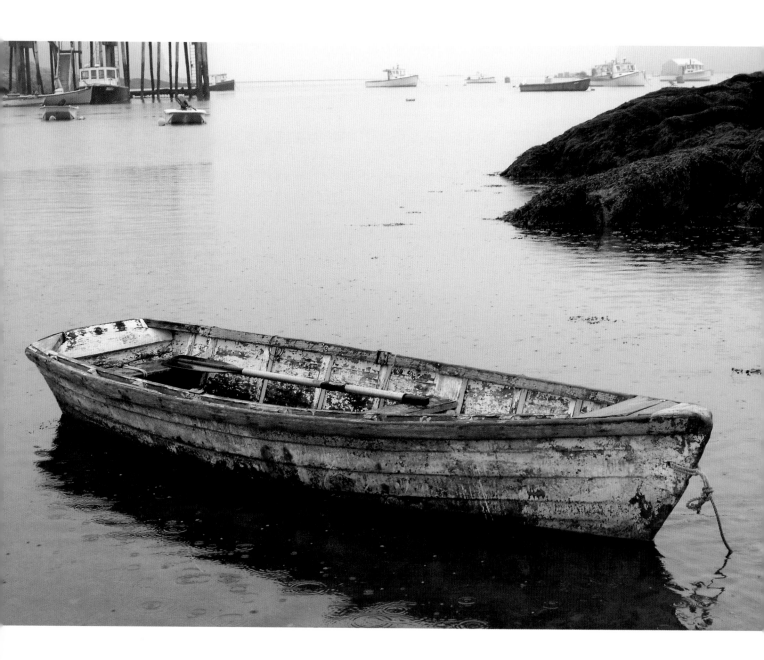

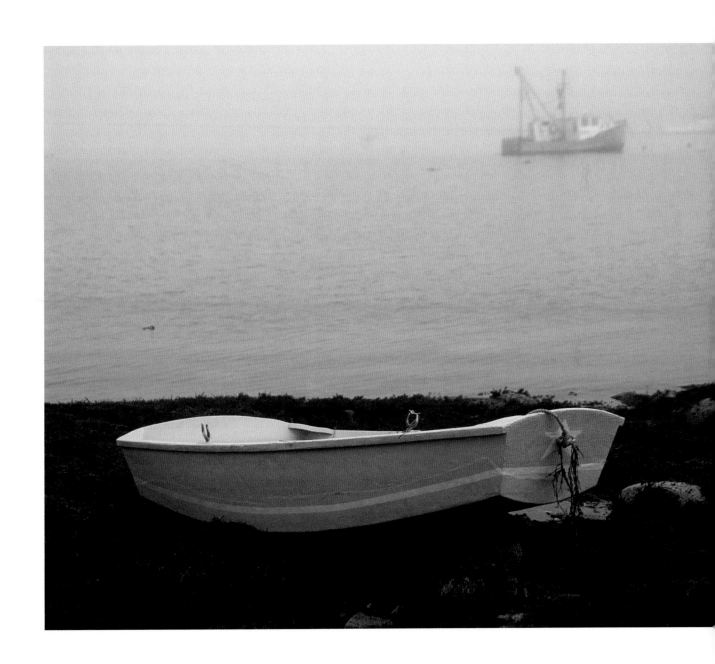

Vessels large may venture more,
But little boats should keep near shore.
—*Benjamin Franklin*

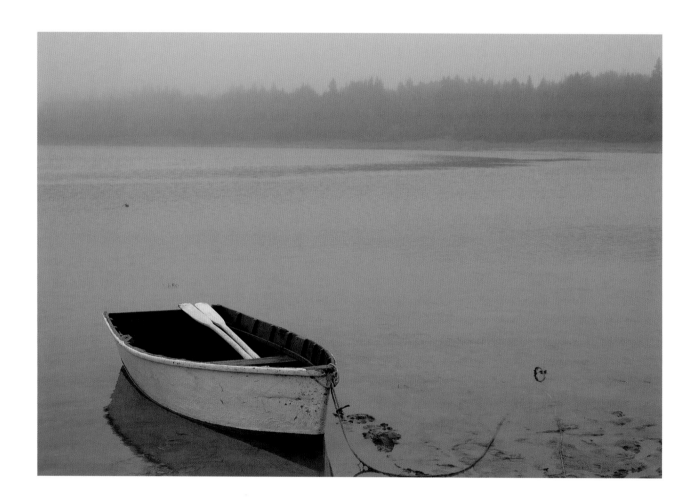

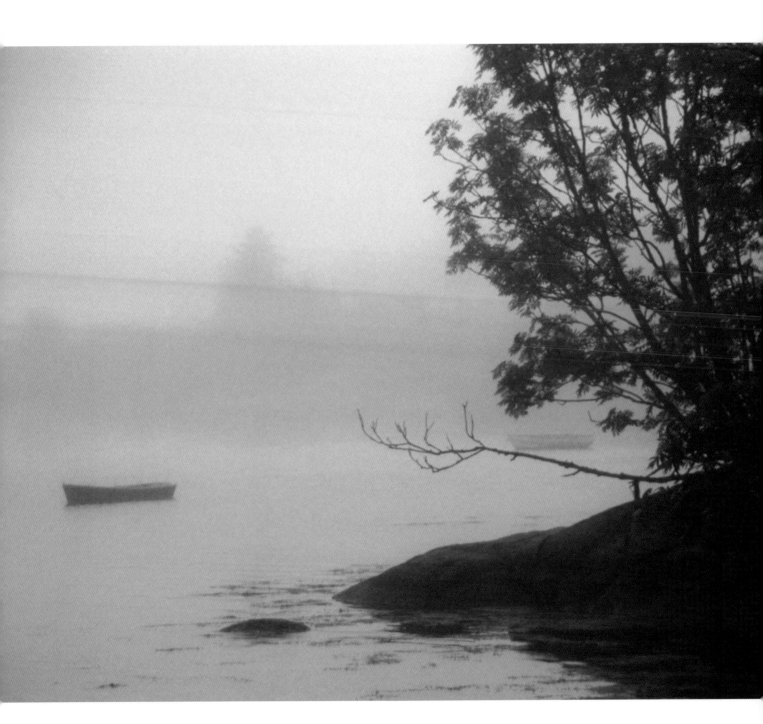

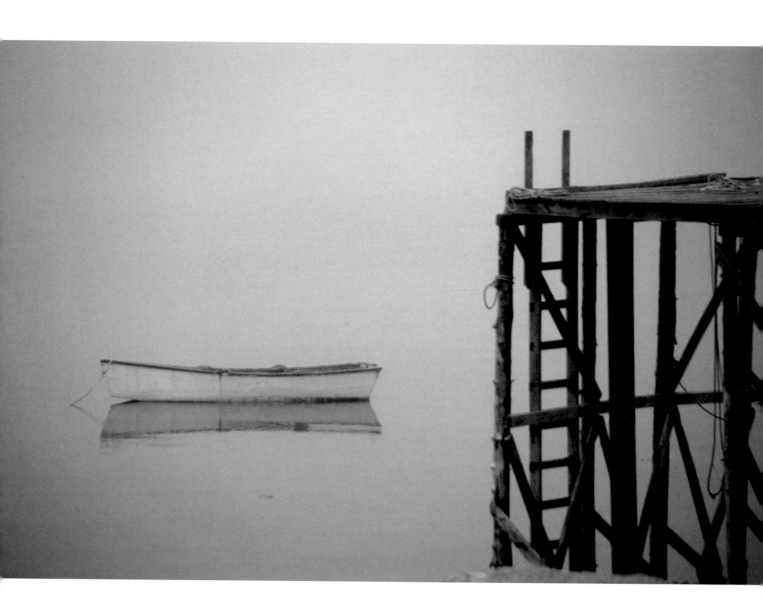

She sat on the water like a swan.
—*Joshua Slocum*

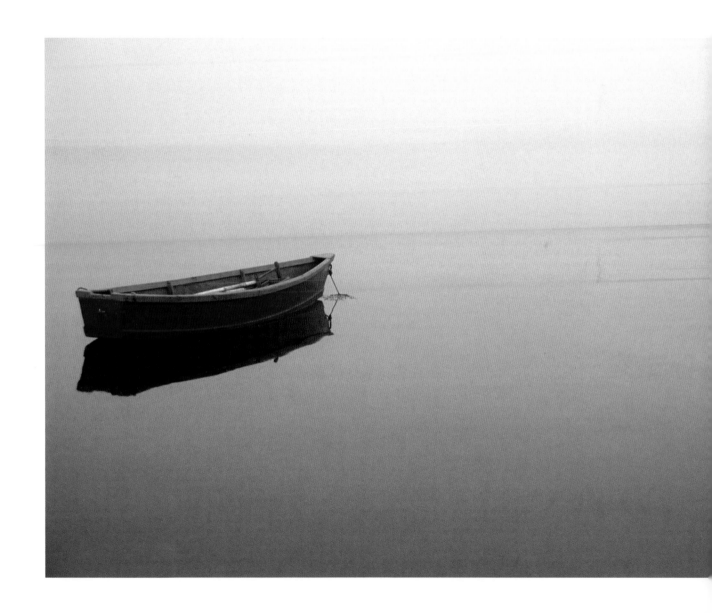

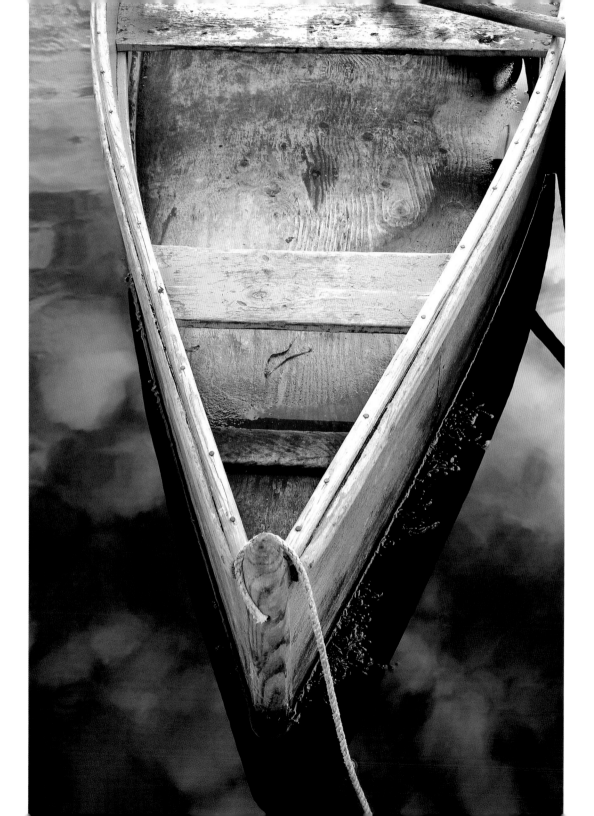

# Upon Reflection

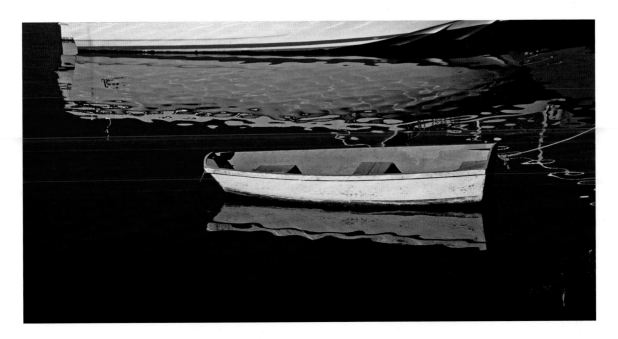

The least movement is of importance to nature.
The entire ocean is affected by a pebble.

—*Blaise Pascal*

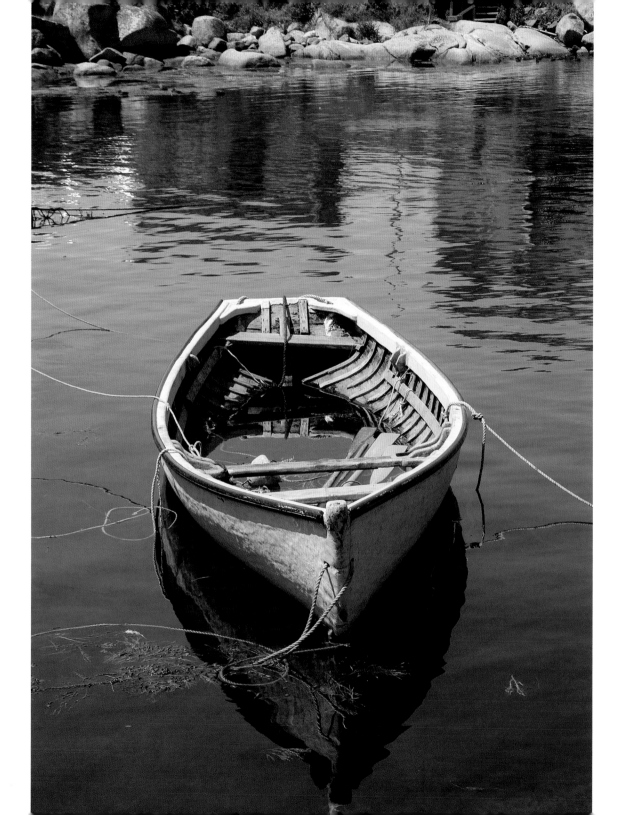

I've got a rowboat tied to a stake on the shore by the dunes, and when things are getting me down and the tide is right I'll launch her into the creek and row her up into the marsh as far as I can go.

—*E.H. Morgan*

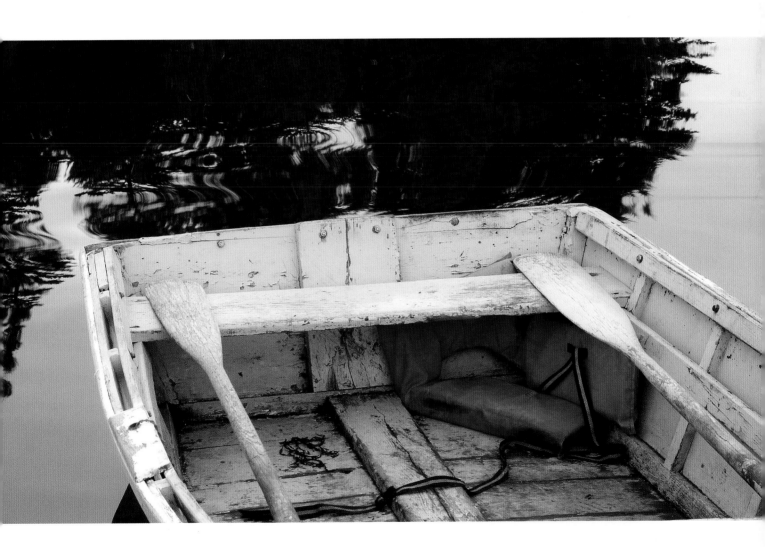

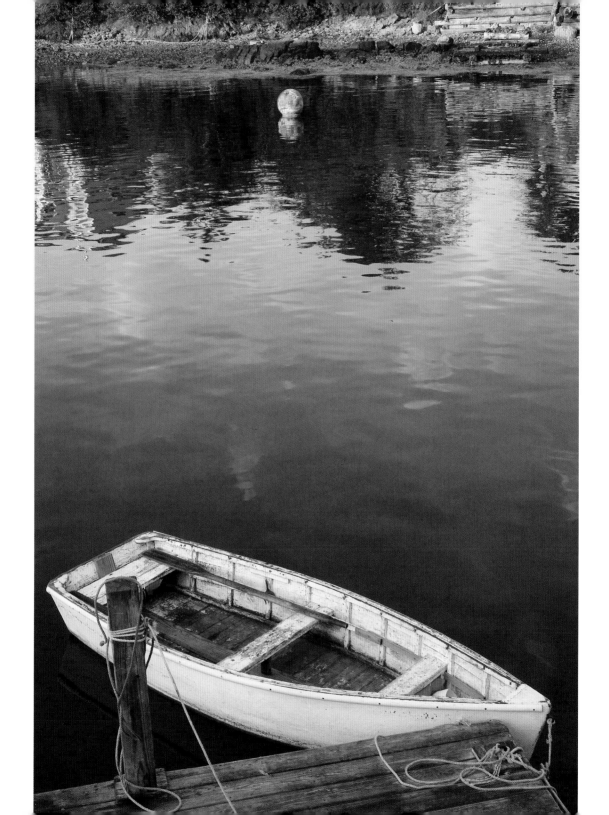

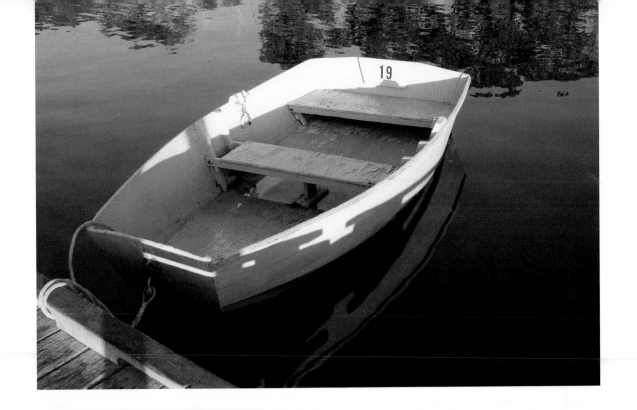

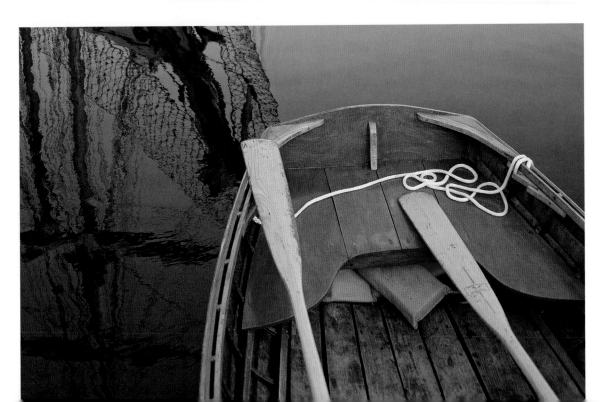

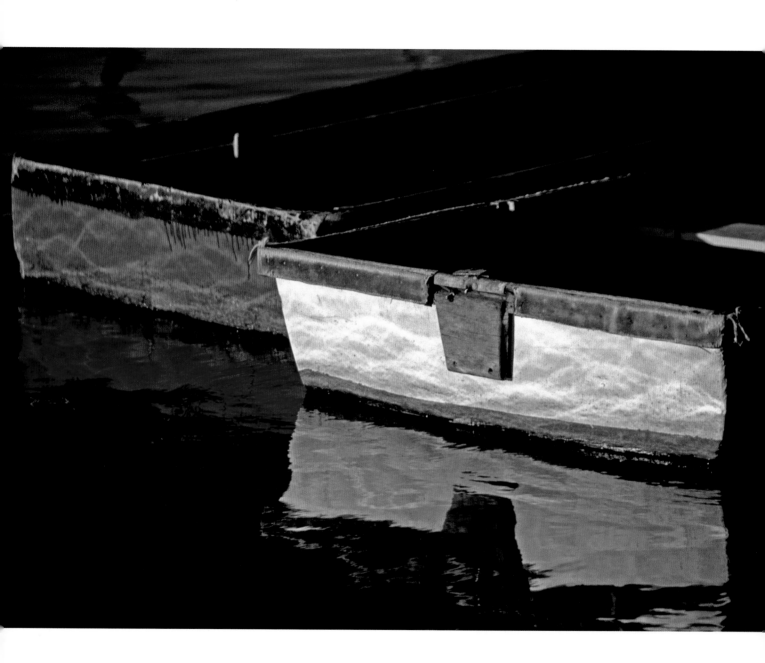

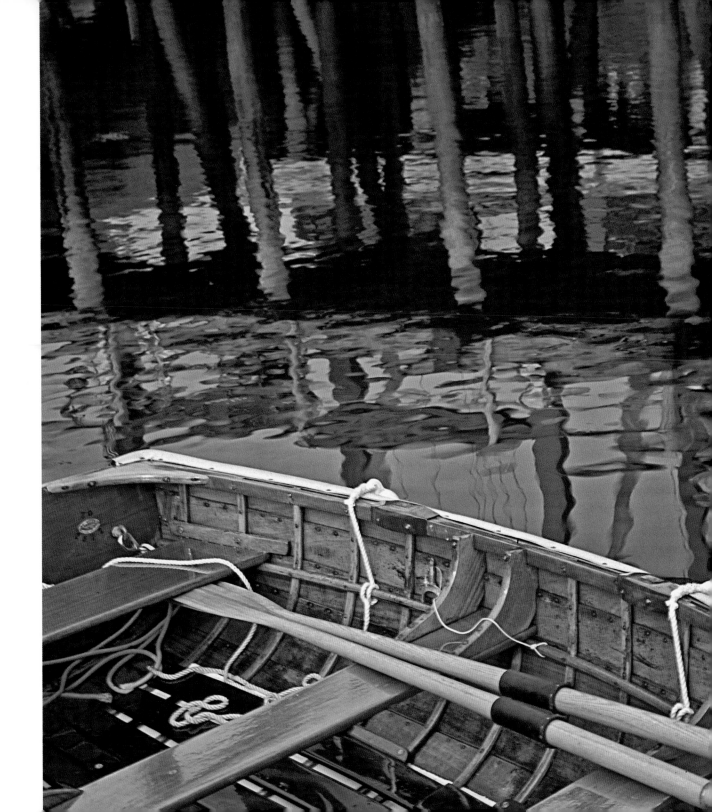

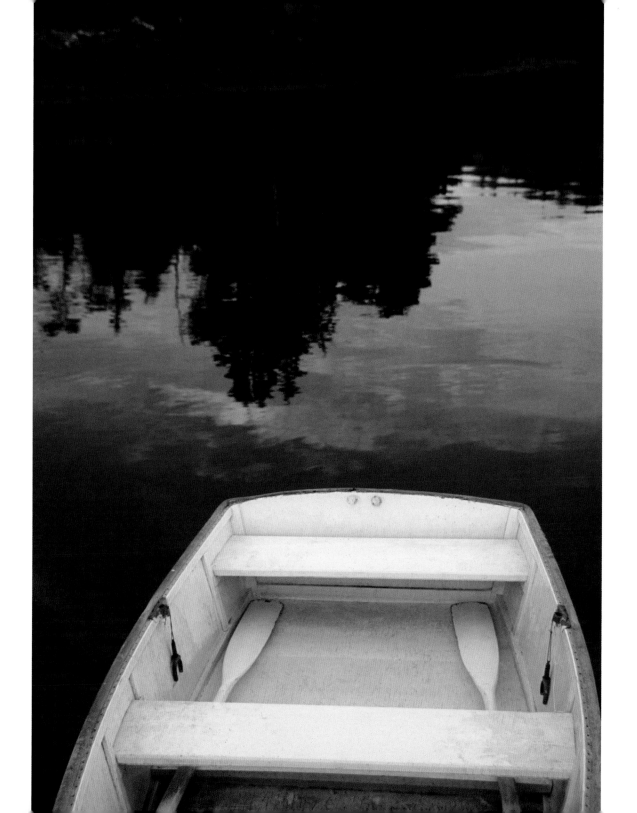

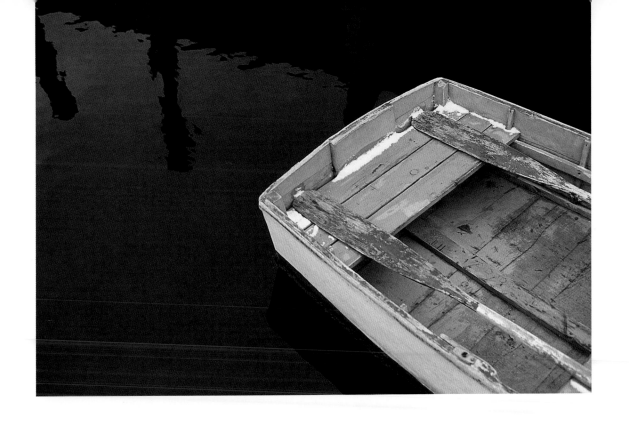

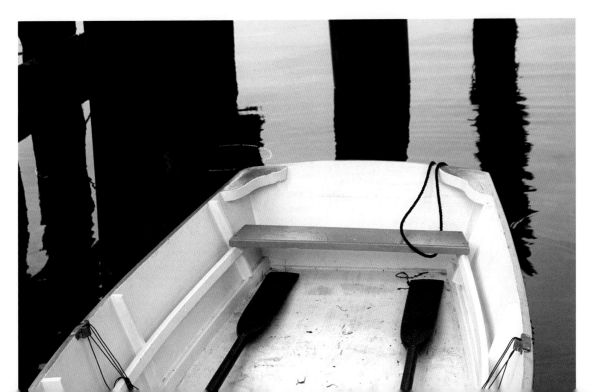

Whenever the water rises,
the boat will rise too.
—*Chinese proverb*

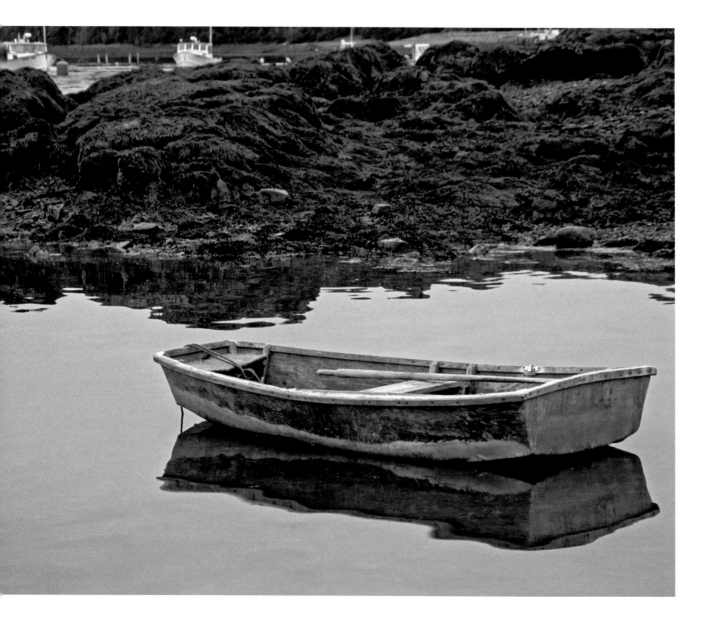

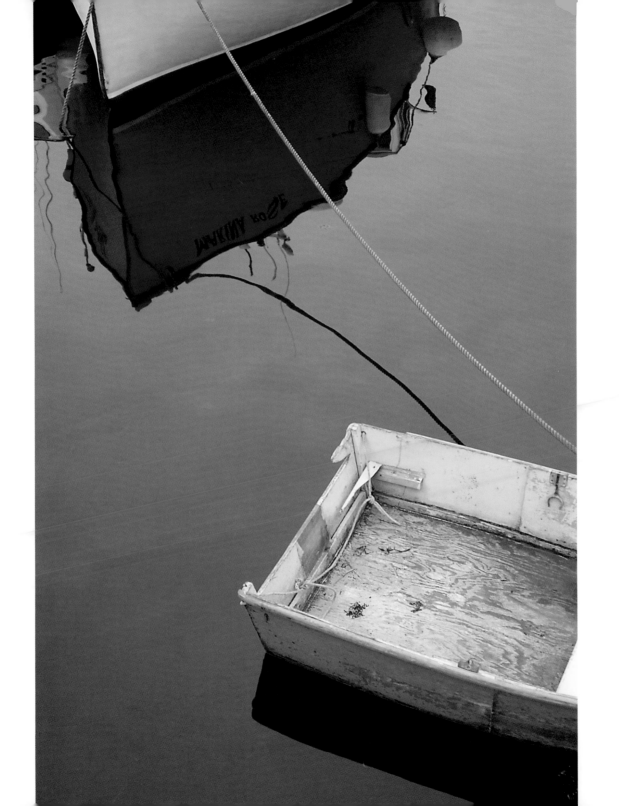

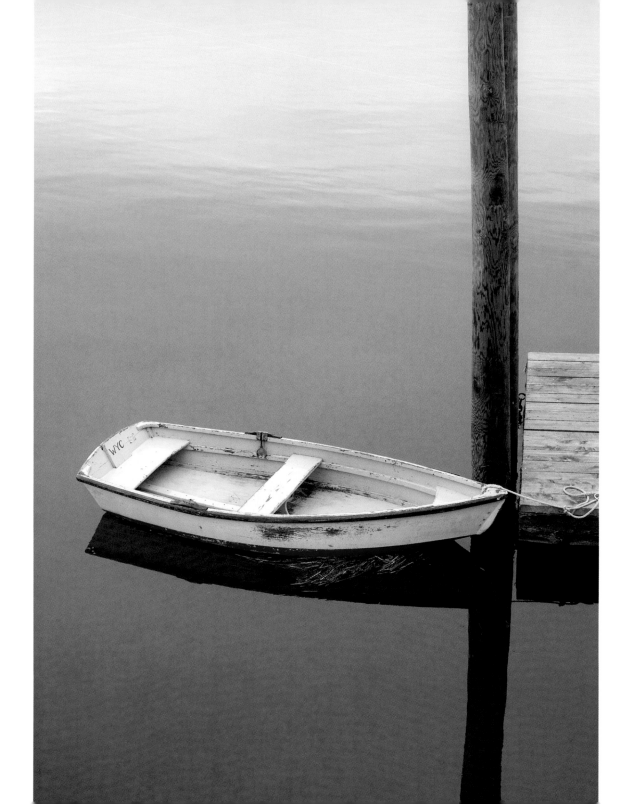

A boat's importance as an escape from reality,
as a change of pace, as a theme for reflection,
and as an art form gives it worth or value.
        —*William Garden*

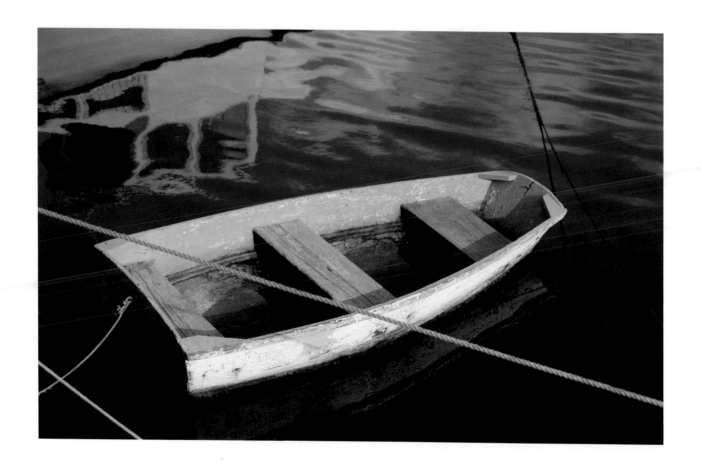

Is there anything prettier than a
pretty boat floating beside a dock?
—*Elisabeth Woodbridge Morris*

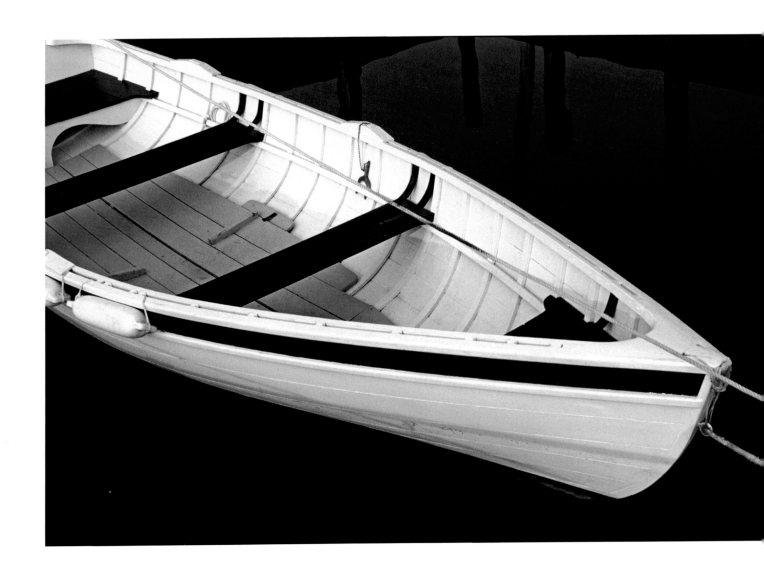

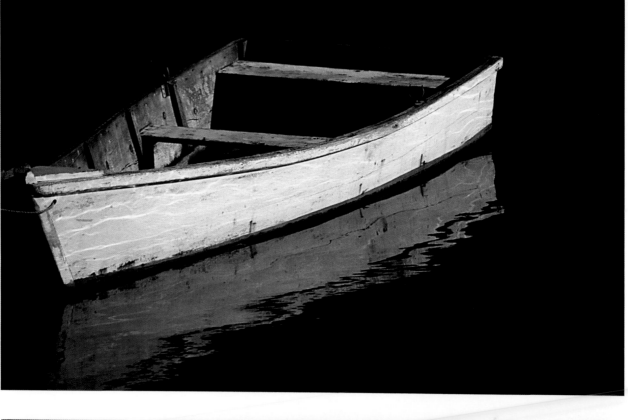

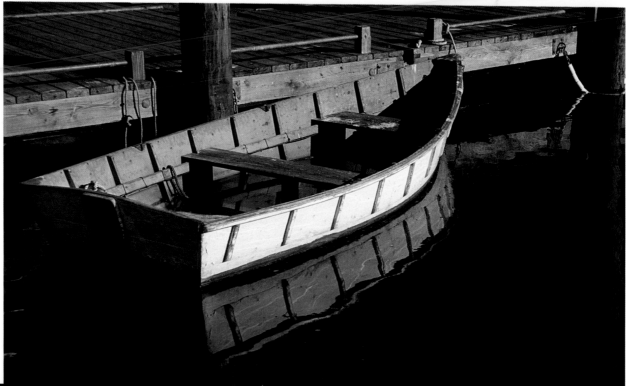

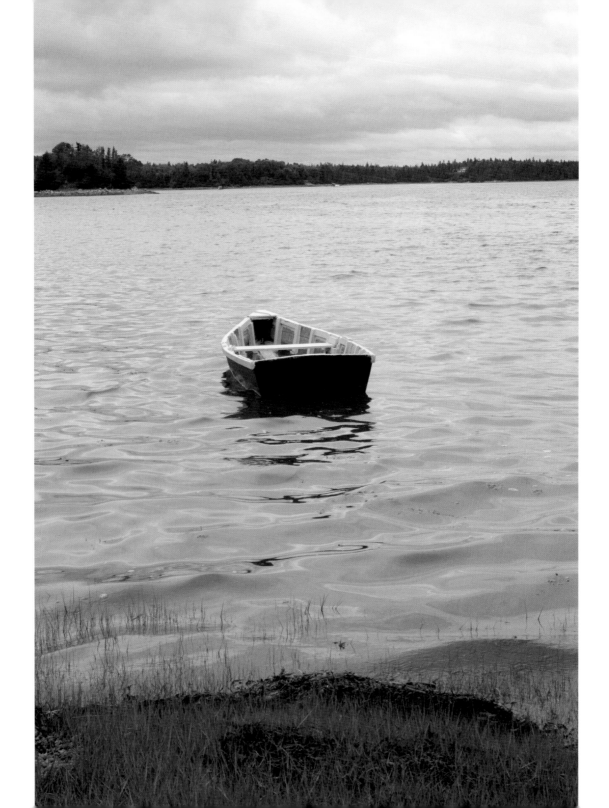

# Peace

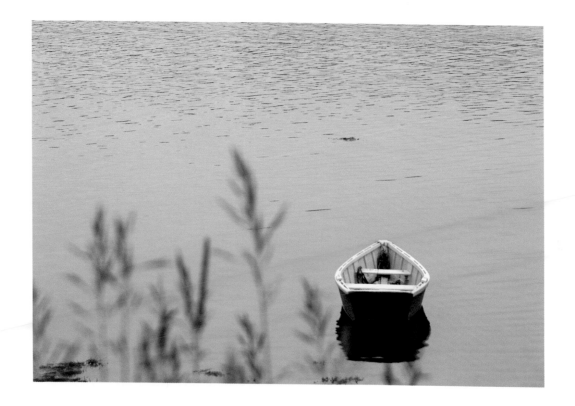

**The goal of life is living in agreement with nature.**

*—Zeno*

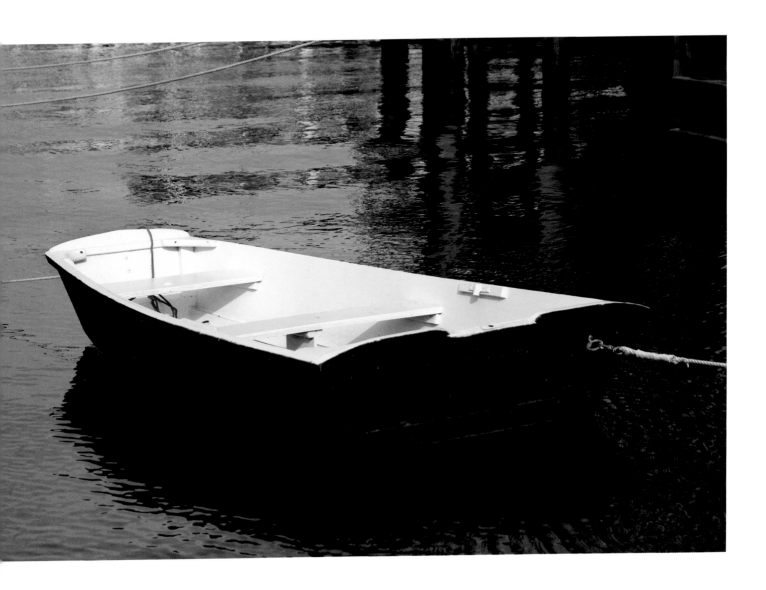

**Peace is liberty in tranquility.**
—*Cicero*

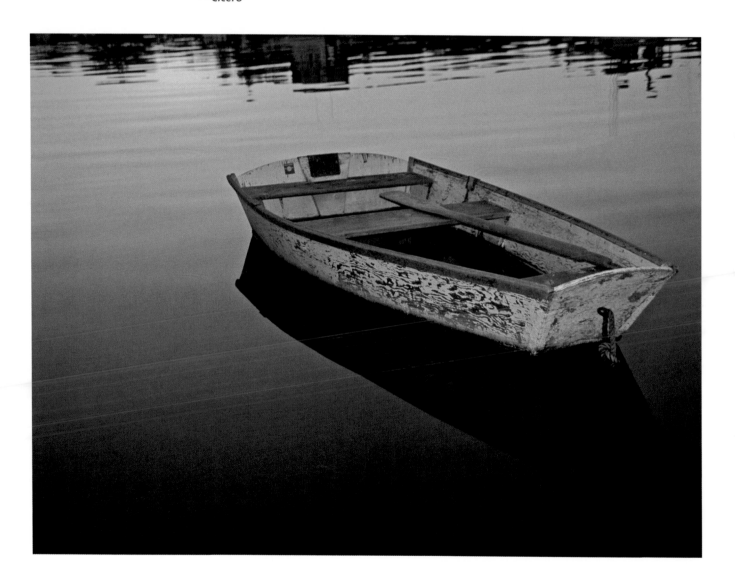

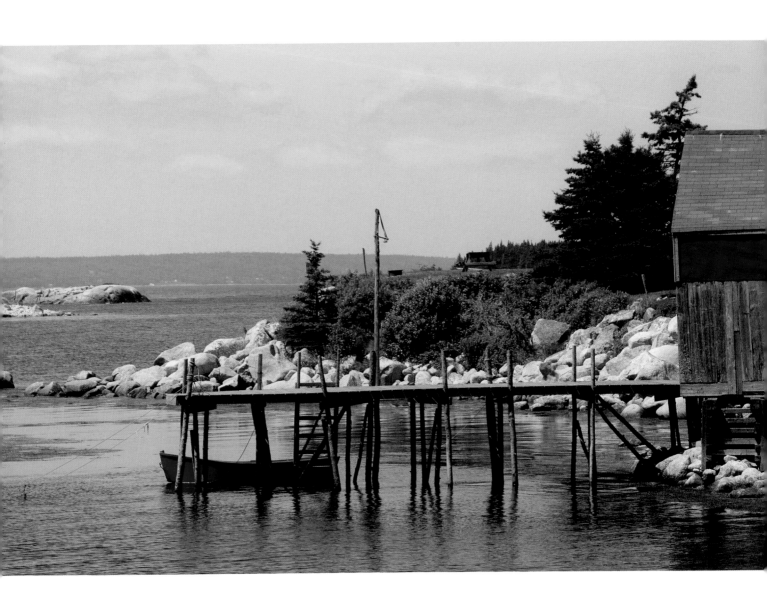

**Peace is always beautiful.**
　　　　*—Walt Whitman*

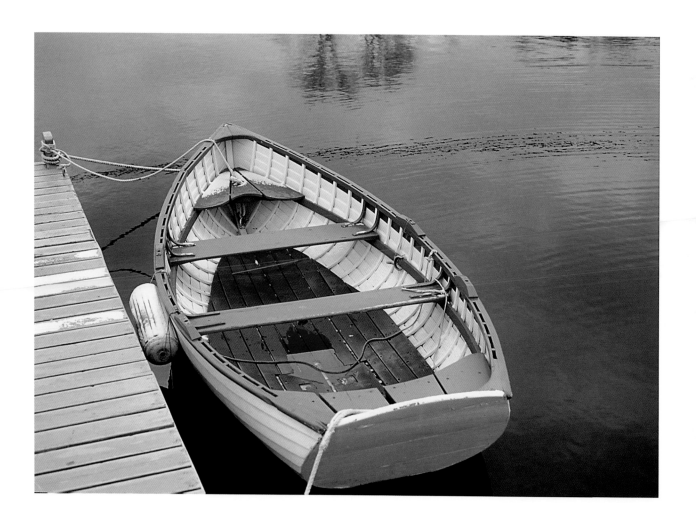

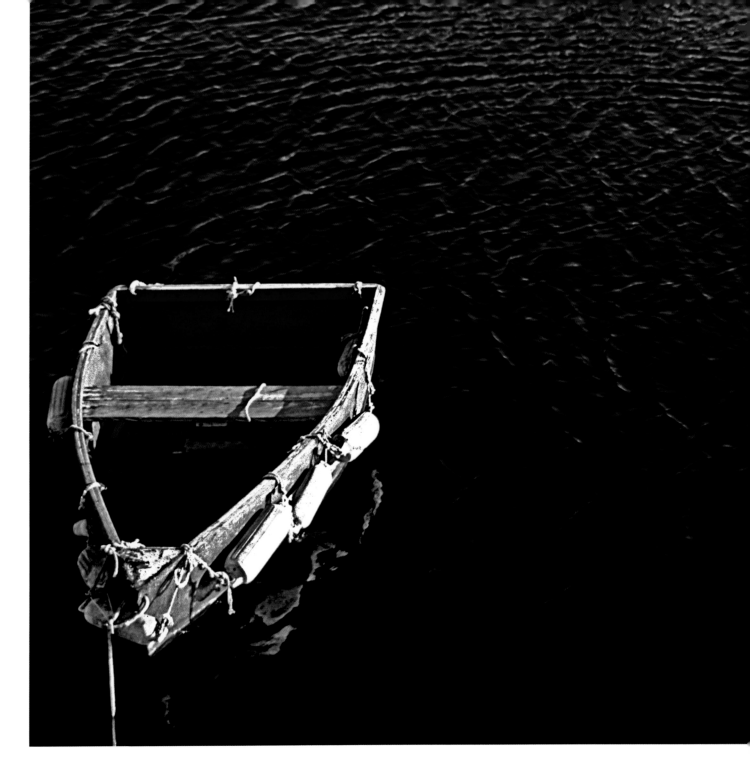

Peace is rarely denied to the peaceful.
—*Friedrich von Schiller*

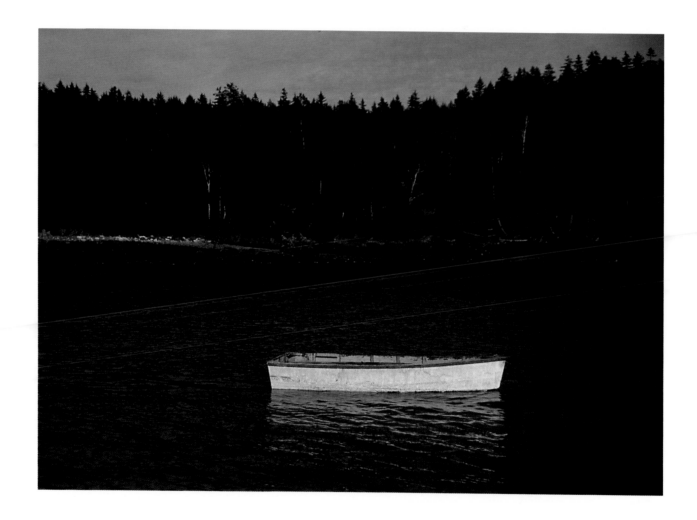

The boat was one of those happily
turned out craft that seem to love
the water, to ride it lightly and
gracefully, and seem to form always
a felicitous part of any moving
picture in which they appear.
—*Winfield M. Thompson*

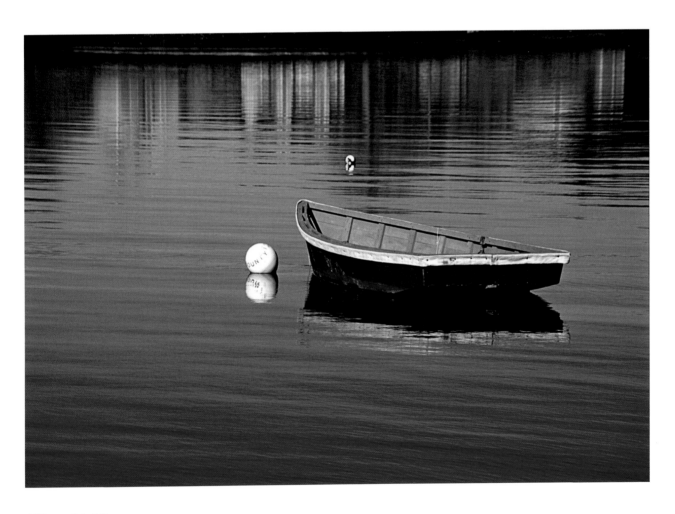

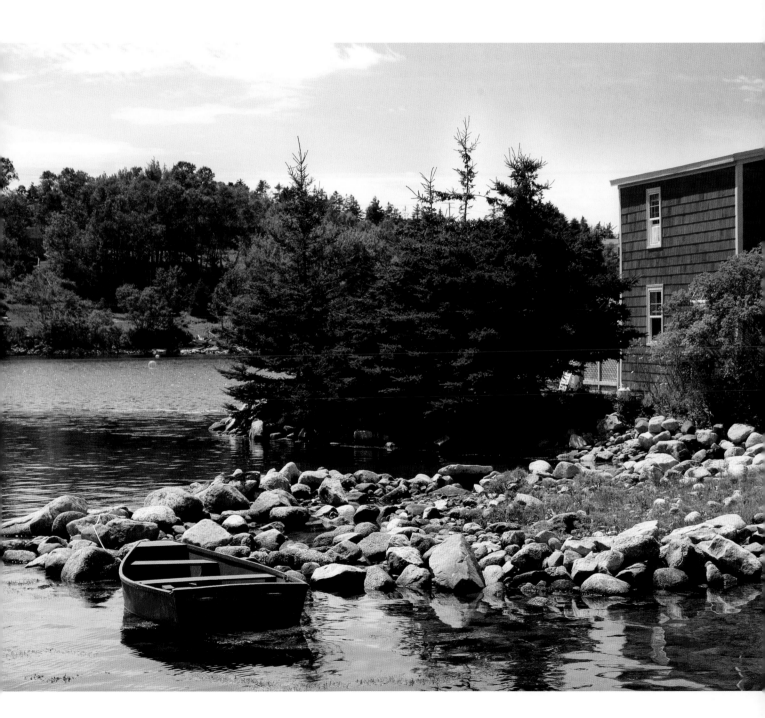

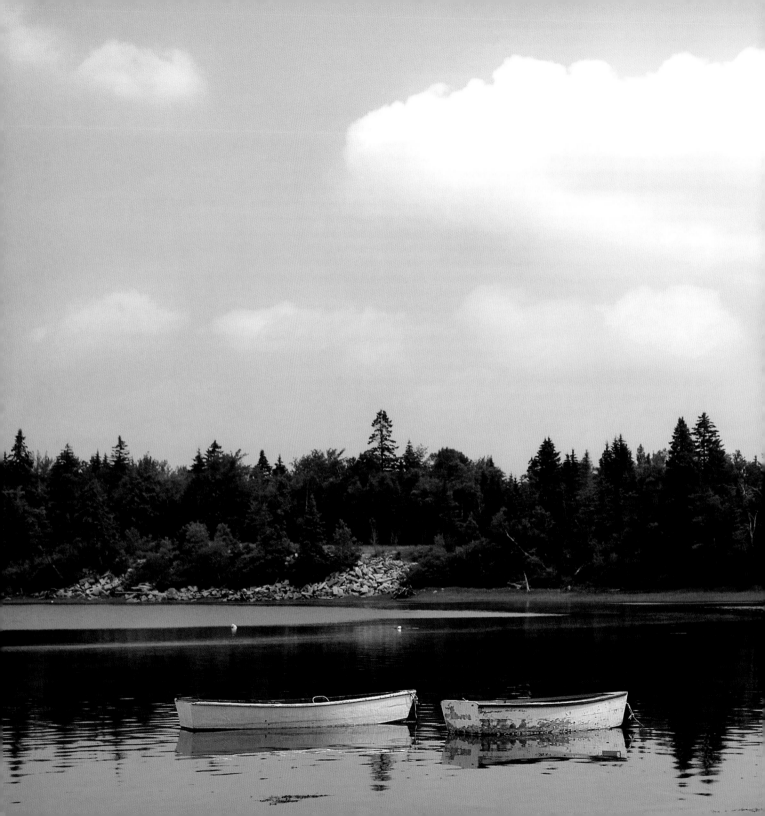

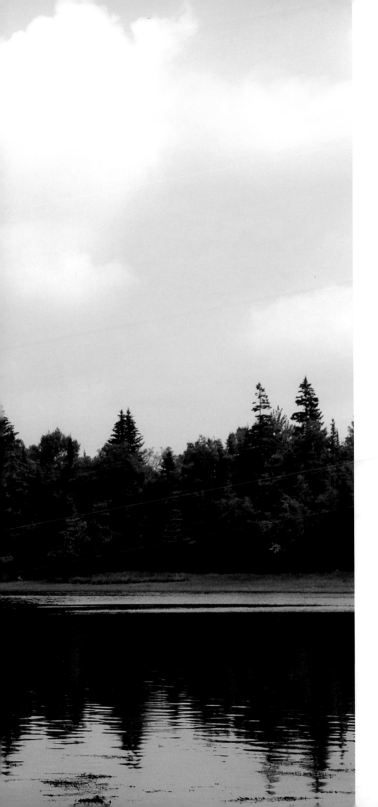

# KEEP IN THE SUNLIGHT

Rowboat. Skiff, punt, flatty... They differ a lot, badly, good. A pristine dog of a skiff will die under the scorn heaped atop it in a few seasons. A ratty, battered scow will be loved and tortured through a half-century. The test of how things go for a skiff happen not by its condition, but by how it's fixed, and its colors. If regularly patched and puttied, and painted something garish or unique, then it is a good punt and has a future. If it has been spread with wider thwarts, and painted any shade of gray, it has alienated affections it may once have enjoyed. Good skiffs, not bad ones, become planters in the yards of old fisher families.

—*George Putz*

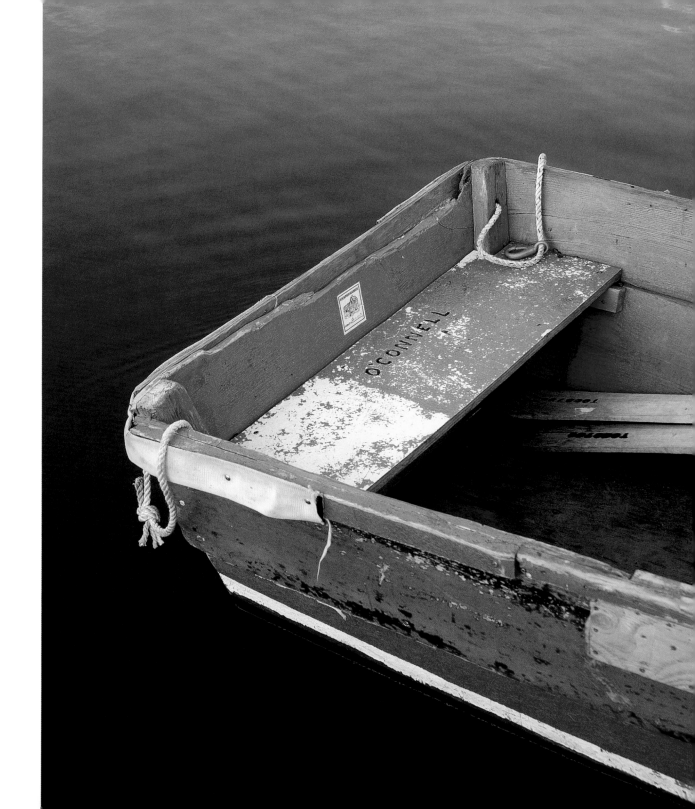

# A Splash of Color

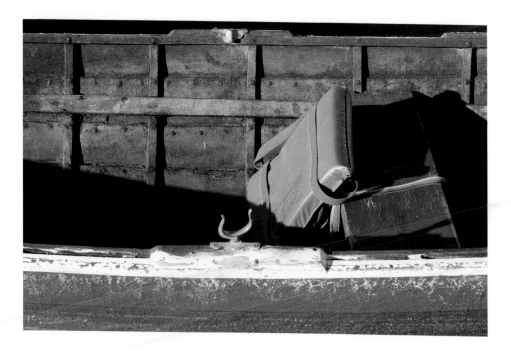

The little things are infinitely the most important.
—*Sir Arthur Conan Doyle*

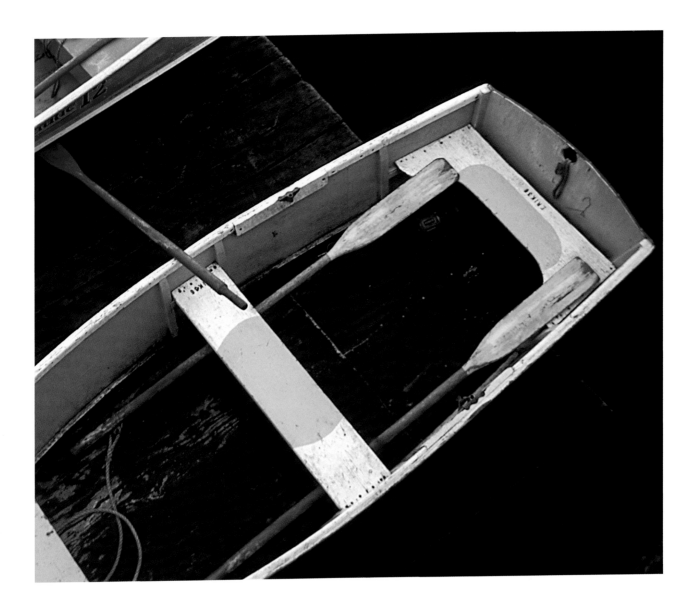

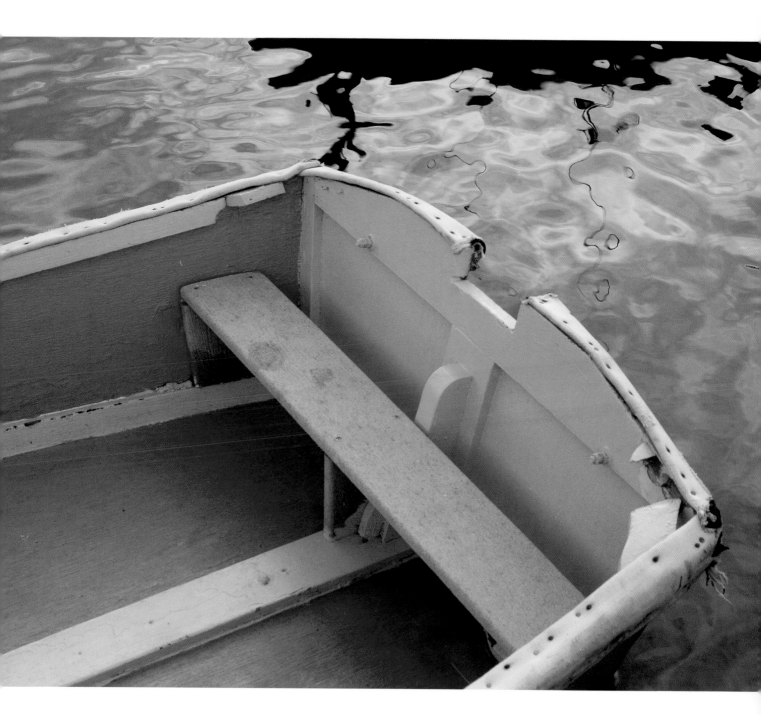

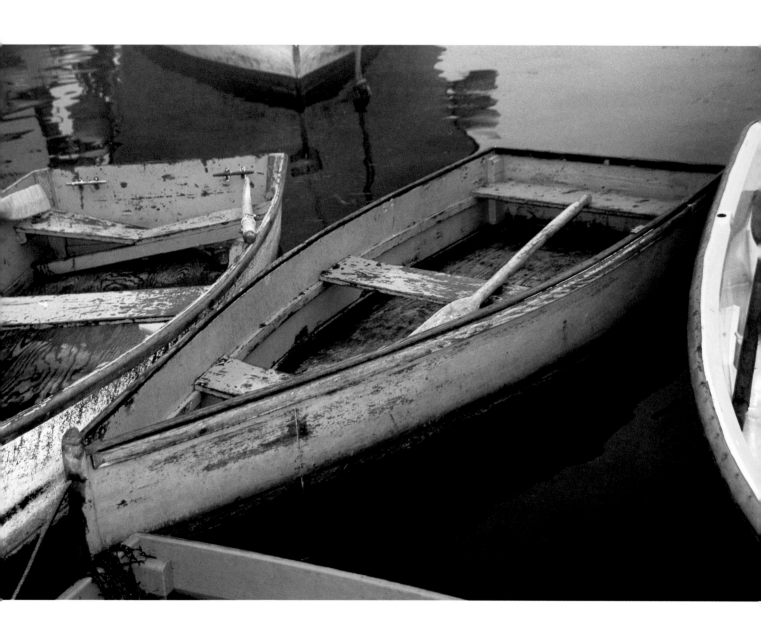

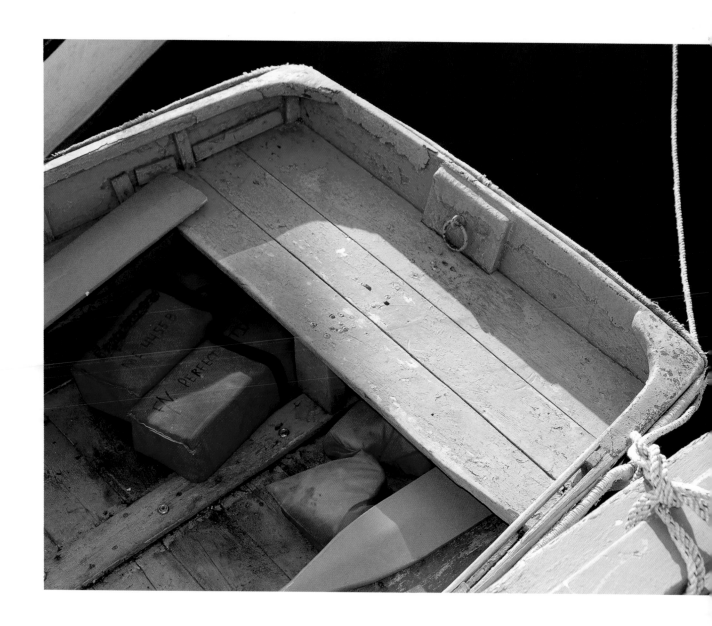

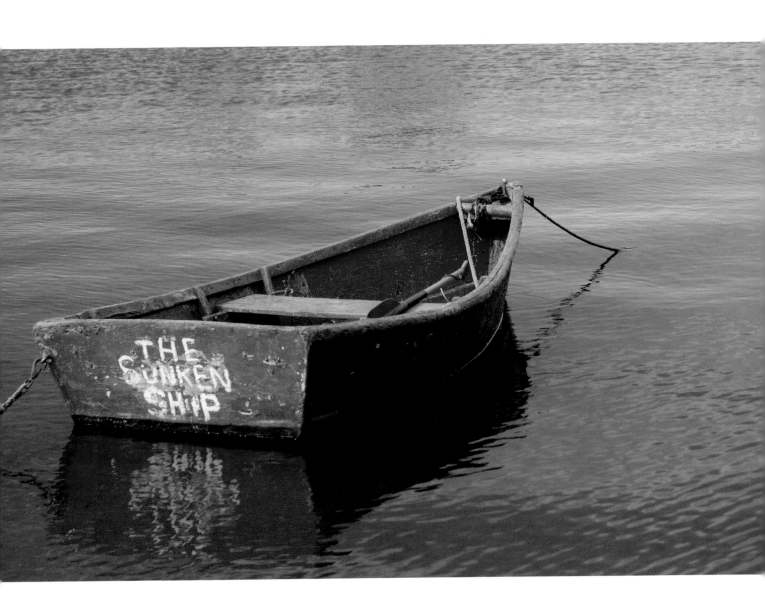

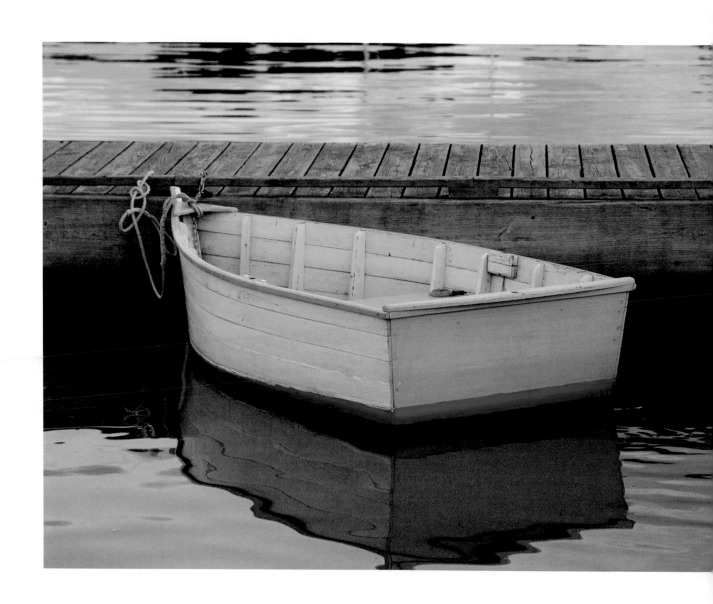

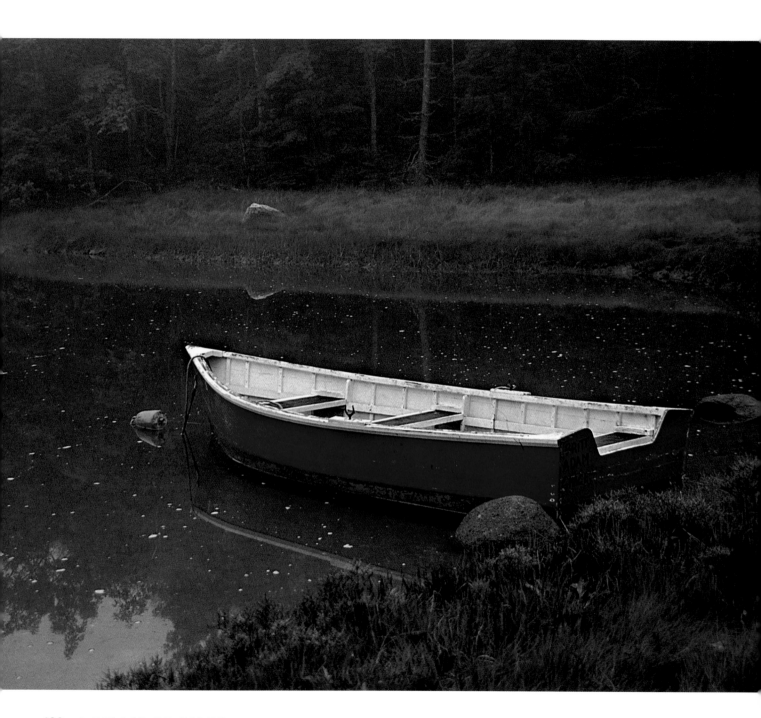

Grace is the beauty of form
under the influence of freedom.
—*Friedrich von Schiller*

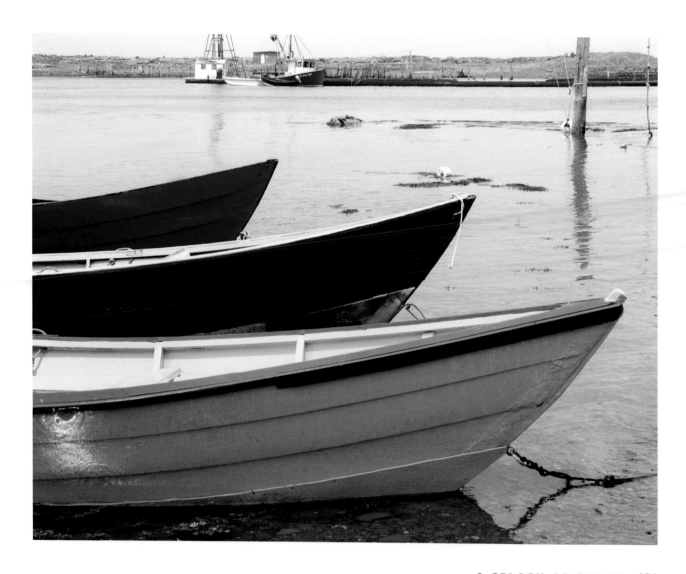

A skiff upon the inland streams,
And not a frigate on the sea,
Is this, my heart, that drifts and dreams
In sweet, alluring vagrancy.
—*Jessie Belle Rittenhouse*

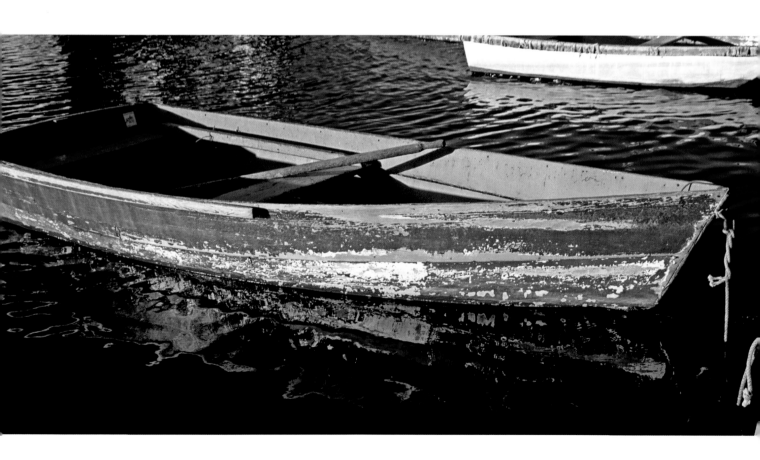

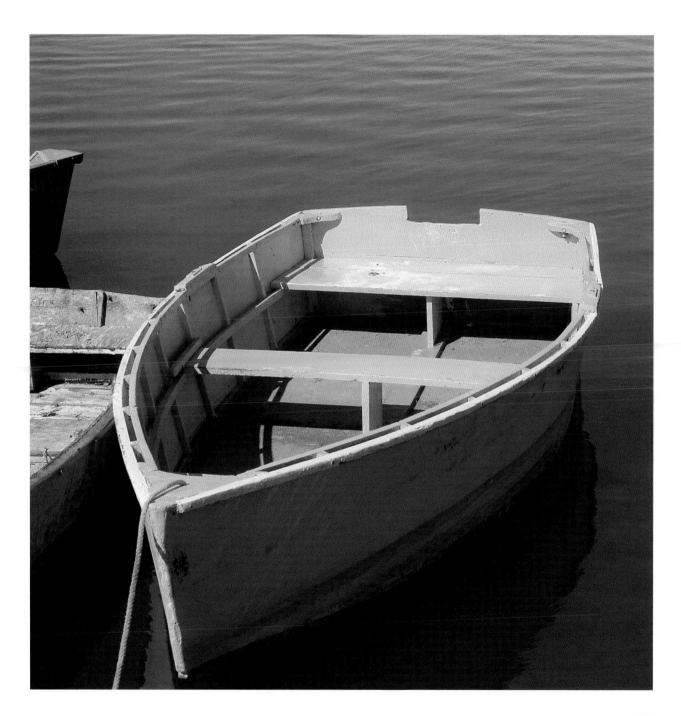

All things are well when there is sunlight.

—*Hilaire Belloc*

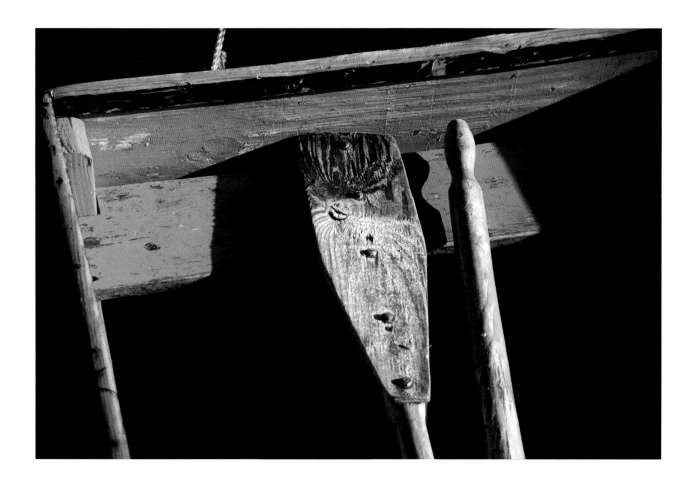

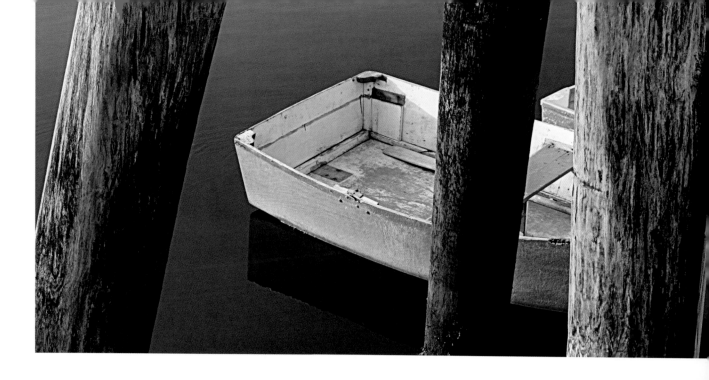

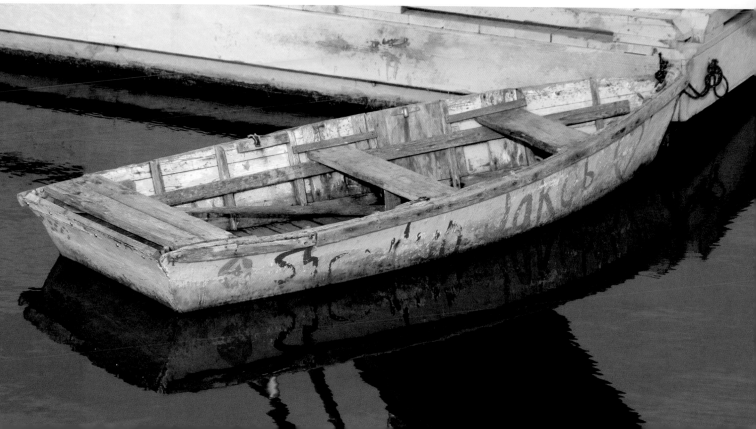

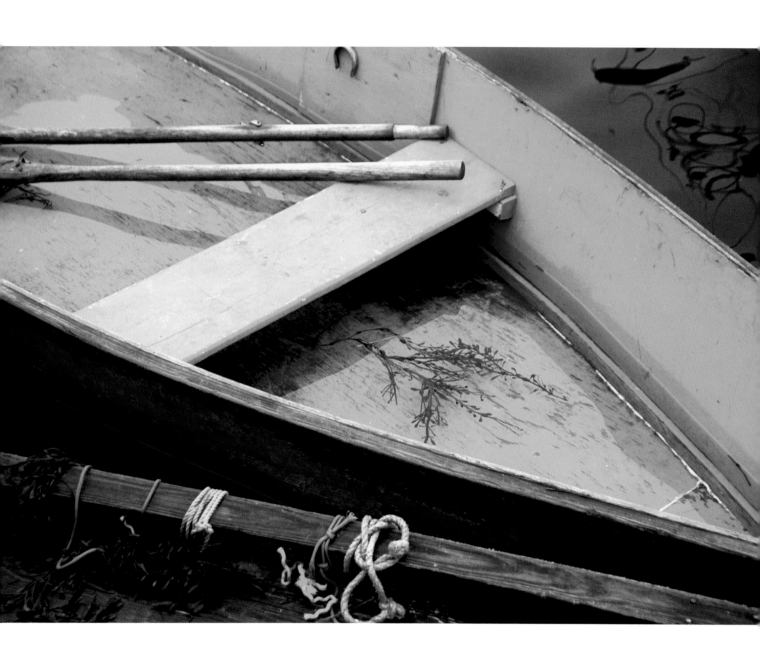

An artistic touch is needed to
create a good-looking boat.
— *Francis S. Kinney*

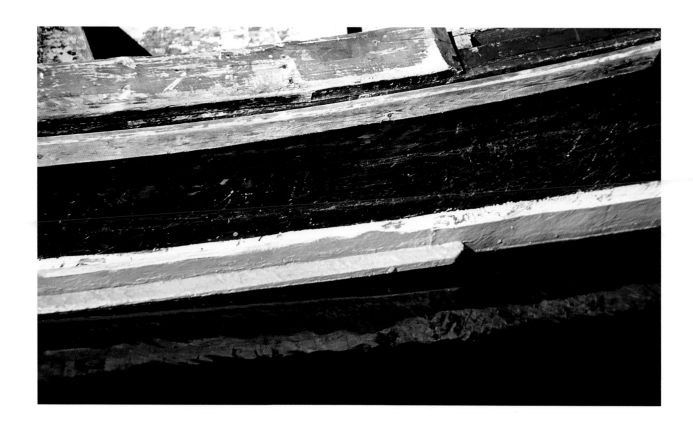

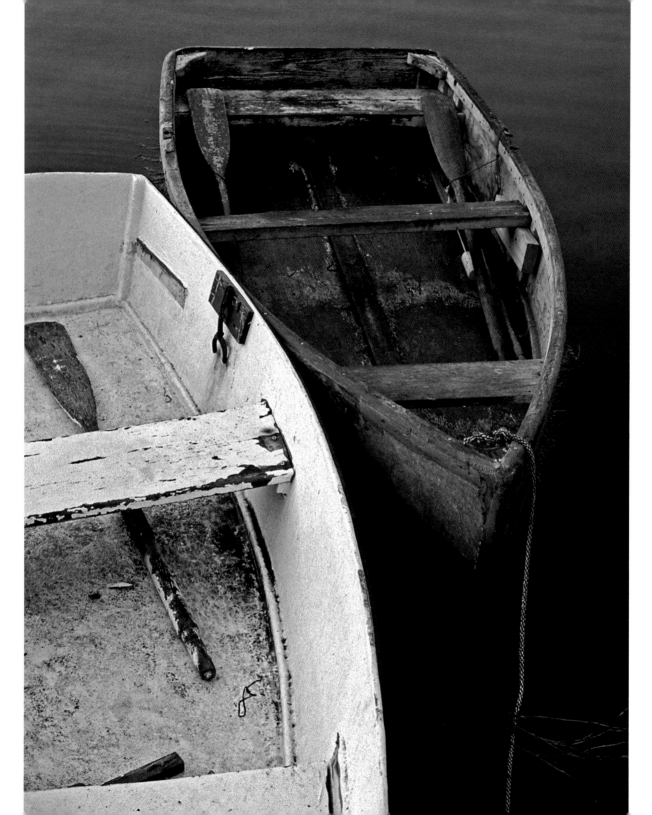

# Love Boats

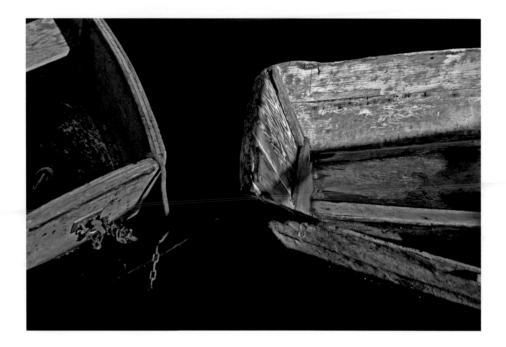

There is something about boats which makes one feel
they are living creatures — each as different from her
sisters as human beings are from each other.

—Francis S. Kinney

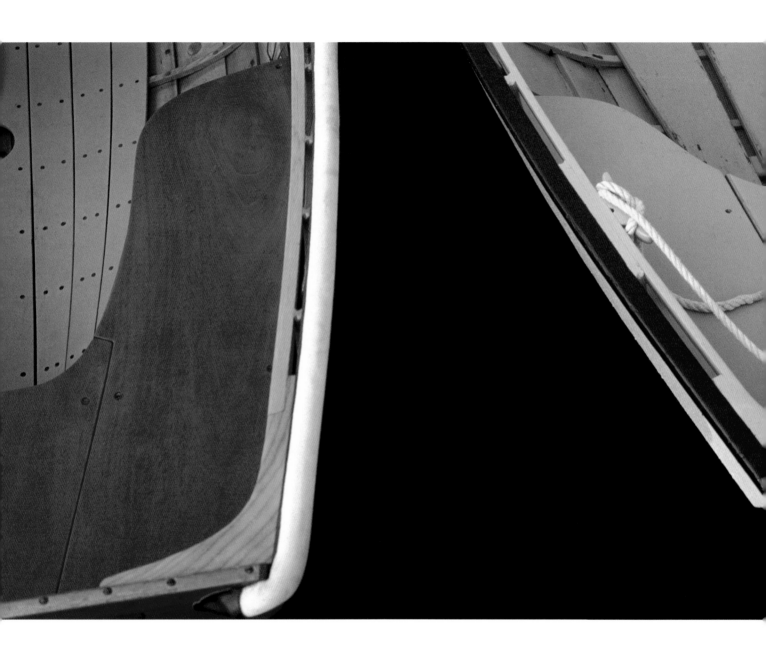

My boat breathes sturdy eager confidence.
— *H.W. Tilman*

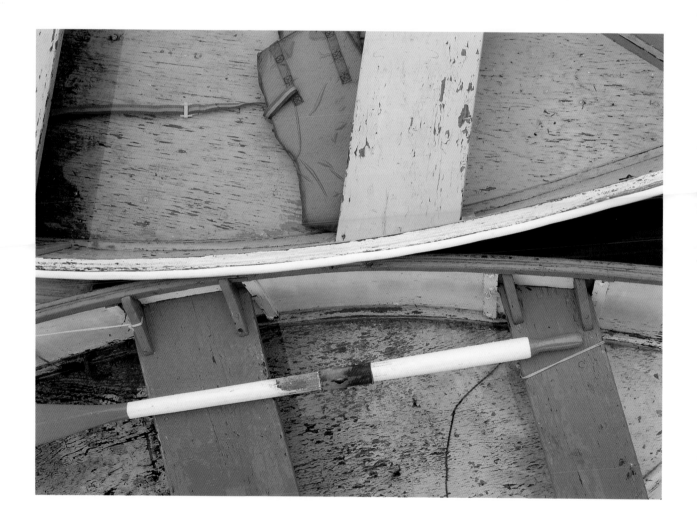

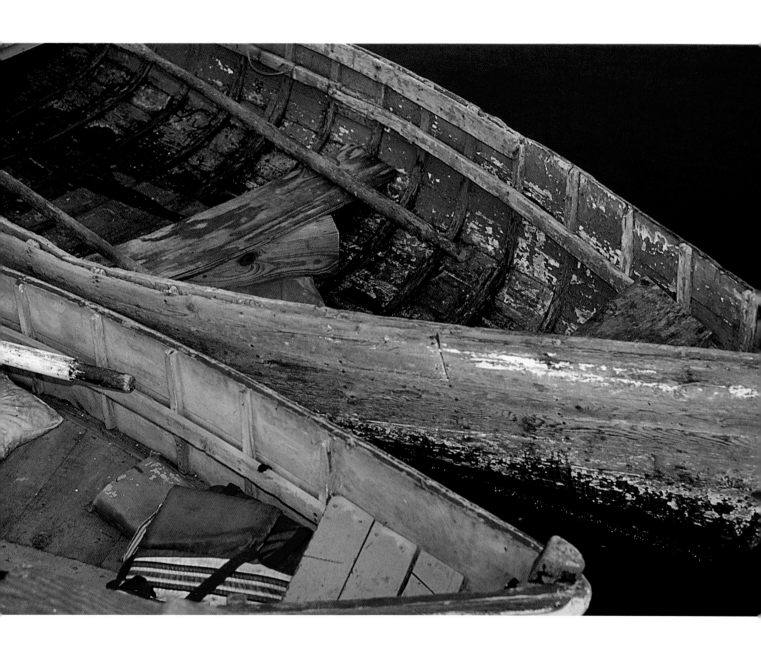

Not infrequently the old-time
oarsman thought and spoke
of his boat as a live thing.
            —*John Gardner*

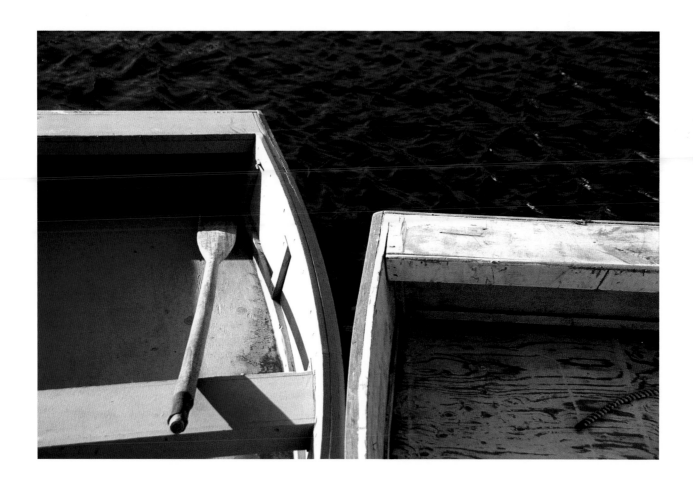

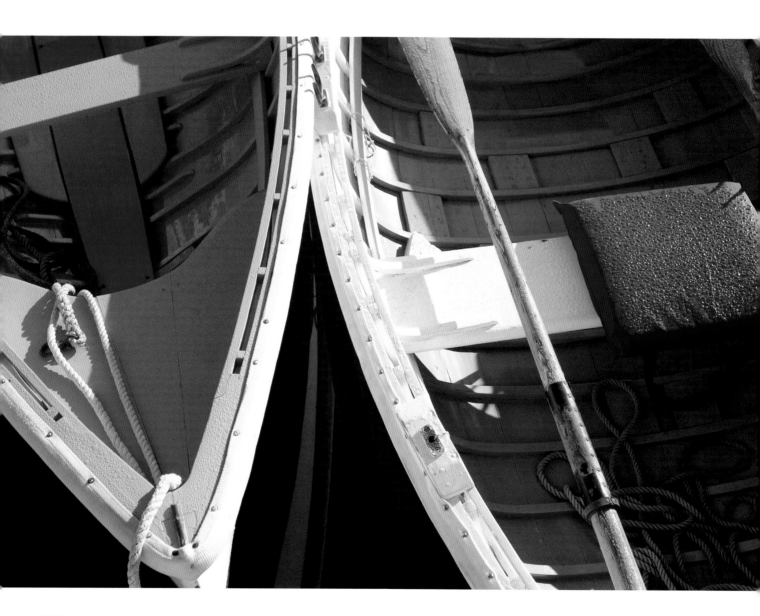

The sweep of a sheer-line is a poem.
—*Vincent Gilpin*

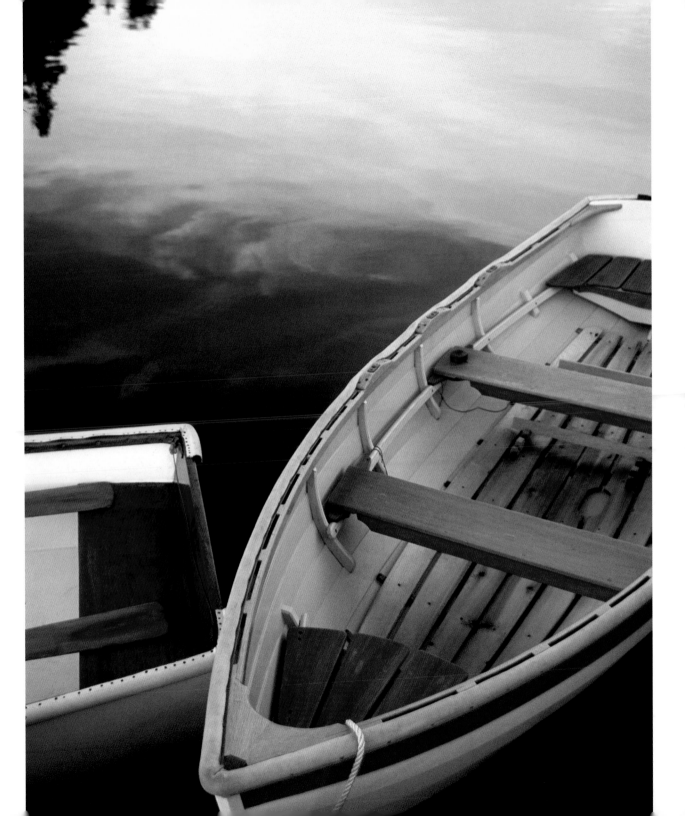

Of all inanimate objects a boat
is surely the most beloved of its
owner; there is something almost
human in its ways and vagaries.
—*E.F. Knight*

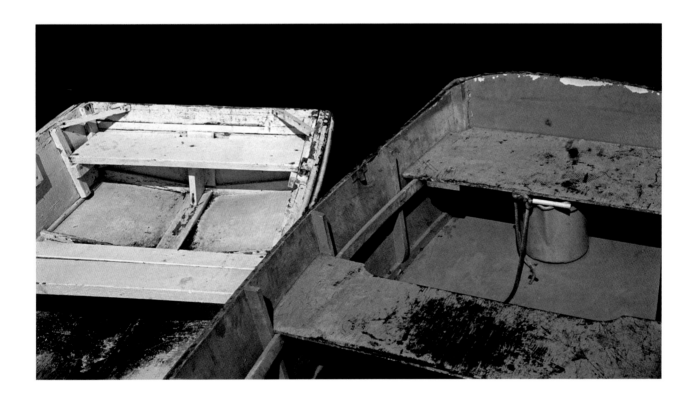

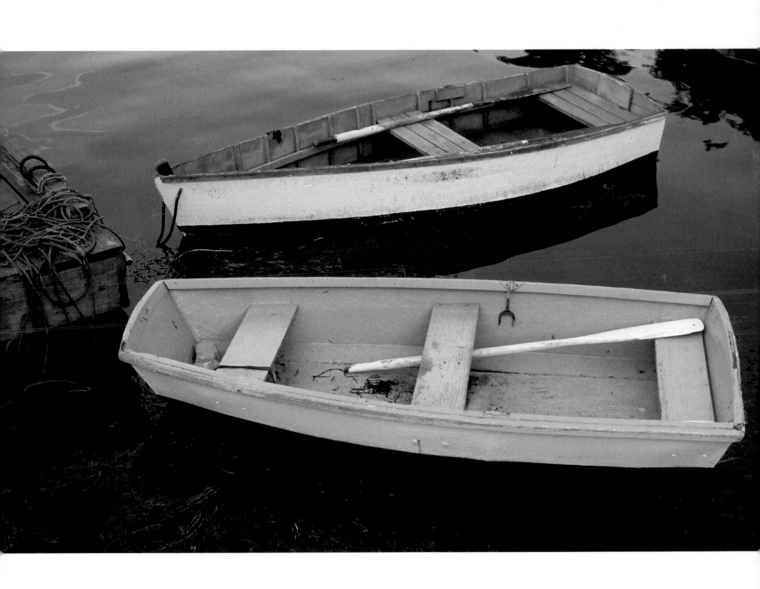

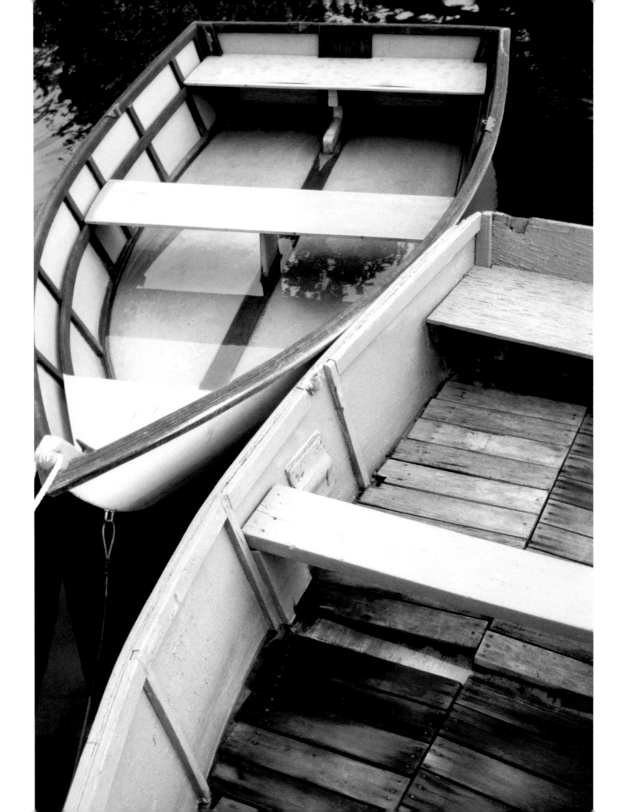

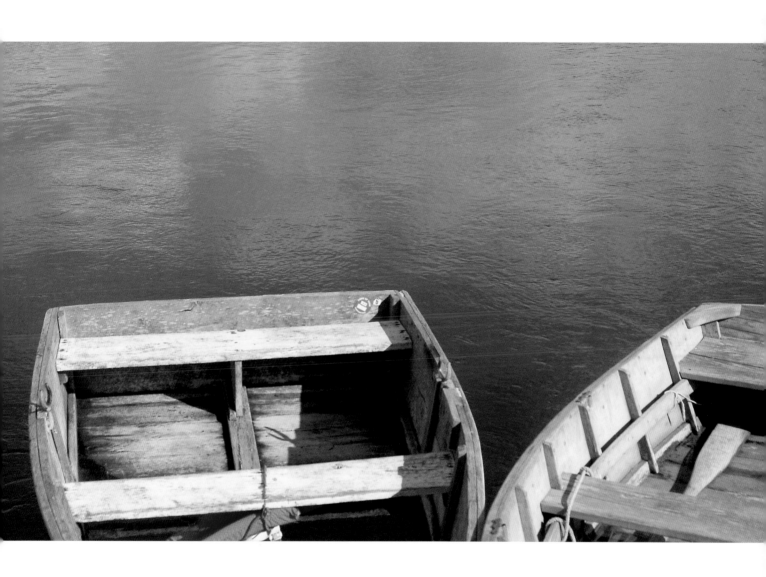

And what do boats — old ones and young ones — talk about? They will talk about themselves, their neighbors, their ailments, their hopes, their prospects, and their discouragements much the same as people talk.
—*William Atkin*

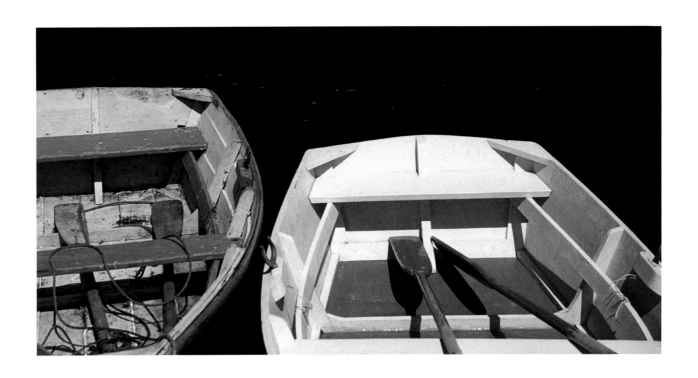

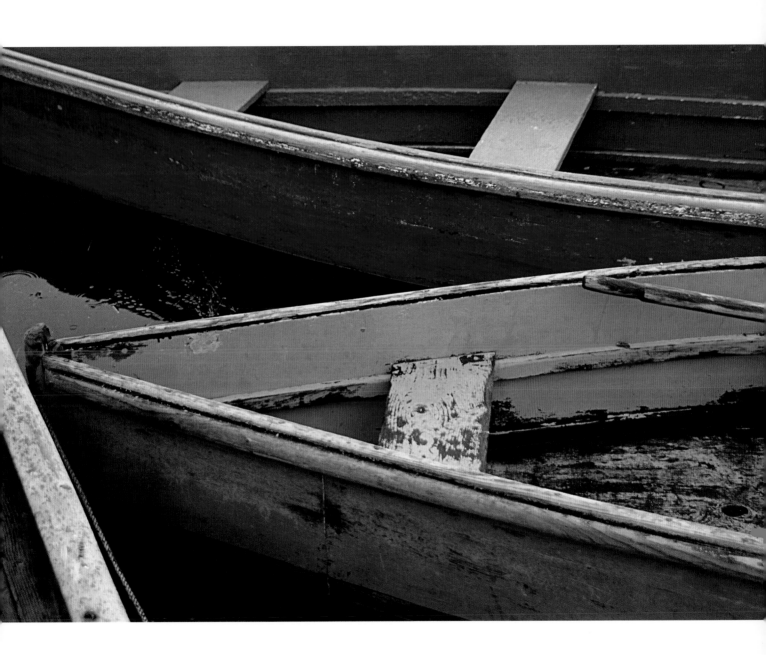

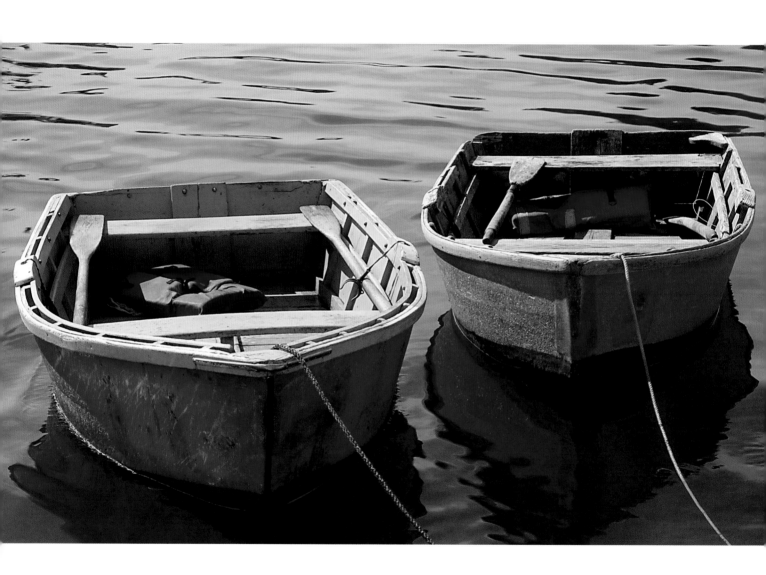

We, watching, praised her
beauty, praised her trim.
—*John Masefield*

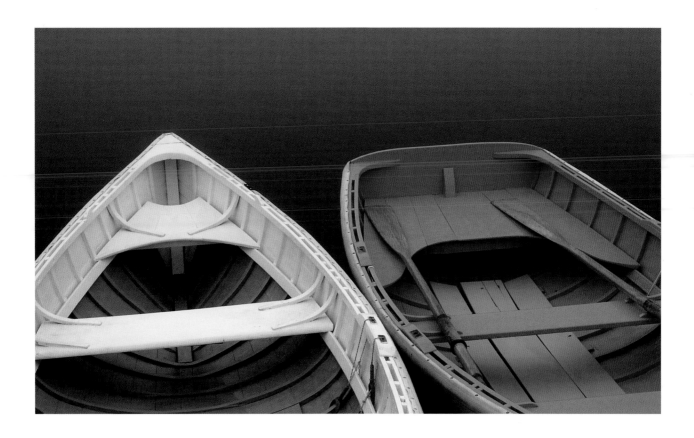

# Index
## BOAT LOCATIONS

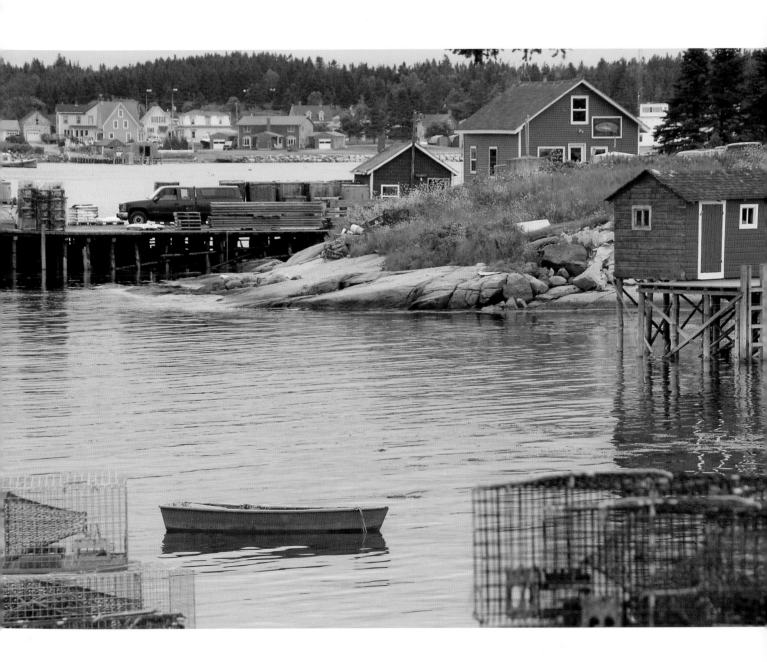

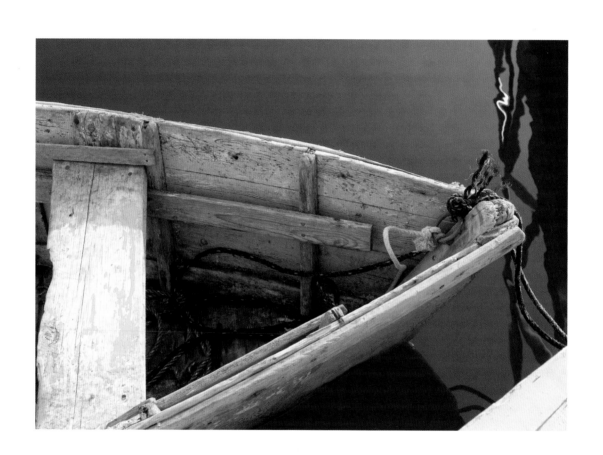